JN094278

Guide to

TRPGのデザイン

TRPG Graphic Design

Have you ever played a tabletop role-playing game (TRPG)? In the opening scene of the Netflix drama "Stranger Things," Mike and his friends are playing Dungeons & Dragons (D&D), a classic TRPG. While some may believe that these analog games, which take place in the 80s and rely on tabletop figures, dice, and rulebooks, have been replaced by computer RPGs that appeared around the same time, TRPGs - the origin of these games - spread throughout Japan in the late 1980s and continue to be played today as a unique game style. In recent years, with the rise of online sessions and distribution, especially with the spread of telework, both the tools and works have undergone remarkable development. However, the most important characteristic that has not changed is that both the game master and players are flesh and blood, and the game is played through "free verbal exchange" such as voice and text.

TRPGs are stories created through conversation, and at the same time, they are an opportunity for players to become the creators of their own stories. While there is no set formula, the techniques are open, and anyone can become a creator if they wish. While only a small portion of this can be captured and conveyed at this point, the role of this book is to respond to the evolving interest in TRPGs and design, and to help those who are creating, especially those who want to design on an independent basis.

Additionally, we take a big look at the Murder Mystery genre, where online sessions are booming at the same time, and where the essentials of design can be applied. We dedicate this book to our comrades who see new possibilities in these fascinating and interesting genres and who are shaping the future together.

はじめに

　TRPGを遊んだことはあるだろうか？

　Netflixドラマ『ストレンジャー・シングス』の冒頭でマイクたちがプレイしているのが、王道TRPGの「ダンジョンズ＆ドラゴンズ（D&D）」だ。舞台は80年代、卓上のフィギュアをコマに、ダイスとルールブックを頼りに進行するアナログなRPG——と聞くと同じ頃登場したコンピュータRPGに取って代わられたのではないかと思う方もあろうが、それらの源流であるTRPGも80年代後半には国内へと普及し、独自のゲーム様式として今も脈々と遊び継がれている。

　近年では配信を含むオンラインセッションの盛り上がり、特にテレワークの普及を糧に、ツールも作品も目覚ましい発展を遂げた。それでも変わらぬ一番の特徴は、ゲームマスターもプレイヤーも生身の人間であり、音声やテキストなど"自由な言葉のやりとり"でプレイすることだ。

　TRPGは、会話で創り上げる物語であると同時に、遊び手が作り手になる機会でもある。

　定型はあるようでなく、技術は開かれており、望めば誰でも作り手になれる舞台で、今まさに、あらゆる物語とさまざまなデザインが生まれている。現地点で切り取って伝えられるのはそのごく一端であるが、本書の役割は、進化するTRPGとデザインへの関心の高まりに応え、創作する人、特にデザインしたい人の手助けとなることだ。

　併せて、オンラインセッションが同時期に盛り上がり、花開いたマーダーミステリーゲームも大きく取り上げた。デザインの要点は現代のTRPGに通じるものがある。

　これらの非常に魅力的で興味深いジャンルに新たな可能性を見出し、共に未来を切り拓く同志に捧げたい。

Contents

Chapter1. デザインの基本

Chapter2. デザインのポイント

Chapter3.
デザインのアイデア

Chapter4.
マーダーミステリーのデザイン

TRPGの現在

　冒頭でも紹介した『ダンジョンズ＆ドラゴンズ』（以降『D&D』とする）は、1974年に発売された世界初のRPGであり、今もなお製品版がアップデートされ続け、世界中で遊ばれている。こうしたテーブルゲームが翻訳・翻案されて入ってきた1980年以降の日本では、すでにD&Dに影響を受けて生まれた『ウルティマ』や『ウィザードリィ』といったファンタジー設定のコンピュータゲームが"RPG"として紹介され、今ほど一般的ではないながらも一部のユーザーの中で遊ばれ始めているところだった。

　以降、瞬く間に普及した『ドラゴンクエスト』をはじめとする所謂コンピュータRPG（CRPG）と区別して、「テーブルトークRPG」、略して「TRPG」の呼称が定着していったとされる。英語圏でもTRPG、またはTTRPGと呼称されるが、これは「Table Top Role-Playing Game」の略であり、いずれにしても"テーブルを囲み、会話形式で行うロールプレイングゲーム"の意である。

　「ロールプレイ」とは、想像上のキャラクターを演じることだ。剣士や魔法使い、僧侶といった役職に、名前だけでなく自分で創作した人格や自己解釈した設定を付与することで、生き生きと仮想世界に立ち上がらせる。ルールブックではゲームの世界観やゲームシステムが定義されており、物語の設定として用意されるのがシナリオである。それらに基づきゲームマスターやキーパーと呼ばれる進行役がガイドする世界の上で、プレイヤーはそれぞれのキャラクターを動かし

て、ときに行動の成否をダイスロールに委ねながら、そのキャラクターでしか体験することのできない唯一無二の物語を作り上げていく。

『D&D』で確立されたこのプレイパターン——ゲームマスターが進行し、複数のプレイヤーが個別の役割を演じ、会話や探索や戦闘を通じて独自の物語を紡ぐ——をベースに、あらゆるTRPGが生み出された。

パッケージや書籍、ウェブサイトで公式ルールブックがリリースされると、各システムに紐付くシナリオが続々と創作され、自らプレイするキャラクターのイラストを創作する文化も生まれた。また、ゲームプレイの様子を戯曲形式で書き起こした「リプレイ」を読む楽しみ方や、リプレイ集を原案とした小説が人気となり、『ロードス島戦記』や『ソード・ワールドRPG』はアニメやコミックなどあらゆるメディアに展開をみせ、国産ファンタジー作品の勃興とともにTRPGプレイヤーの増加の一翼を担った。

現在では、実際にテーブルを囲まずともオンラインでプレイする人口が膨らみ、オンラインセッションを前提としたシステムやシナリオも多数生まれている。ゲーム実況の人気も相まって、リプレイ動画やセッション配信でこれまで馴染みのなかった人がTRPGを目にする機会も増え、この人気は今後もさらに高まっていくといえよう。

RPGの王道の世界観といえば、剣と魔法が登場する壮大なファンタジーをまず初めに思い浮かべる方も多いだろう。しかし、どんなゲームにおいてもそうであるようにTRPGでもまたジャンルは多様化し、和製ホラーやSF、近現代を舞台にした謎解き、ただ日常を過ごすものも登場した。

数あるTRPGの一例となるが、日本ではハワード・フィリップス・ラヴクラフトをはじめとする作家らが創作した神話世界をベースにした『クトゥルフ神話TRPG』の人気が高い。『クトゥルフ神話TRPG』は神話生物と呼ばれる仮想の生物が登場するホラーRPGだが、二次創作されたシナリオの中にはそういった生物が登場しない、あるいはホラーではなく喜劇のシナリオもある。しかし、公式ルールブックにおいても「ラヴクラフトのスタイルを踏襲したものでさえあれば、必ずしもクトゥルフ神話の話でなくてもかまわない」(『クトゥルフ神話TRPG』より)とされている。ラヴクラフトの小説がそうであったように、TRPGは今も世界中で人々の想像力を刺激し、自由な発想を肯定し、新しい物語や創作物を生み出す芽となっている。

TRPGのシステムいろいろ

現在遊べるTRPGのゲームシステムの多くは、書籍などのルールブックで礎となる世界観や判定のためのデータが定義されている。遊びたいシナリオが決まっていない場合は、好みの世界観を持つシステムから探すことができる。ここではその一部を紹介する。

神話、ホラー

　人知を超えた怪物や超常現象により、人間の恐怖を呼び起こすホラー。小説家H.P.ラヴクラフトらによって紡ぎ出されたクトゥルフ神話を題材に、アメリカのゲーム会社が製作したTRPG『クトゥルフの呼び声（Call of Cthulhu）』（1981年）が現在も改訂を重ねており、国内では第6版の邦訳『クトゥルフ神話TRPG』、第7版『新クトゥルフ神話TRPG』が絶大な人気を誇る。クトゥルフ神話をモチーフにしたTRPGとしては他にも、イギリスの『トレイル・オブ・クトゥール』、スウェーデンの『Kutulu』などがあり、いずれも邦訳されプレイされている。日本発のホラーTRPGとしては、妖怪や怪異、都市伝説や怪奇現象などさまざまな超常事変を題材とした『エモクロア』、一見すると何の変哲もない世界で、心に秘密を抱えた人物たちが奇妙な怪事件に巻き込まれていく『インセイン』などが挙げられる。

ファンタジー

　剣士や魔法使いが登場し、探索をしながらドラゴンなどのモンスターとの戦闘を繰り広げ冒険する、現在のゲーム文化の王道ともいえるファンタジー。TRPGの元祖ともいえる『D&D』をはじめ、国内では『D&D』を題材にしたリプレイ小説『ロードス島戦記』を発端に、グループSNEが制作した『ソード・ワールドRPG』シリーズが初期のTRPG人気を牽引し、今も広く遊ばれている。『アリアンロッドRPG』『ログ・ホライズンTRPG』など多くのシステムが後に続き、『DARK SOULS TRPG』『OCTOPATH TRAVELER TRPG』などTRPG化されるCRPGも少なくない。さらに、『ウォーハンマーRPG』など王道の世界観から派生したダークファンタジーや、魂を持った人形になって冒険を繰り広げるメルヘンファンタジー『スタリィドール』など、ハードなものから可愛らしいものまでさまざまなテイストが揃っている。

SF

　1977年にアメリカで発売された『トラベラー』をはじめ、超未来やパラレルワールドが題材となるSF。サイバーパンク、スチームパンク、ディストピアなどに細分化される。架空の1980年代を舞台に、少年少女となり謎の科学施設「The Loop」が存在する島の謎を解くスウェーデン発の『ザ・ループTRPG』、映画作品を模したフィクションが具現化し、現実を書き換えてしまう現象「虚構侵蝕」に立ち向かう『虚構侵蝕TRPG』、「第四次企業戦争」後の荒廃した「赤の時代」に巨大都市ナイトシティを冒険する『サイバーパンクRED』などがある。

アクション

　バトルなどのアクション要素を主軸に据えているジャンル。現代を生きる忍者を題材にした『シノビガミ』、現代社会に潜在する異能力者が活躍する『ダブルクロス』、本格的な銃撃戦と映画さながらのアクションシーンが魅力のガンアクションTRPG『ガンドッグ・リヴァイズド』などがある。アクション×SFやアクション×ホラーなどもあり、天変地異が起きた地球の近未来都市が舞台の『トーキョーN◇VA』は、判定にダイスロールでなくトランプを使い、手札をどのように出すかの判断や駆け引きが楽しめる。

その他

　この他にも、人に化ける力や魔法の力を持った動物「変化（へんげ）」になって、どこか懐かしいのどかな田舎町を舞台にほのぼのとした物語が繰り広げられる『ゆうやけこやけ』、プレイヤーの最大人数が2人と限られたバディ探偵モノ『フタリソウサ』、オモテとウラを持つキャラクターが会話と演技で物語を紡ぐ『ストリテラ』など、さまざまなジャンルのTRPGが、国内外のTRPGデザイナーによって次々と生み出されている。また、TRPGを気軽にプレイできるようカードに落とし込んだ『のびのびTRPG』シリーズでは、同じシステムでジャンルを超えた作品展開がなされている。

TRPGのシナリオいろいろ

TRPGでは、各ゲームシステムに紐付くシナリオを選び、プレイすることになる。ルールブックと一体になってるものもあり、システムの自由度にもよるが、具体的な舞台やストーリーはシナリオで定義される。シナリオにはいくつかの型や特徴があり、ここではその一部を紹介する。

クローズド

クローズドとは、限られた、または閉ざされた空間やエリアが舞台となるシナリオ。扉のない一室、閉鎖された施設、海の上の客船、ホワイトアウトした雪山など、密室または広義の密室状態である。ダンジョンのように限られた範囲を探索するため、「脱出する」など行動の目的もわかりやすく、シンプルなストーリーであることが多い。仮に限られたエリアが舞台であっても、密室ではなくそれなりの移動を伴ったり、順を追い探索範囲が変わる／広がるシナリオは「セミクローズド」、「半クローズド」と呼ばれることがある。

オープン

クローズドとは反対に、広い／開かれた空間やエリアが舞台となるシナリオ。思い思いに動き回れることから攻略手順などの自由度が高く、アドリブの利くストーリーであることが多い。中でも、国や都市の一部を探索できるオープンシナリオは「シティシナリオ」と呼ばれ、交通機関を利用して街を移動し、人に会ったり、図書館で調べ物をしたりといった普段の生活のような選択肢をとりうる。広大なマップを縦横無尽に攻略するとなるとプレイ時間も膨大になることから、範囲を絞った「半シティ、半クローズド」のような設定もある。

タイマン、ソロ

「タイマンシナリオ」や「ソロシナリオ」は、基本的に1人のプレイヤーとGM、またはGMレスでプレイするシナリオを指す。通常のTRPGとは異なり、他のプレイヤーとの交流や協力ができない点が欠点として挙げられることもあるが、キャラクターがシナリオの世界に深く没入できる形式であり、個人に焦点を当て、キャラクターの成長や内面の描写、ストーリー展開により時間を費やすことができる。ソロシナリオはPCが1人で物語を進めていくことが多く、時間や周囲を気にせずプレイしたい人にも向いている。CoCのタイマンシナリオはKPC（KPが作成したキャラクター）とPC（プレイヤーが作成したキャラクター）の関係性を深掘りして2人で物語を進めていく。一対一の環境ではGMがプレイヤーをサポートしやすく、ルールやシステムに慣れることができ、スケジュール調整も比較的容易になるため、初心者やグループでのプレイに抵抗がある人にも向いている。

キャンペーン

キャンペーンシナリオは、いくつかのエピソードが連なり最終的に完結する長期的な物語を、複数のセッションにわたって遊ぶ形式をとる。テンポよく短期間で終わるものから一年を超える長期にわたるものまで幅広く、キャラクターはエピソードごとに経験を積み、成長していく。キャンペーンシナリオでは短期的な目標やイベントに加えて、長期的な目標や大きな謎も提示される。同じキャラクターで継続して遊べるので、物語が進むにつれ、キャラクターが手に入れた新たな能力やアイテムを駆使して、より強力な敵や困難な状況に立ち向かうことができる。キャラクターの成長を感じながら、シナリオ全体のテーマや、キャラクター同士の関係性をじっくり味わうことができるのが魅力だ。デメリットは参加者のスケジュール調整が難しいことだが、ストーリーへの深い没入感やキャラクターとの強いつながり、そして協力して難題を解決する達成感を得ることができる。

協力型／PvPと秘匿HO

「PvP（Player versus Player）」はプレイヤー同士の対決を意味し、反対にプレイヤー同士が協力してゲームのクリアを目指すものを「協力型」と呼ぶ。PvPはPC同士が敵対する組織に所属している、相手を出し抜く必要がある……など、PCの目標が対立したり、争う可能性がある。PCには個別の目標や他者に話してはいけない秘密が与えられることがあり、それらは「秘匿HO（ハンドアウト）」に記載されることが多い。PvP要素の有無はシナリオ概要であらかじめ明記されることもあれば、特定のタイミングまで明かされない場合もある。また、PvP要素を含むシナリオでもプレイヤーの選択によってPvPを回避できる場合もある。なお、TRPGは基本的にはプレイヤーたちが協力してひとつの世界を築くものであり、協力型であろうとPvPであろうと、自分のキャラクターの行動を他のキャラクターが理解できる程度にロールプレイで表現し、物語を進めていくことが求められる。

TRPGの遊び方

TRPGはコミュニケーション型のロールプレイングゲームだ。参加者は協力して物語を創り上げ、スキルや能力の活用、情報共有、対話や交渉を行いながら、ダイスを使った判定などでキャラクターの行動の成否を決めていく。ここでは一般的な遊び方の一例を紹介する。

システム・シナリオの選択

遊びたいTRPGのシステムとシナリオを選ぶ。公開されている作品の世界観や傾向のほか、プレイ想定時間も参考にしたい。短いシナリオであってもボイスセッションであれば1時間以上、テキストセッションであればその数倍かかることがある。

ゲームマスターとプレイヤーの決定

ゲームマスター（GM）は物語の進行役で、プレイヤーは物語の登場人物となるキャラクターを演じる。GMはストーリーや舞台設定の理解を深めるためにシナリオを読み込み、登場人物（NPC）の管理、進行手順の確認、ルールの解釈・アレンジなどの事前準備を行う。プレイヤーは同期的に集まれるメンバーを募り、ゲームマスターと調整して日程を決める。

ハンドアウトの選択とキャラクターの作成

ハンドアウト選択制のシナリオでは、プレイヤーは自分が選んだハンドアウトごとに演じるキャラクターを作成する。ルールブックに従って、キャラクターの能力値やスキル、装備などを決定し、キャラクターシートに記入する。またキャラクターの背景や性格を考え、自分のキャラクターがどのような思考を持ち行動を取るか考えておくことで物語の世界に入りやすくなる。キャラクターシートはゲーム開始前にGMに提出し、GMはキャラクターシートを確認して、プレイヤーへアドバイスするほか、ゲームのバランス調整を行う。

セッション開始

GMがシナリオの導入説明を行い、ゲームを開始する。プレイヤーはキャラクターとしてロールプレイ（RP）をしながら物語を進める。GMはストーリーの進行に合わせてプレイヤーに状況を説明し、プレイヤーはキャラクターとしてどのような反応をし行動を取るかを考え、伝える。GMはプレイヤーの行動の結果やどのような結果が予想されるかの描写を行い、それを受けてさらにプレイヤーがキャラクターを動かす……というように進んでいく。

物語の進行

プレイヤーはハンドアウトに書かれていた目標、あるいは物語が進行する中で生まれた目標を達成するために、戦闘や交渉などさまざまなシーンを経験する。シナリオにはプロットがあるが、物語はプレイヤーの選択や行動によって変化する。積極的にプレイヤー同士、またGMとコミュニケーションを取り、ストーリーや自身の行動についての考えやアイデアを共有しながら進めていこう。

行動判定

プレイヤーが行動を決定したら、GMはその行動が成功するか失敗するかを判定する。多くのTRPGではダイスの出目とキャラクターの能力値やスキルを組み合わせて判定が行われ、判定はルールブックに準拠する。

セッション終了

ストーリーが一定の終わりに達するか、プレイヤーが目標を達成することで、セッションは終了する。GMが物語の顛末を語り、プレイヤーはキャラクターの今後について考えたり、経験値を獲得してキャラクターを成長させたりする。

アフタートーク

セッション終了後、参加者は物語の感想やキャラクターの行動について語り合ったり、次回のセッションについて話し合う。

TRPGで準備するもの

TRPGは時間とメンバーが確保できればオフラインでもオンラインでも遊べる。前提として、オフラインの場合はセッションができる場所、オンラインの場合は、セッションツールが快適に動くデバイスやWi-Fi、ボイスセッションならヘッドセットなどを用意し環境を整える必要がある。

ルールブック・サプリメント

　遊ぶTRPGのルールブック、必要に応じてサプリメントと呼ばれるルールブックを拡張する追加データ集を用意する。ルールブックにはゲームの世界観、システム、ルール、キャラクターの作成方法、キャラクターシートのテンプレートなどが記載されている。参加者全員が所有しているか、あらかじめGMが把握し説明するなど、前提を確認・理解していることが理想だ。システムごとに必要になるため、初めて遊ぶときには負担になるが、何度も遊びたい場合はプレイヤーも購入して手元に用意しておくのがマナーといえる。

シナリオ

　遊ぶシナリオ。GMはあらかじめシナリオ展開を読み込み、ストーリーや背景設定、登場人物、事件や謎、目標などを確認して物語をどのように進めていくか構想しておく必要がある。プレイヤーがシナリオを入手した場合も、公開されている情報以外のシナリオ展開を閲覧しないように注意し、GMにキャラクター作成のために考慮すべき点を確認しておこう。

キャラクターシート

　プレイヤーが演じるキャラクターの情報を記録するシート。ルールブックに準じた形式で、キャラクターの名前、職業、年齢、能力値、スキル、装備などを記載する。オンラインでキャラクターシートを記入・保管できるツールや、クリックするだけで自動でステータスが振れる仕組みもあるが、初心者には展開を見越したバランス調整が難しい。ゲーム開始前までに作成し、あらかじめGMに確認してもらおう。GMはキャラクターシートに応じてゲームバランスの調整を行う。

ダイス

　TRPGでは、基本的には行動の成否や効果を決定するためにダイスを使う。主に6面ダイスや10面ダイスなどが使われるが、システムによっては特殊なダイスが必要な場合もある。ダイスはオンラインツールやアプリなどで代用できるが、こだわりた

い人はオリジナルデザインの多面体をダイスをオーダーすることができる。ダイストレイもあると便利だ。

筆記用具・メモ

　キャラクターシートに情報を記入したり、ゲーム中にメモを取るために筆記用具（書いて消せるもの）を用意する。オンラインではメモアプリ等で代用できる。

参考資料

　GMは世界観や各シーン、NPCやモンスターの情報、プレイヤーはキャラクターの設定の詳細などをいつでも確認・肉付けできる資料を手元に用意しておくとよい。

マップとコマ

　一部のTRPGでは、ゲームの状況を視覚化するためにマップやキャラクターのミニチュア（フィギュア）を使用する。これによりプレイヤーがキャラクターの位置関係や状況を把握しやすくなる。ボードゲームで利用される汎用コマでも代用できる。オンラインセッションでは、キャラクターの立ち絵を用意したり、シーンの参考画像を用意することが多い。

BGM・SE

　物語を盛り上げる、適切な音楽や効果音を用いることで、より没入感を高めることができる。音素材がシナリオに同梱されている場合もあるが、手軽に利用できるBGMやSEのDLサイトがたくさんあるので、GMがテーマやシーンに合う好みのものを見繕っておけるとよい。

飲み物や軽食

　セッションは数時間続くことがあるため、各自飲み物や軽食を用意しておく。オフラインセッションの場合は会場が飲食可かあらかじめチェックしておこう。また、無理のないよう適宜休憩を挟む。

TRPGの用語集

❧ GM（ジーエム）/ KP（ケーピー、キーパー）

それぞれゲームマスター、キーパーの略。TRPGにおける進行役を務める人のこと。DM（ダンジョンマスター）、SD（セッションデザイナー）などと呼ぶ場合もある。

❧ PL（ピーエル）

プレイヤーの略。ゲームをプレイする人のこと。

❧ PC（ピーシー）

プレイヤーキャラクターの略。PLが作成し、操作するキャラクターのこと。CoCでは「探索者」、エモクロアでは「共鳴者」などと呼ぶ場合もある。PLが操作せずGMが操作するキャラクターはNPC（ノンピーシー）と呼ばれ、KPが用意するNPCをKPCと呼ぶこともある。

❧ RP（アールピー、ロールプレイ）

ゲーム内でPCが行う言動。PCの人格やライフパス、立場等を考慮して役割を演じること。

❧ ライフパス

キャラクターの出自やこれまでの人生の経歴を示す要素。

❧ ルールブック

ルルブと呼ばれる、ゲームシステムを定義したTRPGの本体。ゲームを進行するためのルールが記されている。

❧ サプリメント

サプリと呼ばれる、ルールブックを拡張する追加データ集。特定の情報にフォーカスして知識を深めることができる。

❧ リプレイ

TRPGで実際に行われたセッションを記録したもの。また、その記録を物語として第三者も楽しめるよう編集したもの。動画や創作を含む小説などの形態がある。

❧ シナリオ

キャラクターが冒険する舞台の設定や、遭遇する事件の内容、事件を通して語られるストーリーのプロット（物語の要約）をまとめた資料。

❧ キャンペーンシナリオ

世界観や登場人物などを共通とした、複数のシナリオの集まり。ひとつひとつのシナリオとして完結しつつ、キャンペーン全体でも物語が進行するため、基本的には同じPCや関連するPCを使用する。

❧ CoC（シーオーシー）

『クトゥルフの呼び声（Call of Cthulhu）』の略。シナリオにおいてはクトゥルフ神話をベースとしたTRPGシステムを指す。

❧ ハウスルール

GMがそのシナリオ内のみで独自に設定するルールのこと。または、そのGMが主催するセッションすべてに共通するルールを設けている場合があり、それをハウスルールと呼ぶ。

❧ セッション / 卓

TRPGを遊ぶこと、遊ぶ場のこと。通常、1セッションは1つのシナリオを遊び終わるまでを指し、1セッションを複数回に分けて行うこともある。セッションの予定を立てることを「卓を立てる」などと呼ぶ。

❧ 通過

シナリオをプレイすること。「シナリオを通る」と表現することもある。まだプレイしていないことを「未通過」と言う。

❧ 回す

GMを行うことを「シナリオを回す」「卓を回す」と言う。PL側が「卓を回る」と言うこともある。どちらもTRPGを遊ぶことを指す。

❧ オンセ / オフセ

オンラインセッション、オフラインセッションの略。オンラインセッションは通話・チャットアプリやオンセツールを使用する。オフラインセッションは実際にPLが一堂に会して対面式で行う。

❧ オンセツール

オンラインセッションツールの略。チャット機能をベースに、ダイスロールやコマをボードに置く機能、キャラクターシートの表示機能などが付与されている。

❧ ボイセ / テキセ

ボイスセッション、テキストセッションの略。オンラインセッションの方法を細分化したもので、音声による会話とテキストを併用して進めていくセッションと、テキストのみで進めるセッションがある。オフラインセッションは基本的に対面式となり、これらの語は使われない。

❧ 身内卓 / 野良卓

身内卓は友人や知り合いなど固定のコミュニティ内で行うセッションのこと。野良卓は誰でも参加できる条件で広く募集をかけて集まったメンバーで行うセッションのこと。

突発卓

あらかじめ予定しているセッションではなく、思いつきで即日（または近い日付で）行われるセッションのこと。

ダイスロール

サイコロ（ダイス）を振ること。ダイスの出目により成否判定およびダメージ量の決定に用いる。

成否判定

キャラクターが行いたい行動の可否の判定。あらかじめ成功値が決められており、ダイスの出目で判定するほか、GMがアドリブで値を設定する場合もある。

1d100（いちでぃーひゃく）

「100面ダイスを1個振る」という意味。「d」はダイスのこと。6面ダイスを1個振る場合は「1d6」と表す。

クリティカル / ファンブル

ダイスの出目で最も良いとされるものがクリティカル、逆に最も悪いものがファンブルと呼ばれ、クリティカルの場合はPCが追加で通常よりも有益な情報や多くの結果を得られることがあったり、ファンブルの場合は追加でダメージを受けたり、情報取得に失敗することがある。大成功と大失敗を表す語。

HO

ハンドアウトの略。シナリオが物語全体の進行に関わる内容であるのに対し、HOは作成するキャラクターの設定に関わる内容であることが多く、通常1PCごとに1HOが配られる。PLに向けた事前情報のひとつ。キャラクターの職業や考え、キャラクターの置かれる状況や立場、物語における役割、動機、目的などが書かれている。キャラクター作成の自由度はシナリオにより幅があるが、基本的にはHOに記載された内容に合うPCを用意する。

秘匿HO

他のPLには伏せられた、そのPC独自の秘密の情報。最後まで隠し通すことがゲームの目的である場合もあれば、シナリオ中に開示して場を盛り上げるエッセンスにすることもあり、遊ぶTRPGの性質によって扱いが異なる。秘匿なしのケースと比べ、少し高度な遊び方となる。

継続

過去に作成してシナリオで使用したPCを、他のシナリオでも使用すること。シナリオに矛盾が生じる必要があるため、事前にGMに相談することが望ましい。シナリオによっては継続不可もあり、その場合「新規限定」などの記載がある。

キャラ作成 / キャラクターメイキング

PCを作成すること。多くの場合、キャラクターの能力値はダイスロールによって決定するが、さらにそこからPC固有の設定を付与し、肉付けすることまでを含む。

キャラクターシート

キャラクターの能力値、スキル、持ち物、人格、ライフパスなどの設定を書き込むシート。「キャラシ」「CS」などと略される。シートのテンプレートはルールブックに付属しているが、オンラインで作成・保存・共有できるツールもある。

技能

PCの能力、パラメータのこと。主にゲームでの行動を判定する際に用いる。キャラクターの職業によって取得できる技能の種類が決まっていたり、シナリオによって必須の技能や推奨される技能がある。

SAN値 / 正気度

クトゥルフ神話を題材にしたTRPGで使われるPCのパラメータの一つ。HP（体力）とは別に、精神的にショックを受ける場面に遭遇すると減ることがある。SAN値が減ると狂気状態（錯乱状態）に陥ったり、ゲームオーバーになることもある。

ロスト

PCが失踪したり死んだりすること。「高ロスト」は高確率でロストするシナリオであることを表し、事前に注意喚起されることも多い。

生還

PCが生きてシナリオをクリアすること。

セッションルーム

キャラクターのコマや立ち絵、マップやアイテムなどのグラフィックが置かれる盤面のこと。一般的にはGMが用意するが、シナリオに同封されている場合もある。

立ち絵

ゲームに登場するキャラクターのイラストやグラフィックのこと。表情のみに変化をつけた「表情差分」、衣装に変化をつけた「衣装差分」を用意することもある。作品に付属している場合もあるが、参加者が作成することが多く、自分で描くほか、フリー素材やイラストメーカーを使用したり、イラストが描ける人に依頼して用意する場合がある。必ずしも立ち絵がなければTRPGを遊ぶことができないというわけではない。

トレーラー

シナリオを宣伝するための動画やイラストやグラフィック。タイトルとイメージとキャッチコピーのみのものから、概要やルールを明示するものまである。SNSや頒布サイトなどに掲載し、作品を印象づけるために作成・使用する。

スチル

ゲームの雰囲気や特定の場面を伝えるイラストやグラフィック。元々は「スチル写真」が語源とされ、ある瞬間を撮影した1枚の画像を指す。動きのある映像の対義語。転じて、ゲームの場面を切り取った静止画を指すようになったとされる。

デザインの基本

Chapter 1

デザインとは、デザインツールを使った作業と結果だと思われがちだが、アウトプットを導くまでの思考プロセスのことでもある。この章では、まずデザインで扱う要素に分解した後に、デザインをするために向き合っていくべきこと、また、とりうるアプローチについて紹介する。

Ch.1-1-1

❖ デザインの構成要素 1 ❖

フィジカル（物理）版

ここでは、TRPGでよくみられるフィジカル（物理）版のデザイン要素を紹介する。とあるシナリオ集をイメージしているが、構成や組み合わせは自由であり、この限りではない。また本という形にも正解はない。よくある要素を掴んだ上で、ぜひオルタナティブな試みを目指してほしい。

サンプル作品制作・提供：喪花

仕様

表現したい内容、予算によって落としどころを決める。A5判なのかB5判なのか、並製本なのか上製本なのか、無線綴じなのか和綴じなのか、表紙や本文にどんな用紙を使うのか、箔押しやカッティングなど加工の有無も検討要素だ。

装画

装丁に配される画、表紙絵にあたる。ほとんどの本は縦長のため、表1で完結する縦位置のビジュアルを用意するか、表4までひと続きのビジュアルを用意して見所を表1にもってくる。コンセプチュアルな画が向いている。

タイトルロゴ

ロゴは話題の尽きることのない一大デザイン要素だ。アニメやゲーム、漫画といった娯楽作品のロゴは、凝った作字にさまざまな要素が詰め込まれている。一方で、本のタイトルという観点においては既存書体でも問題ない。

背

本文がある程度の頁数を超えると背が生まれる。4mm以上の背幅（束）がある場合、背にタイトルなどのデザインを入れることができる。背幅（束）は、本文用紙と表紙用紙の厚み、頁数が決まれば計算で導き出せる。

裏表紙

手に取って裏返した時に目にする面で、カバー表4にあたる。表1が顔なら、表4は裏の顔だ。表1と関連のあるビジュアルを入れたり、目次のダイジェスト、導入文、概要を要素にデザインすることもある。

表紙

カバー表1にあたる。商業出版では本体表紙と呼ばれ、外側に袖付きのカバージャケットが巻かれることがある。装画がなくともタイトルをメイン要素に色面やタイポグラフィを駆使して表紙をデザインすることが可能だ。

構成

フィジカルならではの体験をデザインするためには、物としての魅力だけでなく、複数の機能を備えた構造物であることを重視する。この体験には入口と出口があり、デジタル版ほど簡単にはアップデートできない。バランスや流れを注意深く設計しよう。

扉

タイトルを明示し、p1、p3などに扉として据えることが多い。前扉、本扉の2扉構成、また見開き扉も効果的だ。遊び紙や口絵を扉前に挟むケースもあり、序奏の流れで改めて提示される、文字通りコンテンツへの扉である。

目次

それぞれ別の機能を持つコンテンツが同居している場合、巻頭にナビゲーションとして必要となるのが目次だ。読者がコンテンツのラインナップを把握し、必要な情報が収められている場所の目処をつけることができる。

導入

目次は左右ページどちら始まりでも構わないため、目次に挙げる項目数によっては片頁で終わり、対向頁を序文や概要、中扉などに使えることになる。イントロの結びとして、あらすじやキーフレーズを据えても効果的だ。

ノベルティ

せっかく物理本を作るなら、と付けることのあるノベルティ。ポストカードや栞といった印刷物以外にも、小ロットで製作できるグッズには多様な選択肢がある。読者に喜んでもらえて、利益調整にもなる便利なアイテムだ。

DLコンテンツ

物理本を購入してもセッションはオフラインに限らない。ダウンロードURLやパスワードを巻末に明記し、シナリオのPDFやオンライン用の素材、オフライン用の印刷データなど、購入特典のDLを促すことが多い。

Ch.1-1-2

デザインの構成要素 2

デジタル（データ）版

ここでは、TRPGでよくみられるデジタル（データ）版のデザイン要素を紹介する。とあるシナリオをイメージしているが、構成や組み合わせは自由であり、この限りではない。あくまで本体はシナリオだ。シナリオで連れていく世界をどこまで可視化するか、楽しみながら探ってほしい。

サンプル作品制作・提供：喪花

タイトルビジュアル

表紙にあたるもの。タイトルロゴとビジュアルを合わせて提示し、インパクトを持つと同時に、互いを引き立たせなくてはならない。ネタバレにならない範囲で内容に沿い、適切な期待感を高める役割を担う。

トレーラー

トレーラーとは本来、本編をダイジェスト的に紹介し、作品の宣伝のために制作された予告編（映像）のこと。TRPGでもプロモーションのために動画が作られることがあるが、本書では、主にSNSや頒布サイトのサムネイルで効果を発揮し、キャッチコピーなどが効果的に加えられた画像を指す。

導入

コンテンツへの導入。興味を引くキャッチコピーやあらすじなど、物語のさわりだけ紹介する。何を優先して読ませたいのか、またはどう印象づけたいかによって、言葉の強弱をコントロールし、視線を誘導する。

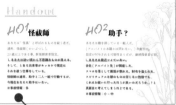

ハンドアウト

事前情報として公開される、プレイヤーキャラクターの設定。キャラクターメイキングが必要なTRPGならではの要素だ。ハンドアウトは「HO」と略され、役ごとのまとまりで目に留まるようデザインする。

チャプタータイトル

複数話あるキャンペーンシナリオの場合、シナリオタイトルの下の階層にチャプタータイトルが存在する。チャプターごとにトレーラーを用意する場合は、大元のタイトルに紐付くようデザインする必要がある。

セッションルーム

オンラインセッションツール「ココフォリア」などのルームデザイン。背景、前景、メニュー、アイコン、コマ置き場、マップなどの画像素材で盤面を構築する。シーンごとに演出・保存を設定し、切り替え表示することもできる。

マップ

オンラインセッションにおけるマップとは、現在PCたちがいる場所をイメージさせる画像のこと。風景や建物などの写真、具体的な地図や間取りといったフロアを表示する、もしくはシーンに沿った盤面デザインに切り替える。

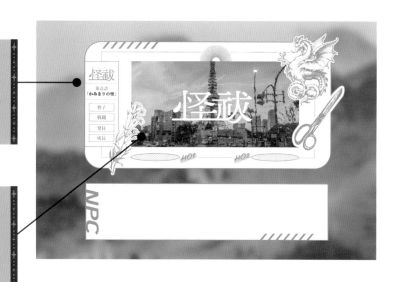

見出し

TRPGのシナリオは要素が多く、見出しが弱いと途端に流れの把握・確認が困難になる。デザイン的なあしらいで目立たせるだけでなく、ナビゲーション機能で任意の項目に飛べるようにするなど工夫したい。

キャッチコピー

コンテンツの傾向や価値を明示し、人を呼び込む目的で据えられる宣伝文句をコピーという。詩的なコピー、煽るコピーなどフレーズによって趣きが変わる。言葉×デザインでターゲットを明確にし、マッチングを図るのが重要だ。

シナリオ

シナリオはPDF、テキスト、htmlなど任意の形式にまとめられる。PDF版とテキスト版など複数用意して、ユーザーに選んでもらう場合もある。「TALTO」などの投稿サイトでは、専用エディタを介して作成・公開できる。

本文

まさにこれがメインコンテンツであり、読みやすい本文を作るための組版(レイアウト)にリソースを割きたい。フィジカル / デジタル問わず本文の可読性は重要な課題だ。原稿もデザインを見据えて整理・整形される。

Ch.1-2

デザインの6つのステップ

一般的なデザインのフローを紹介する。ステップを踏むごとにゴールがクリアになるはずだ。デザインとは手を動かす部分に限らない。デザインツールはより直感的に、高性能になり、デザインは多くの人に開かれている。それでもイメージ通りのデザインに仕上げるのは難しい。ほとんどの場合、足りないのは思索である。

Step1

デザインの目的を精査する

すっ飛ばしがちなプロセスだが、何のためにデザインするのか？はとても重要な分岐点となる。

たとえば、「新しい表現に挑戦したい」、率直に「目立ちたい（売れたい!!）」、「技巧を凝らしたい（デザインが好き!!）」こともあれば、「エモいシナリオなので雰囲気たっぷりにしたい」、「センシティブなシナリオなので警告を込めたものにしたい」、「続編だと伝えたい」といった内容ありきのゴールもある。粒感は違えど、これらはすべてデザインをどこに向かわせるかを決める、立派な目的だ。

Step2

デザインのテーマを決める

目的が定まったら、テーマも定めよう。この2つは似ているようで違う。目的は達成すべきゴールであり、テーマは達成に向けた指針であり、これらはセットでトーンや構成に反映させるべきものだ。片手落ちにならないよう揃えておこう。

何をテーマにデザインするか？は、言い換えれば、デザインで何を表そうとしているか、だ。作者が最も伝えたい、また暗に醸したい主題を据える。たとえば「目が回る感覚」や「眩い」といった状態でもいいし、「罠にかかる鼠」や「深海」といった具象でも構わない。

Step3

イメージを膨らませる

デザインのアウトプットをばっちり想像できていないのであれば、ムードボードを作ってみよう。単独作業でも効果的だが共同作業としてこれを行うことでイメージの擦り合わせができる。

ムードボードとは、理想を作る作業だ。イメージに近い/またはイメージに合う何らかの要素を備える既存の画像を、ピックアップして群れを作っては選り分けてを繰り返し、どんどん理想のコラージュ（画像群）に近付けていく。画像は写真、イラスト、デザイン、カラーパレット、テクスチャ、なんでも構わない。

Step6 ✨

デザインを作り込む

いい感じになりそうな手応えを得たら、あとは理想に近付けていくだけだ。バリエーションを増やす際は、先に完成に近付いたデザインをもとに展開していくことになる。後で全体をみて調整できるよう、要素を統合する前のファイルや、バージョン管理を怠らないようにしたい。

あれこれ試してどれを採るべきか迷ったら、別の作業をしたり、散歩に出たり、一晩置いて見直してみるといい。他者の客観的な意見に耳を傾けることも大事だが、制作者の意志による選択の積み重ねがデザインであることを忘れずに。

Step5 ✨

プロトタイプをつくる

ラフが出来たら、デザインツールでデザインを始めよう。このとき、全力で細部まで作り上げるのではなく、短期間でプロトタイプ（試作）を作り、方向性を確認するとよい。

また言葉によってデザインは変わる。特に文章は、行数や改行点が変わってしまうと、レイアウトが無駄になってしまうことがある。細かい言い回しの修正は後でもできるが、言葉のニュアンスからデザインを膨らませることも多い。デザインを依頼する際はもちろん、自分でデザインする際も、文字要素は先に用意しておこう。

Step4 ✨

ラフスケッチを描く

すでに頭に「こうしたい」というイメージが湧いているかもしれないが、ここで実際の素材を作り始めてしまうと、引き返すのが難しくなる。ラフスケッチを残しておくことで、いつでもベースキャンプのように戻ることができ、今後の制作の糧にもなるはずだ。

スケッチといっても、この時必ずしも「絵」を描く必要はない。設計図や構成図のように、必要な要素をマッピングするのでも構わない。具体的に何が必要かを洗い出すことができ、イメージが現実的かどうかの判断も下しやすくなる。

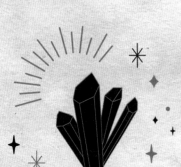

ゴールまで走り切る喜びを実感しよう

デザインは始めることより終わらせることが難しい。デザインツールを思うままに扱えるようになり、遊びや変化を盛り込む余裕が出てくるといつまでも弄ってしまう。まずはひとつの型として完成させ、人に見てもらうことを目指してみよう。ゴールまで走り切った達成感は、必ず次の機会と新たな視点を与えてくれる。

Ch.1-3-1

✦ 受発注の流れ 1 ✦

デザイン/イラストを依頼する

デザインは協働できる。コミッションサービスを利用して、イラストやデザインを発注してみよう。個人で技術を磨き、できることを増やすことも素晴らしいステップアップになるが、多様な表現ができるクリエイターと手を取り合うことで、一人では到達できない世界へ足を踏み入れることができる。ここでは詳しく触れないが、文章や添削、動画なども得意な人に依頼できる。

Step1 ✦

👥 クリエイターを探す

依頼したい人が決まっていればよいが、悩んでいる場合はたくさんの作品を見てから決めたい。頭の中で完成イメージをシミュレーションしながら実績を見比べることで、基準や優先度がはっきりし、目的に合致するクリエイターに絞れる。

ツールやタッチ、作品傾向など、クリエイターの持ち味が自分の狙いと本当に重なるか、特性を生かしてもらえる依頼内容か、今一度確認しよう。オーダーメイドにも限界があり、クリエイターの作風を軽んじた依頼をすると、お互い不幸になるだけだ。

Step2 ✦

📖 依頼用資料をつくる

依頼の概要、内容、デザインの必要要素といった指示書と併せて参考資料をまとめよう。

参考画像やムードボードを共有すると、より好みやイメージが伝わるが、イメージを限定する他のクリエイターの特定の作品画像は指定しないほうがベターだ。他者の作品を示してゴールを明確にしすぎることは、高度な解釈や模倣を促す行為であり、依頼方法としても失礼にあたる。部分的に参考になる場合や、本人（依頼側/依頼を受ける側）が過去に制作したものであればもちろん構わない。

Step3 ✦

💬 クリエイターとやりとりする

打診のタイミングで、正確な依頼点数やフォーマット、ラフやリテイクなどの進行方法、納品時期、納品方法、そして必ず報酬の金額面で合意を取り、成約後も、連絡や案内を受けたら速やかに返事をしよう。

納期までに連絡がとれなくなる期間があるなら、不安を与えないようあらかじめ伝えておこう。クリエイターが十分に力を発揮できるようなストレスのないコミュニケーションを心掛け、最後までお互い気持ちよく仕事ができるようにしたい（コミッションの中には、こうしたやりとりの手間をあえて排除した簡易サービスもある）。

Ch.1-3-2

◆ 受発注の流れ2 ◆

デザイン/イラストの依頼を受ける

得意なことができたら、コミッションサービスを利用して、イラストやデザインを受注してみよう。はじめはSNSのDMなど、知人間でオーダーを受けて実績を増やしてもよい。プラットフォームを利用することで個人で宣伝するよりマッチングの可能性が広がり、トラブルが起きた際にサポートが受けられるなどリスクも少なくなる。自分に合ったサービスを探してみよう。

Step1.

サンプル作品を準備する

できることを伝えるために最も重要な要素が、サンプル作品だ。仮にコミッションの実績がまだなくても、過去の作品が閲覧できるポートフォリオを充実させ、そのうちのいずれかを、受けられる仕事の幅や仕上がりがわかるサンプル作品に改めて仕立てるとよい。

元が1つの作品でも、デザインなら表紙とロゴだけ抜き出したものとで画像を分けたり、イラストなら背景ありのバージョンとキャラクターだけの立ち絵やバストアップを用意し、さまざまなオーダーを想定して仕様別に準備しよう。

Step2.

条件を設定し依頼を受ける

サンプル作品が準備できたら、条件の設定に入ろう。システムやオーダーに慣れていない人に向けて、支払いや納品がどのような流れになるのか文章で表すとよい。

納期には、純粋に手を動かす時間だけでなく、提案や修正、やりとりにかかる時間も含まれることに注意したい。制作料からはサービス手数料が引かれることを念頭に、制作単位ごとの価格設定を行う。これらは制作環境や実績に合わせて適宜更新できるので、まずは条件をクリアにし、相談や見積り依頼を受けられる状態を目指す。

Step3.

依頼主とやりとりする

依頼主がどこまで任せたいのか、イメージやラフはあるのか、オプションは必要か……。依頼したつもりのことと受けたつもりの仕事に齟齬がないよう、相談を受ける中で曖昧な点は明らかにしよう。見積りもそれによって変わるはずだ。加えて、実績として完成後に公開してよいかも確認しておきたい。

プロセスはアウトプットを左右する。チェックしてもらう内容とタイミングはしっかり決めておこう。納期を守るといった最低限のマナーに加え、良い評価レビューをもらえるよう迅速で丁寧なやりとりを心掛けたい。

Ch.1-4-1

ムードをつくる色

ここからはデザインの選択に関わる基本要素を見ていこう。色は欠かせない要素だ。それぞれの色に意味や効果があり、人の認識や感情にも大きく影響する。色が与えるさまざまな印象を理解することで、意図を持って色を使い、ムードを作るのに役立てることができる。配色を紹介する本や画像からカラーパレットを生成するツールも上手に活用したい。

トーンの概念を理解する

トーンとは似た見え方をする明度と彩度の領域をまとめて捉えた概念であり、有彩色は12種類のトーンがある。5種抽出すると、明度の高い順にペール(a)、ブライト(b)、ビビッド(c)、グレイッシュ(d)、ダーク(e)、彩度の高い順にc、b、e、a=dとなる。

彩度をコントロールする

彩度の高いデザインは目立つ反面、長時間注視していられない（通常の印刷では表現できない色域も多い）(a)。中でも蛍光に近い色はネオンを表現するなど特別な場面を除き使うのが難しい。用途により彩度をコントロールできるようになろう(b)(c)。

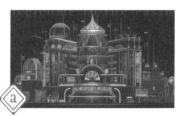

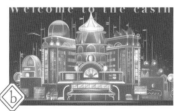

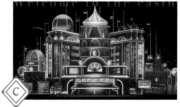

明度をコントロールする

見やすくするためには明度差の調整が欠かせない。背景と文字や図の色の明度差が大きいほど、文字は読みやすく、図は理解しやすくなる(a)。よくある色の組み合わせも明度差に注意したい(b)(c)。自分を過信せず、コントラス比を判定するツールを使うのも手だ。

爽やかな雰囲気を演出する

明るいメインカラーを据えることで、透明感のあるノスタルジックな配色（a）、砂糖菓子のように淡くて甘い配色（b）、ナチュラルで自然を感じる配色（c）、ポップで若さが弾ける配色（d）、シックでエレガントな配色（e）などが表現できる。

ダークな雰囲気を演出する

暗いメインカラーを据えることで、クラシカルで権威的な配色（a）、ゴシックで退廃的な配色（b）、危険を匂わす警告的な配色（c）、埃やまとわりつく湿気を感じる不快な配色（d）のほか、ほぼ暗闇（e）などが表現できる。

時代や地域を表現する

伝統色かつ特徴的な組み合わせを用いることで、フランスの配色（a）、中国の配色（b）、和の配色（c）、ミッドセンチュリーの配色（d）、大正浪漫の配色（e）など、特定の時代や地域に合うレトロで情緒のある配色を表現できる。

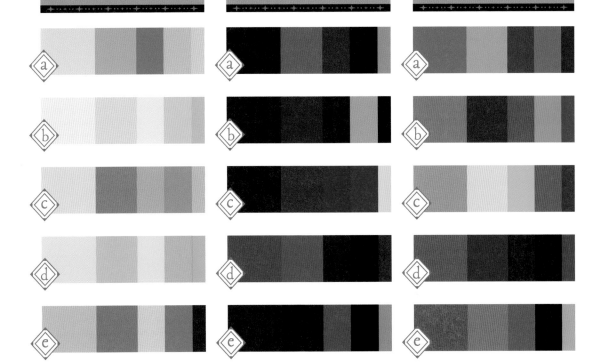

Ch.1-4-2 ✦

◆ デザインのアプローチ 2 ◆

光と影

平面のデザインで見落としがちな要素が、光と影だ。明度の高い色を光の当たる面に、明度の低い色を影の落ちる面に見立て、2色で塗り分けるだけでも、面が構造物のように立ち上がり、向きや奥行きが現れる。光と影、陰と陽の2つの面に、多くの物語が介在する。光の抑揚を操ることで画面にストーリーが生まれるはずだ。

光と影を
塗り分ける

パスで描ける省略した景色を塗り分けてみよう(a)。差を強めると光の強いドラマチックな画面になるが(b)、明度差があれば明るい画面でも立体感を出すことができる(c)。また色相差のない色を使うことで同じ素材を表現できる。

グラデーションで
表現する

奥行きを表現するのに便利なのがグラデーションだ。グラデーションだけで空を表現することができ(a)、闇を照らしたり、光のベールをかけたりすることができる(b)。光の筋を操ることで、魅惑的な空間が浮かび上がる(c)。

光や影の
レイヤーを加える

さらに手軽に光と影を共存させる方法は、モチーフに擬似的な影を落とすことだ。画面外の世界を想起させる幾何学的な影(a)や木漏れ日(b)、光のプリズム(c)などをオーバーレイさせるだけでも、空気感が変わる。

Ch.1-4-3

絵×デザイン

絵は、デザインの主役にも脇役にもなれる効果的な要素だ。モチーフでも世界観でも、見せたいものを見せたいままに表現することができる。写真より内面に迫ることができる一方で、好みのテイストや個性が反映されてターゲットを絞る可能性もある。デザインの方向性を左右するため、しっかり意図と構図を計画して取り入れよう。

絵画を使う

静物画は「Still Life（動かない命）」や「Nature Morte（死せる自然）」と呼ばれ、えも言われぬ空気を纏っている（a）。抽象画では独自の解釈や想像力を刺激し（b）、素描では物語に未完成の手触りを与えることができる（c）。

光景を描く

世界観やテーマを十分に理解して描写するイラストは、現実で出会えない理想の光景を可視化できる（a）。非現実的な機構は異世界や神秘主義を立ち上がらせ（b）、素朴な風景はメルヘンなファンタジーへの入口となる（c）。

幾何学で描く

幾何学の描画でさまざまイメージを作ることができる。幻覚的な構造を描き分けたり（a）、変幻自在のグラデーションで視覚的な深みを与えたり（b）、単純な形の組み合わせで都市景観を表現することができる（c）。

✦→ デザインのアプローチ 4 ←✦

キャラクターイラスト×デザイン

ゲームに登場するキャラクターのグラフィックは、全身または膝から上の立ち姿を描いた立ち絵、会話シーンなど表情にフォーカスしたバストアップまたは顔、背景のあるスチルイラストに分けられる（アイコンやグッズ用にデフォルメイラストが描かれることもある）。それぞれにデザインを加えるときのポイントをみていこう。

キャラクターイラスト描き下ろし：今野隼史

全身をみせる

立ち絵をメインに据えるときは、背景をキャラクターのディスプレイ空間に仕立てよう。キャラクターの設定を殺したり、カラーパレット（配色）を壊すことなく、うまく引用しながらデザインしたい。

表情をみせる

バストアップをメインに据えるときは、顔まわりを避けて要素を置き、キャラクターと視線が合うようデザインしよう。ロゴ／キャラクター／背景といった要素を階層化することで、情報が順々に伝わる。

世界観をみせる

背景を生かしてデザインするときは、視線が意図した通りに流れるよう、コンポジションを意識しよう。イラストとデザイン要素が相互作用するポイントを作ることで、視覚的な興味を引くことができる。

昔使っていたPC、長杖使いの武闘派神官です。PCのイラストって、自画像でも他人でもない、不思議な感覚がありますね。1色の背景でも映えるシルエットになるように、長杖と髪の毛の配置に気を付けました。（今野）

表情を変えて、暗色を主体にしたミステリアスな雰囲気にしてみました。アップにも耐えられるように、顔周り・瞳などは意識してしっかり描き込んでおいたほうがよさそうですね。（今野）

背景のディテールは世界観を見せるチャンス、できる限り凝りたい！　それ自体がフレームになるような窓や扉、木の枝や鎖といった要素を持っておくと、イラスト・デザイン双方の構図作りにとても役立ちますよ。（今野）

❋ デザインのアプローチ 5 ❋

装飾×デザイン

グラフィックデザインの要素として用いられる装飾は、イラストレーションの一種だ。主題を引き立たせるフレーム（飾り枠）の場合もあれば、壁紙や包装紙を模した背景パターンの場合も、装飾自体が表現のメインになる場合もある。地域や時代によって装飾のデザインには特徴があり、作品の題材や時代設定にマッチすればより効果的だ。

飾り罫で囲む

シンプルな罫線や幾何学のパーツを組み合わせて、フレームが作れる(a)。イラストやアイコンをちょっとアシストするだけでも、立派なあしらいになる(b)。装飾的なオーナメントを使うと、歴史や高級感を醸し出せる(c)。

模様を繰り返す

シームレスに面を埋める装飾はパターンと呼ばれ、スマホアプリでも作れる。壁紙のように繰り返し必要なだけ展開できるため、背景に使いやすい(a)。くっきり文字を乗せるには色場を作るか(b)、フレームと組み合わせるとよい(c)。

装飾を主題にする

装飾的なラベルやカードのデザインは、それだけで存在感のあるオブジェとなる。古典から現代(a)、西洋から東洋(b)までさまざまなモチーフが適用でき、パブリックメインで利用できる古い意匠もたくさん見つかる(c)。

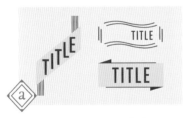

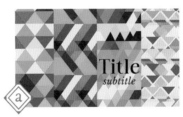

Ch.1-4-6 ✦

写真×デザイン

写真をメインの要素とする場合、デザインに適した構成の素材を用意できると望ましい。素材サイトで探すのも手だが、スマホやタブレットでも撮影できるので制作に織り交ぜてみよう。余白をとって構図を組んだり、ボケ味を調整することで、ぐっとデザインしやすくなる。ここでは簡単にできるスタイリングと効果的な加工のパターンを紹介する。

接写して 質感を出す

重なり合う植物(a)やドレープした布地(b)、パウダーソルト(c)など、身近にあるものを質感に迫るように接写してみよう。自分で撮影してもある程度絵になり、色面や文字と組み合わせることで背景として機能する。

モチーフを スタイリングする

物撮りすれば、テーマに沿う具体的なモチーフを据えることができる。文字の入る部分を意図的に空けられるのもポイントだ(a)。背景に色紙を敷くと日用品もポップに映り(b)(c)、配置や色でバリエーションを作れる。

風景の空気感を 生かす

風景写真は色調補正をすることで思い思いの空気感を纏うことができる(a)。感情を揺さぶりたいなら、空の広がりやクリアな抜けを大事にしよう(b)。あえてねむいモヤのかかったような写真を使うと、一気に幻想的になる(c)。

大きくカラー
変換する

写真の元の色を捨てることで情報を減らし、デザインに馴染ませるのもテクニックのひとつだ。色味で絵画のように見せたり(a)、スポットカラーで造形を際立たせたり(b)、モノクロにして得体の知れなさを出してみよう(c)。

ぼかし/モザイクを
かける

意図的にぼかしやモザイクをかけてみよう。ミステリアスな印象が加わり、文字も載せやすくなる。一部にガラスを置いたような表現(a)や、何者かわからなくなるほどぼかす(b)など、加工の程度によって印象が変わる(c)。

コラージュ/
モンタージュする

写真を切り貼りしてフォトコラージュ/フォトモンタージュを作ってみよう(a)。テーマに合う複数のイメージを合成したり(b)、イラストとミックスしたり(c)、実験的な手法だが異質なものを生み出すことができる。

Ch.1-4-7

テクスチャ×デザイン

テクスチャはデザインの飛び道具だ。色面だけでは物足りないときに独特の風合いを加えることができる。質感を与えると情報が増え、大理石ならば高級感、水彩なら柔和な優しさといった、テクスチャの持つイメージを擬似的に伝えることができる。合成技術は必要だが、アクション機能付きの素材集なども活用しながら味のある表現を追求しよう。

リッチな表現

箔（a）やホログラフィック（b）、マーブル模様の石のテクスチャ（c）を加えることで、シンプルなデザインがかなり豊かに仕上がる。特に、よく見ると粒子や肌触りの写る画像がおすすめだ。細い線で抜いたときも存在感が残る。

グランジの表現

ノイズや掠れ加工をすることで、ざらざらした年季を感じるテクスチャを与えることができる（a）。折れや染みを加えるとヴィンテージの紙が表現でき（b）、より粗くテクスチャの整列を乱すことでホラーな演出にも振れる（c）。

テクスチャを描く

アナログな画材かそれを模したアプリが用意できるのであれば、アーティスト気分で画面を汚してみよう。筆のタッチ（a）や、絵の具の滲み（b）、インクドロップ（c）など画材そのものの振る舞いが、オリジナルのテクスチャになる。

Ch.1-4-8

可変する書体

ロゴづくりに欠かせない作字だが、レタリングにはさまざまな作法があり、プロのようにラフから書くのは難易度が高い。ここではゼロから作る必要のない、既存の日本語フォントをベースに文字を加工するアイデアを紹介する（各フォントデータの改変・加工・再配布が制限されていても、特定の文字列に利用し、形状を弄るのは自由なのでご心配なく）。

掠れる、溶ける

パスのオフセット機能を使うことで、文字を掠れさせたり（a）、文字を溶かしたりすることができる（b）。少しなら味や違和感の演出に留まるが、大きく溶けると不穏さが出てくる（c）。逆に消失寸前まで細らせることも可能だ。

バラける、ズレる

文字をパーツにバラして、アンバランスに崩してみよう。パーツごとに伸ばしたり縮めたりして再配置すると、新しい印象が生まれる（a）。漢字のパーツを大胆にズラしたり（b）、違う書体のパーツを組み合わせても面白い（c）。

揺れる、伸びる、欠ける

線の形を部分的に変形させてみよう。歪みツールで揺らしてみたり（a）、スワッシュやフローリッシュのようなヒゲを生やしたり（b）、見えない形を前に置いて欠けさせるといった、文字の周辺を変えるテクニックもある（c）。

Ch.1-4-9

❖ デザインのアプローチ9 ❖

読みやすさと限界

作家性のある作字や装飾として使う文字の中には、ひと目で読ませることを目的としていないものもある。読んでほしい文字は、読みやすさ＝可読性に気を配ろう。サイズだけでなく字形や色の組み合わせにもNGがある。ここではやりがちな例で読みやすさを比較してみた。避けたほうがいいラインと対応策が見つかるはずだ。

△ 文字を崩す

文字を崩しすぎないこと(a)(b)(c)。知名度のあるアーティストのロゴや漫画のタイトルなど、スタイルやキャラクターを知っているからこそアイコンとして機能するケースがある。単発の作品タイトルならば、読める範囲に留めておこう。

○ 正しい読みをアシストする

どうしても崩して表現したい場合、読みをアシストする文字を添える(a)という対応策がある。黙読でも音読でも、読めないタイトルは広まりづらい。読みがなを振ったり(b)、読ませたいルビを振ったり(c)工夫してみよう。

△ 手書き風文字を使う

本文に癖の強いフォントは使わないこと。特にゆるい手書き風のフォントや毛筆フォントが連なると読むのに忍耐がいる(a)。手紙などの演出で部分的に使う場合はきれいめのフォントを選ぶか(b)、長文にならないよう注意しよう(c)。

〈ストーリー〉

○ 文字を手書きする

もちろん、フレーズによっては手書き文字が効果的だ。走り書きは想いが乗って、印象に残る(a)。素朴なタッチにすると、カフェのメニューのような表現ができる(b)。直線や曲線はペンタブの補正機能があれば綺麗に書ける(c)。

△ 色の視認性を チェックしない

背景色と文字色の関係に気を配ること。明度差（コントラスト比）が小さかったり(a)、配色でハレーションが起きたり(b)、色味が近いと(c)、視認性は下がる。色の見え方には環境差や個人差があるため、客観的なチェックが欠かせない。

○ 色の視認性を 高める

対策としては背景と文字の際に白を敷いたり、背景を部分的にぼかすことで馴染まないようにする(a)。背景色の明度を高く、文字色の明度を低くする(b)。またはその逆にする(c)ことでコントラストがつき、視認性が上がる。

Ch.1-4-10

✦ デザインのアプローチ 10 ✦

素材を探す/使う

既存のデザイン素材には多様な選択肢があり、あらゆるスタイル、テーマ、トレンドが揃っている。理想のデザインが見つかれば、時間の節約にもなりその他の作業に専念できる。特に有料素材はクオリティが期待でき、定期的なアップデートやデザイナーからのサポートが受けられることがある。AIを使って生成する画像も現時点では既存素材の組み合わせに近い。

素材の用途を明確にする

具体的にどの部分にどのように素材を使用するかを明確することで、適切な素材を効率的に探せる。高解像度の画像や多機能な素材を求める場合、素材を編集して利用したい場合は、特に注意して用途に合ったデータか見極める必要がある。

素材サイトを活用する

今や世界中のクリエイターが作品を素材として提供しており、商用利用可の高品質な画像やイラストが揃っているサイトは少なくない。TRPGに特化した素材制作者も見つかる。ただし、使用が許可されている範囲はさまざまで、都度確認が必要だ。

使用条件を把握する

商品説明をよく読み、素材の使用条件や制約に同意できるかどうかを確認する。クレジット表記が定められている素材も多い。権利がクリアでアクセスしやすい素材ほど、同様に素材を探している他者と被る可能性を念頭に置く。

CCライセンスとパブリックドメイン

CCライセンス付きの素材は、作者の意向により特定の条件のもと利用できる。また、著作権が切れてパブリックドメインとなった名画、イラスト、歴史的な画像をDLできる美術館や博物館のアーカイブサイトも増えてきている。

提供者の信頼性を確認する

同時代に生きる作者であれば、クリエイターとしての評価や過去の作品をチェックすることができる。提供者本人であるかを確認し、プロフィールページや作品一覧を辿ったり、使用者のレビューを参考にしたりして、より安心して使用できる素材をピックアップしよう。

オンラインコミュニティやSNSの活用

TRPGに関連するオンラインコミュニティやSNSでは、素材に関する情報やリンクが共有されていることがある。また素材制作者をフォローして新作をキャッチしたり、販売サイトのデモやサンプルをチェックするのも役に立つだろう。

❖ デザインのアプローチ 11 ❖

素材を作る

自分でデザイン素材を作成することで、独自性の高いTRPG体験を提供できる。過程で磨かれるデザインのスキルは、他のプロジェクトにも活きる。デザインの細部に至るまで自由にコントロールでき、クリエイティブな達成感や満足感を得ることにも繋がる。ただし、時間や労力がかかることを忘れずに、余裕をもって取り組みたい。

ベクター（ベクトル）画像を作る

Adobe Illustrator、Inkscape、Affinity Designerといったベクターグラフィックスアプリは、スケーラブルなデザインが可能で、拡大縮小しても画質が劣化しない。逆にベクターを扱えないアプリは最初に最大画質が設定される。

ビットマップ（ラスター）画像を作る

Adobe Photoshop、GIMP、Affinity Photoなどのビットマップ画像編集アプリは、ペイント機能と同時にフォトレタッチに必要なツールを備えている。これらのレイヤーやフィルター機能はテクスチャの制作に向いている。

オンラインで作る

Vectr、Gravit Designer、Canva、Figma、Pixlrといったオンライングラフィックツールは、インストールが不要で、ウェブブラウザ上で手軽にアクセス・作業できる。テンプレートやキットも充実しており、直感的な作業が可能だ。

モバイルで作る

Procreate、ibisPaint、Adobe Fresco、Autodesk SketchBook、Infinite Painterといったモバイルデバイス向けグラフィックアプリは、スマートフォンやタブレットで利用でき、外出先でも手軽にデザイン作業ができる。

作った素材を頒布する

オリジナルの素材を使うことで、頒布・販売に向けたライセンスの確認の手間を省けるが、受け取る側に伝わるまでクリアとはいえない。頒布にあたっては、素材の著作権とどのようなライセンスを提供するのかを明確にしよう。

作った素材を販売する

自分の手を動かすことで、予算を抑えて必要な素材を揃えられると同時に、販売の機会にも繋がる。アクセスしやすいプラットフォームを選び、購入前に品質を確認できるデモを用意し、競合と比較して適切な価格をつけよう。

Ch.1-4-12

印刷物の仕様

使いやすく、魅力的なデザインの印刷物を提供するために、目的に適う仕様を検討しよう。印刷物はデータ完成後に製作が開始されるため、仕上がりに不満があっても短期的なアップデートは難しい。発色や加工の仕上がりを納品前に確認するには、追加でコストと納期がかかるので注意しよう。以下のポイントを総合的に判断してから、デザイン作業に入りたい。

用紙サイズを選ぶ

ルールブック、シナリオ、各種シートの用紙サイズを選択する。一般的にはA4やB5を縦位置で使うことが多いが、各判の変型も選択肢となる。無駄に余白の出る紙取りや、特殊なサイズを選択すると、ロスが多くコストにも影響する。

色数とインキの種類

モノクロ印刷から、特色1色、2色、3色、4色のフルカラーまで選択肢がある。色数が増えるとコストが高くなるため、本文は1色で印刷されることが多い。CMYKのほか、インキの種類や色を指定してイメージの再現を目指す。

用途に応じた仕様

キャラクターシートや戦術マップには書き込みやすく消しやすい素材を使う、表紙やカード類には厚手の紙を使い保護・仕上げ加工を施すといった、耐久性を重視した仕様の確保を優先してから、箔押しなどの装飾的な加工を練ろう。

用紙の質感・色味・厚さを選ぶ

紙の質感は紙の銘柄によって異なり、紙の厚さは銘柄ごとに斤量によって段階分けされている。非塗工紙、微塗工紙、塗工紙、嵩高紙、ボード紙といったカテゴライズ、紙の平滑度、色味、印刷適性を加味して絞り込む。

印刷方法を選ぶ

大部数や高品質な印刷にはオフセット印刷を、少部数や短納期にはオンデマンド印刷を選ぶことが多いが、近年はオンデマンド印刷の品質も上がってきている。オフセットでは版を作るため、固定費がかかる分、部数が多くなるほど単価が下がる。

製本方法を選ぶ

本の綴じ方にもいくつかのオプションがある。全体の頁数や紙の厚みによって、最終的にとれる製本のスタイルが変わるので注意したい。また製本によってはノド（綴じられる背側）が引き込まれて平らに開くことができない。使用・保管の方法も想定して適切な形を定めよう。

❈ デザインのアプローチ 13 ❈

頒布データの仕様

頒布データの仕様に気を配ろう。仕様が使われ方を規定し、プレイ体験を左右する。ファイル形式の利点と欠点をふまえ、クオリティとファイルサイズのバランスを考慮し、対象となるプレイヤー層にとって望ましい形を採用しよう。プレイ環境の変化によってはアップデート版を頒布し、複数のツールやデバイスで利用可能にするために選択肢を用意する必要がある。

シナリオの ファイル形式

レイアウトが固定できデザインを維持することができるPDF、リンクやメディアを組み込めるHTML、環境により見た目が変わってしまうが編集が容易なDOCX、最もシンプルでコピーしやすいTXTファイルなどが一般的だ。

タイトルを正しく 表示させる

PDFをブラウザ閲覧させたりUL+DLをかませた場合にタイトルが正しく表示されないことがある。実はPDFのタイトルは、ファイル名ではなく、文書のプロパティからタイトルを入力することでのみ設定できる。

JPEGとPNGを 使い分ける

JPEGは色彩豊かな画像向き。圧縮率を上げると画質と引き換えにファイルが軽くなる。PNGはロゴやアイコンなどシンプルな図形向き。JPEGにない透過情報を持つことができ、圧縮による画質の劣化が少ないが、重くなりがちだ。

適切な解像度を 設定する

オンラインセッションでは解像度72dpi、画像サイズはディスプレイ解像度(800x600px、1280x960px、1600x1200pxなど)に合わせて用意する。プリント用素材は、印刷実寸で300〜350dpiの解像度が推奨される。

データを整理する

ディレクトリ構造とファイル名を整理し、最適化する。わかりやすいフォルダ分けをし、特殊文字やスペースを避けて命名する。古いOSやアプリを使用して作成する場合、日本語ファイル名は文字化けの要因になるため注意したい。

ライセンスと著作権

頒布データに含まれるコンテンツの権利に注意する。データ内に権利表記や使用範囲を明示し、制作に関わった人の名前をクレジットする。これは作成者のみでなく、ユーザーがトラブルに巻き込まれないための配慮だ。

デザインのポイント

Chapter 2

前章では基本的なデザインのアプローチを紹介したが、この章ではより具体的に、TRPGでデザインされている要素の役割と表現のパターンをみていく。実際には型などなく、現febの傾向から抽出したに過ぎないが、制作の足がかりにしてもらえると嬉しい。(※動画以外の画像は解説用に作成した架空のサンプルであり、気に入ったものがあれば真似してもらって構わない)

Ch.2-1-1

タイトルロゴ

タイトルロゴとは作品名をロゴ化したものだ。看板のように目印になるものであり、視認性だけでなくオリジナリティも強みになる。ある意味、タイトルロゴそのもので世界観を伝えることができれば、メインビジュアルとしても成立する。タイトルの文字列やデザインに、ひと目で興味を引く要素を取り入れることが成功への鍵となる。

POINT

レテはTwitterなどでの掲示を前提に横長に作られることが多いが、ロゴ自体は縦型の本の表紙に据える用、頒布サイトのサムネイル用、セッションルーム用など、いくつかの使い所と比率を想定して組み方のバリエーションを用意しておけると便利だ。

check

縦組みと横組み、縦3行組みを用意したケース。組みの他にもバリエーションとして、背景透過と背景あり、カラーとモノクロ、プラスして英語タイトルなどを揃えることもある。

死を招く夜陰

死を招く夜陰

死を招く夜陰

炎の奏者

POINT

世界観にマッチしたユニークで印象的なロゴにしたい一方で、全体としては視認性の高いデザインが望ましい。書体に癖があるなど視認性が低いと、プレイヤーがひと目で認識できず、手を止めない可能性がある。書体はロゴの主要な要素であり、印象を大きく左右する。

check

ジャンルや設定をロゴデザインに反映させることで、プレイヤーがそのゲームの雰囲気をひと目で把握できる。古典的なファンタジーなら抑揚のある書体、現代的な作品ならスッキリとしたエレメントの書体をベースに、字形以外の彩りを加えてみよう。

色はロゴデザインにおいても重要な要素だ。作品に合ったカラースキーム（色彩計画）で、かつ視覚的なインパクトを与えたい。配色のバランスに気を付けて、視認性を向上させることで、プレイヤーに強い印象を残すことができる。

check

背景色込みでロゴをデザインする場合、背景とのコントラストを高めることで、タイトルが目立つようになる。基本的には明るい背景には暗い文字色、暗い背景には明るい文字色を用い、鮮明でクリアな表現を心掛けよう。

世界観を象徴するシンボルを取り入れることで、視覚的なインパクトを高めることができる。魔法がテーマであれば神秘的な装飾を施したり、消失がテーマであれば文字も消えていくように欠けさせたり、さまざまな足し引きをしてみよう。ロゴはさまざまなサイズで使用されるため、スケーラビリティに優れたデザインが望ましい。

要素を加えても、小さなサイズにしたときにタイトルの字形がはっきりと認識できるようにしよう。タイトルは短く、読み上げやすく、興味を引くものが望ましい。長すぎるタイトルは覚えづらい一方で、他の作品と差別化することができる。長いタイトルはサイズに強弱をつけて短縮読みを促そう。

プラットフォームやSNSの仕様変更に伴い、頒布物も定期的に見直し、改善していく必要が生じる。デザインを改良する機会にもなるが、ロゴの変更は蓄積した印象を変えてしまうため、注意が必要だ。

check

大幅なアップデートのタイミングがあれば、ロゴのブラッシュアップを検討しよう。ユニークなデザインで新たに興味を引くこともできるが、トレンドによらないシンプルなデザインに落とし込むのも魅力的だ。印象が継続するレベルで微調整する、データ形式を増やすなど、小さな改善も視野に入れよう。

✦ 公開用シナリオトレーラー 1 ✦

メインビジュアル

ここでいうメインビジュアルとは、タイトルの入ったメインのトレーラーのことだ。キービジュアルとも呼ばれ、コンテンツや商品において使用される代表的なイメージを指す。宣伝も兼ねた一枚と考えると、自ずと役割が明確になるだろう。掲示の場によっては、その一枚だけを頼りに人を惹き込む必要がある。

POINT ✦

PCはPLが創作するため、タイトルがメイン要素になることが多い。この時、背景と文字とのコントラストが重要になる。背景を暗くしがちだが、逆転させても効果は絶大だ。

check

背景写真は雄弁で、季節や心象を語ってくれる。具体的すぎると内容と乖離することもあるが、ぼかす、絵画調にするといった加工が有効だ。輪郭を際立たせないことで、乗せた文字が読みやすくなる。

花宴

PASSAGE OF CRIMSON

朱の門をくぐれば

POINT ✦

色面で押し切るのも有効だ。特に警告色をベタに敷いたデザインは目を引きやすく、同系色でまとめることで「あの朱色のシナリオ」というように色がシナリオの代名詞になり得る。

check

シンプルだとつい装飾を施したくなるが、要素を盛るほど印象がぼやけていくことがある。色面で魅せる意図があるなら、遮られず広がっているほど気持ちがいい。ワンギミックを加える程度で十分だ。

崩壊の
エレジー

Whispers of a Dying World

POINT

建造物や小道具、動植物など、象徴的なモチーフを用意できるのであれば、デザインの幅が広がる。シナリオに具体的に登場せずとも、窓や道といったメタファーは活かしやすい。

check

モチーフ×色で魅せるなら、ペーパーバックの装丁や、映画のポスターが参考になる。詳細なイラストが描けなくても、単純な描画を何かに見立てる術や、自作できるモチーフが見つかるはずだ。

POINT

これ！というメインを張る写真も色もモチーフも絞れない場合、デザインの心得があれば、要素盛りで画面をまとめることができる。大事なのはタイトルがタイトル然としていること。

check

凝ったタイトルロゴがあれば、デザインの要素を増やしても視覚的に優劣をつけることができる。逆に何も要素が用意できない場合もタイトルロゴだけで間をもたせることができる。

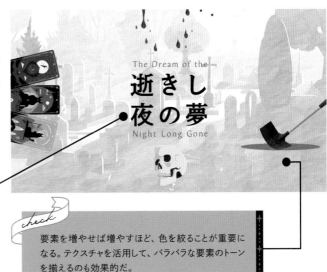

The Dream of the

逝きし
夜の夢

Night Long Gone

check

要素を増やせば増やすほど、色を絞ることが重要になる。テクスチャを活用して、バラバラな要素のトーンを揃えるのも効果的だ。

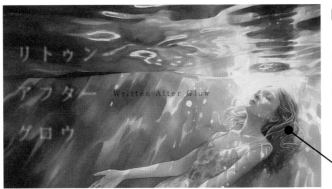

リトゥン／
アフター／
グロウ

Written After Glow

POINT

イラストが描けるのであれば、絵になるシーンを切り取ることもできる。キービジュアルはPCが遭遇する光景「そのもの」である必要はない。デザイン的な構図を意識しよう。

check

イラストが全面になる時は、タイトルの配置を決めてから描けるとよい。タイトルの処理によって、イラストのサイズや色や密度、そして見所をどこに作るかが決まってくる。

Ch.2-1-3

ハンドアウトまとめ

ハンドアウト（handout）とは、一般的に事前配布資料を指す。TRPGにおけるハンドアウト（以降「HO」）とは、シナリオに備わっているプレイヤー用資料のことだ。特に役の初期設定のことをいい、トレーラーに明示することでそのシナリオや役を選ぶヒントとなる。プレイ人数によって、また事前開示のレベルによってもデザインに幅が生まれる。

POINT

設定のみ明快に記載し、役割を立たせるパターン。画面が大きすぎる場合はビジュアルで見所を作り、視線が役割に流れるようにする。エリアを区切り、人数分に等分することで役割の重みが均され、注目も等分になる。

check

役を立たせる最も効果的な手法はタグだ。文字の下に地色を敷くことで、座布団とも呼ばれる。単純に読みやすく、選択できるボタンのように目立つ。この時も、地色と文字のコントラストが重要になる。

あなたはその日、留まった。

探索者① 寮生

探索者② 下宿生

あなたはその日、引っ越した。

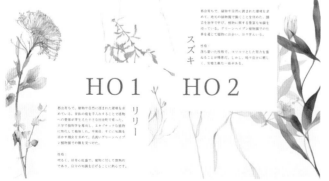

POINT

「HO」を立たせるパターン。初見で見慣れない名やコードネームをPCに振り分けたい場合は、No.で強調・区別するとわかりやすい。

check

すべてのHOに設定があるとは限らない。タイマンシナリオや、プレイ人数に幅があったり自由枠を含む場合、トレーラーにHOを並べる必然性は低くなる。

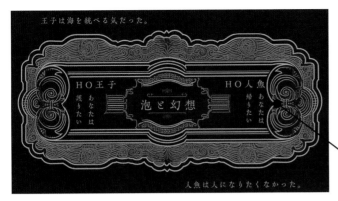

通常、HO1が主人公的役割を果たすことが多く、HO2がサブ的役割、HO3が別の立場の者として並ぶ傾向があるが、対比的に提示できる場合、HOにNo.を振らないパターンもある。

check

数字を振らない場合、役の説明ではなく覚えやすい名を振る必要がある。

POINT

役職ごとに特別な役割やステイタス、NPCとの関係性など、特徴が定められていることがある。ほとんどの場合キャラメイクは自由だが、より楽しめる設定が付与されているケース。

check

こうした探索者の詳細や特別な役割は、テキストで秘匿HOとして提示されることもある。条件や背景なども事前公開し長くなる場合は、メインの情報と、その他のサブの情報に分割してレイアウトしよう。

POINT

1枚のトレーラー画像にHO以外の要素を含めるパターン。これ1枚およびタイトルとの2枚セットでもトレーラーの役割を果たせるが、情報量が多くなるため、視線誘導が重要になる。

check

視線誘導は、見る者の視線の流れをコントロールし、情報認知を促す設計の手法。別種の情報を不均等に並べる場合、大きな塊から小さな塊へ、太いものから細いものへと視線が遷移するのを意識しよう。また、同色の情報はグループで捉えられる傾向がある。見逃してほしくない情報は色を変えるとよい。

Ch.2-1-4

導入、キャッチコピー

導入とはイントロダクションのこと。ストーリーラインのさわりを示すこともあれば、世界観を示すこともある。多くの場合、キャッチコピーのほうが短く読まれやすいが、キャッチコピー並みに短い導入を用意することもできる。関心を呼ぶ、心に刺さるパンチラインが思いついたら、キャッチコピーを前面に出すとよい。

POINT

導入とキャッチコピーが同居するパターン。ジャンプ率(サイズ比率)を高め、組み方向(縦組み/横組み)を変えることで、キャッチコピーに視線誘導している。

check
キャッチコピーの改行は何より重要だ。目で追いやすい1行10字程度、かつ読点か句点で改行されているのが望ましい。

栄華を誇った世界は、
光を失い、
崩壊の淵へと
追い込まれた。

闇に取り込まれ、
幽かなエレジーが
延々と鳴り響いている。

物語はあなたたちが互いに出会い、
孤立つところから始まる。
闇を越え、失った光を取り戻すのか。
闇に紛れ、闇と唄うのか。

かさなるやみよ、
かさなるうたごえ

崩壊のエレジー
Whispers of a Dying World

check
導入と同居するメリットは、キャッチコピーが多少不可解だったり、導入を読まないとわからない類の言葉遊びでも成り立つ点だ。

あらすじ

気がつくと、アトリエにいた。
どのキャンバスも真っ白だ。

「蒼を取りにいこうよ」
「海に泳ぎにいこう」「宇宙は?」

あなたは生徒たちに手を引かれ、
アトリエの外に出る。
懐かしい痛みを感じ、光に目が眩む。

これは失った色を集める物語。

POINT

導入のみにすることで、落ち着いてあらすじを読ませることができる。インパクトは弱まるが、静謐な物語のさわりや、詩のようなテキストを据えるのであれば、導入の演出としては十分だ。

check
情緒を出すのであれば、必ず適所で改行すること。一行が短ければ中揃えにすることができる。一方で、説明的なテキストに中揃えは向いていない。左揃えや左右の端を揃えた箱組みにしよう。

最高の知性が、世界を滅ぼす

POINT

キャッチコピーまたは端的な導入のみを配置するケース。概要やHO、あらすじなどを一通り提示した後にこの一枚が登場するケースもある。より効果的な順番でトレーラーを構成しよう。

check

トレーラーの枚数が増えるとビジュアルのバリエーションに困ることがある。連関を示すためにも大きく変える必要はない。動画やコマ撮りをイメージして、背景や画面構成を動かしてみよう。

POINT

アニメのサブタイトルや、小説の章扉をイメージしたパターン。内容に踏み込んでいく扉の役目を果たす。型を踏襲することでシリーズが作れるため、キャンペーンシナリオにも向いている。

check

サブタイトル画面とは、各話のタイトルが表示されるアイキャッチのことだ。メインビジュアルほど豪華ではないが、惹き込まれるような文字組み、内容を期待させつつ多くは伝えないビジュアルが適している。

第一話 物書きが夢見た休息
Written after dream

POINT

メイントレーラーにキャッチコピーとタイトルが同居するケース。この時、キャッチコピーは最初に読ませてもよいが、タイトルを凌駕する存在でないほうがよい。

check

ここでもタイトルの横組みに対してキャッチコピーを縦組みにし、目に留まる明るい座布団を敷くことで役割の違いを示唆している。他の要素と同居させる時も同様に、ジャンプ率や配置を工夫しよう。

この世には、幽境の入り口がわかる者がいる

風のなく頃 Breathless Breeze

概要

ここでいう概要とはシナリオのレギュレーションのこと。形式・舞台・傾向・プレイ人数・推定プレイ時間・推奨技能などが含まれる。注意事項やこんなPLにおすすめというポイントを箇条書きにし、好まざる人を避け、好む人がアクセスしやすくすることもできる。前提となる情報を一枚にまとめ、共通知をつくるものだ。

POINT

どんなシナリオかを一言で掲げるパターン。雰囲気重視のリリカルなトレーラーにしたい場合は相応しくないが、ポップなトレーラーには、商品説明的で叙事的な物言いも似合う。

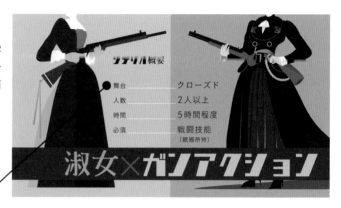

check

概要は読み飛ばされてはならない箇所だ。書体は特に読みやすいものを選ぼう。一続きの文章ではなく、必要な情報を羅列するほうがよい。付記は括弧にまとめたり、サイズを落とすことで見やすくなる。

POINT

端的に傾向を伝えたい場合、複数のキーワードを大きく掲げることもできる。情報量が多くなりがちな概要において、まず目に飛び込んでくるキャッチとして機能する。

check

コントラストに配慮し、最低限の文字数で構成すれば、多少文字のサイズが小さくても必要な情報を拾うことができる。仮にこの文字量が倍程度に増えると、途端に読みづらくなるので注意したい。

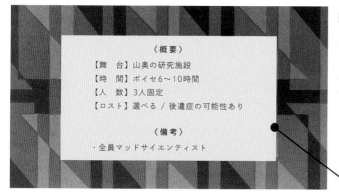

〈概要〉
【舞　台】山奥の研究施設
【時　間】ボイセ6〜10時間
【人　数】3人固定
【ロスト】選べる ／ 後遺症の可能性あり

〈備考〉
・全員マッドサイエンティスト

POINT

概要と備考のみをまとめるケース。項目見出しを付けるなら、それとわかるよう【】などで括るのが望ましい。または「：」や空白（スペースやタブ）を用いて、個別情報の頭を揃えよう。

check

こだわりなく漢数字と英数字、全角と半角を併用したり、情報の区切りとして「　（全角アキ）」「、（読点）」「／（スラッシュ）」「・（中黒）」などを混ぜて使うと読みづらくなる。これらの約物は意識して使おう。

POINT

項目見出しを立てないケース。必要な情報が伝われば役目は果たせるが、絞った情報と背景だけでは間がもたない。シンプルな解決策は、概要部分を囲むことだ。

check

タイトルを再び登場させたり、あらすじを絡めることでもまとまりがよくなる。概要はプレイ開始までに何度も見直す可能性がある。概要が絞れるのであれば、他の情報と抱き合わせてしまうほうが効率的だ。

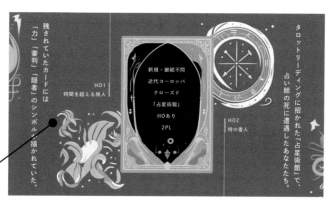

残されていたカードには「力」「審判」「隠者」のシンボルが描かれていた。

HO1
時間を超える旅人

新規・継続不問
近代ヨーロッパ
クローズド
「占星術館」
HOあり
2PL

HO2
時の番人

タロットリーディングに招かれた「占星術館」で、占い師の死に遭遇したあなたたち。

POINT

概要と導入が同居するケース。ジャンプ率で差を付けたり、横組み/縦組みを組み合わせたり、項目をタグ化することで視認性を上げることができる。

舞台	現代日本	時間	テキセ20時間目安
人数	2−4人	推奨	〈生物学〉〈図書館〉
ドレスコード	白いシャツ		

あなたたちはフローリストだ。本と花を配達している。

check

タグ化とは、座布団に限らず項目見出しに色や枠などわかりやすいスタイルを与えることを指す。重要なのは情報の仕分けであり、推測できる項目見出しより、タグに連なる個別情報の読みやすさを重視したい。

✦ 頒布用コンテンツ 1 ✦

表紙

表紙とは本文を包む厚紙の表1を指し、コンテンツの顔になるビジュアルである。第一印象を左右するため、デザインに十分なリソースを割くことが重要だ。パッケージ版やデジタル版なども加味すると横位置の表紙も考え得るが、ここでは印刷・製本に都合のよい、縦を長辺にした書籍のフォーマットで解説する。

POINT ✦

告知用のメインビジュアルとの大きな違いは、立体物であるか否かだ。装丁には計画的にプロダクトとしての魅力を実装することができ、迷うほど多くの用紙・印刷・加工オプションが存在する。ただし本文の仕様が質素な場合、過剰なデザインは本文との印象の落差を生むので注意したい。

check

表紙を短くカットして本文の柄が覗くようにした例。表紙加工といえば箔押しやコーティングが一般的だが、表紙のカットは、商業誌ではなかなかできない個性を生み出す手段のひとつだ。枠を残して内側を切り抜く場合は、プロトタイプを作って穴の形状やサイズを熟考し、持ちづらさや破れを回避しよう。

POINT ✦

適切な色の選択は読者の感情や印象に大きく影響を与える。表紙のカラースキームは、シナリオの雰囲気やテーマに沿った数値としての配色だけでなく、印刷の発色やインクの組み合わせといった刷色のインパクトの力も借りたい。特色を取り入れることでこれが可能になる。

check

オフセット印刷ではDICやPANTONEなど多くの特色が指定でき、適切に組み合わせることでCMYKより鮮やかに、よりイメージに近づけることができる。オンデマンド印刷でも使用できる特色が増えてきている。全特色指定で色数を絞ったり、金銀やメタリック、蛍光といった特殊カラーをスポットで使うのも効果的だ。

表紙上の要素（タイトル、イラスト、テキストなど）をバランス良く配置し、視覚的に魅力的なデザインを目指す。適切な余白を設け、情報が過密にならないよう注意し、全体の調和を保つことが重要だ。グリッドシステムを活用することで、デザイン要素の配置が容易になる。

check

規格化されたグリッドに基づいてほどよい余白を設けることができた例。グリッドシステムは、デザインの整合性とバランスを保つための有効なツールだ。1〜3カラムグリッド、マルチカラムグリッド、モジュールグリッド、階層型グリッド、黄金比グリッド、対称グリッドなどは表紙でも力を発揮する。

POINT

表紙のデザインがまとまるかどうかの一大ファクターに、タイトルとイラストの調和がある。どれだけ用意したイラストが美しくても、またタイトルロゴが独創的であっても、両者がマッチしなければ意味がない。試行を重ねて最適なバランスとインパクトを探ろう。

check

表紙で表現したい要素が多い場合は、ビジュアルに階層を設けてタイトルがまとまる場を作ろう。中央揃え、左揃え、右揃え、上部揃え、下部揃え、対角線配置といったさまざまな配置を試しておおよその位置が決まったら、背景とのコントラストを調整し、視認性を高めつつ、全体の調和を目指そう。

POINT

表紙は、コンテンツの品質や雰囲気を一目で伝える重要な要素だ。全体的なデザインクオリティを高め、中面のデザインとの統一感も保ちたい。それぞれ別の制作者に発注している場合も、タイポグラフィやイラストなど、何かしらの要素で連関を持たせるのが望ましい。

check

統一感を持たせることで、出会いからプレイまで一貫した体験を与えることができる。例えば表紙と扉をセットでデザインする、どちらかのデザインをベースに象徴的な造形を引き継ぐ、互いにレイアウト違いで同じ要素を配置するなど、表紙ならではの部分と中面でも踏襲する部分が設けられるとよい。

Ch.2-1-7

本文

本文とはルールブックやシナリオのメインコンテンツである。印刷された本のほか、PDF、HTML、TEXTなどさまざまな形式がありアプリ化も進むが、ここではレイアウトを要するものについて解説する。レイアウトは、情報が整理され、読みやすく、視覚的に魅力的であることが重要だ。読みやすい本文には、適切な設定がなされている。

POINT

本文にも用紙・印刷・加工オプションが存在する。折り込み口絵や色紙などの遊び紙を綴じ込むことでアクセントになったり、角丸にすることで印象が柔らかく、まためくりやすくなったり、途中で用紙の種類を切り替えることでセクションごとに特別な印象を与えたりと、印象的な読書体験をアシストする要素になる。

check

本文を2色刷りにした例。色分けすることで特定の要素を強調し、視覚的に際立たせ、重要な情報に目を引かれやすくする。また、色によって情報の種類やカテゴリを区別することで、読者にとって内容の把握が容易になる。

POINT

快適に読ませる文字組みを追求しよう。極端な装飾や特殊な形状のフォントを避け、読み疲れないフォントと文字サイズを選び、文字詰め、行間、行長を調整し、段落間のスペースを確保する。ターゲット読者のニーズに応じて、適切なバランスに落とし込むことが重要だ。

〈ストーリー〉

謎の依頼人から届いた手紙によって、日本のある山村へ向かうことになる。手紙には、「村で怪しい出来事が相次いでおり、陰陽師を名乗る者が邪神を復活させる計画を進めているらしい」と書かれている。村で起こる怪奇現象と邪神復活の計画を阻止するために調査を開始する。

check

8ptのフォントサイズ、フォントサイズの1.75倍の行間、24字程度の行長で組んだもの（実寸）。目で追いやすい分量、行頭・行末の禁則処理、全角・半角英数の使い分けなどを徹底し、ほどよい字間を設け、スタイルで読者の読みを阻害しないようにしよう。

セクションごとに見出しをつけ、見出しにもいくつかの強弱を設ける。それぞれに適切な書体とフォントサイズ、ウェイトなどのスタイルを適用することで、情報の階層構造が明確になる。レベルの違いが視覚的に区別できると、読者は情報を効率的に処理できる。

check

見出しは本文よりもふたまわり大きいフォントサイズが目安になるが、デザインのアクセントとしてかなり大きくすることもある。横組みの場合、本文は箱組みが一般的だが、見出しは組み方を変えたり、本文より行間や文字間、マージンを広くとるなどして、強調することが多い。

読みやすい文字組みのために生まれた余白は有効活用できる。ページの見出しやチャプタータイトルを柱（マージンノート）に配置したり、脚注（フットノート）を設けて補足情報を提供したり、読者をフォロー・ナビするための要素を付加しよう。

check

ナビゲーションを意識して余白を十分にとり、柱を設けた例。読者が今どの部分を読んでいるのかをすぐに把握できる。また、余白があれば、特定のイベントを処理するためのヒントやアドバイスをサイドバーにまとめられる。

文字だけでは表現できないものは、イラストや図表を利用して視覚的な理解の促進を図る。複雑な概念やデータは図表で、イメージしづらいアイテムや位置関係はイラストで提示することで、記憶に残りやすくなる。またふんだんに図版が含まれること自体がコンテンツの価値に繋がる。

check

イラストや図表は、読者の注意を引き、特定の情報に焦点を当てる効果がある。興味深い情報が強調されることで、関心が絞れ、理解が進む。実用的なものが用意できない場合も、挿絵や背景のイメージで長いテキストがほどよいタイミングで区切られるだけで、テンポよく読み進められるようになる。

探索マップ

探索マップはゲームの世界を探索する際の参考資料だ。必須ではないが、探究心をくすぐるアイテムとして効果的である。RPGといえばマップを埋めて攻略するように、冒険ではまず地図を広げる。TRPGでもPLは移動して情報やアイテムを得ることが多い。世界観や探索範囲がひと目でわかるマップは、重要な手がかりとなる。

POINT ✦

実用的な探索マップでは、スケール（1マスが何メートルや何キロメートルに相当するか）と範囲（全体の広さ）が定義されていることが重要だ。これにより、PLやKPが距離や移動速度を把握しやすくなる。

check

マップをグリッド状に展開することで、互いの位置や距離、移動範囲の計算が容易になる。ただし、線の太さや色を適切に調整し、マップ全体の雰囲気を壊さないようデザインしたい。

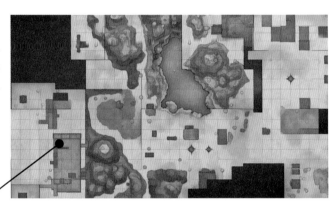

POINT ✦

屋敷の間取り図においても、スケールの設定が欠かせない。表ツールのセルを下地に書く際は、すべてのマスを正方形にし、1マスのスケールを決め、全体の大きさや部屋の大きさを規定する。

check

部屋同士を繋ぐ通路や廊下、出入り口である扉や窓の配置も重要になる。複数階建てなら、階段やエレベーターを忘れずに。線の太さや色を工夫して視認性を高め、必要に応じて部屋の名前を記載し、構造を伝えよう。

POINT

俯瞰のダンジョンマップは、真俯瞰の図面より
環境要素の反映が求められる。例えば、石壁
か洞窟か、水が流れているか炎は届くかといっ
た詳細の描画が、雰囲気や戦術を大きく左右
する。

check

秘密通路や隠し部屋などのトラップ要素
は、PL用マップとKP用マップで区別して
表現し、ゲームの進行に合わせて、マップ
を変化させていくなど効果的に演出しよう
（例はDungeon Builderで作成）。

POINT

街や村のマップは、都市構造を考慮し、中心
部から外れるにつれて建物の密度や規模が変
化するように配置しよう。配置や距離が人の流
れや行動を想起させ、地域の特徴を表現する
重要な要素になる。

check

街の中心部には商業施設や行政機能が
集まり、郊外には住宅が広がることが一般
的だ。街や村の通りや道路は、幅や形状
にバリエーションを持たせ、広場を作るな
ど自然な配置を心がけよう（例はInkarnate
で作成）。

POINT

ワールドマップをデザインするときは、陸地と海
域のバランスを取り、多様な地形を配置して変
化をつけよう。土地ごとに独自の文化や歴史を
持たせることで、世界観の深みが増す。

check

山脈に沿った雨陰効果で砂漠ができる、
河川は海に向かって流れるといった自然の
法則に基づいて地形を配置する。そこに
特徴的な遺跡や神話に基づく地名を盛り
込んでいこう（例はInkarnateで作成）。

Ch.2-1-9 ✧

セッションルーム

近年のオンラインセッションで存在感を増すのがセッションルームだ。GM（KP）はココフォリアやTekeyなどのツールでPLを招く専用の部屋を作成し、シナリオの世界に没入できる環境を構築する。システムやシナリオが頒布している公式の素材をアレンジしたり、汎用的なパーツ素材を活用しながら、独自にデザインする人が増えた。

POINT ✧

セッションツールにはさまざまな機能があるが、デザインに限れば最低限の要素は背景と前景の2種と考えてよい。異なるディスプレイサイズの画面を埋める要素として用いられるのが背景だ。

check
背景と前景を同一の画像にし背景をぼかすパターンと、前景に別の画像を設定するパターンがある。それぞれのオン・オフや切り替えをシーンとして保存し、デザインを遷移させることもできる。

POINT ✧

細かいパーツは、シーンを変えても表示させたいか、特定のシーンでのみ表示させたいかで分け、重なり順なども整理しながら、配置・設定していく。

check
背景の存在感を抑え、前景の階層的なデザインを立たせた例。正方形の写真がマップの役割を果たす。罫で囲まれたタグは情報アイコンになっているが、前景とトーンを揃えて馴染ませている。

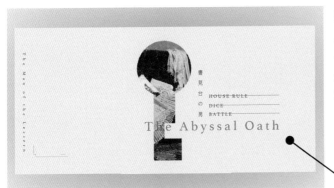

POINT

シナリオに合わせてゼロからセッションルームをデザインするのも楽しいが、部分的にデザインの余地を残すことで複数のシナリオに対応できる、汎用性のあるセッションルームも考えてみよう。

check

前景にフレームをかぶせることで、独特のタッチの絵画を鍵穴から覗くように閉じ込めた例。シナリオのテーマによって窓の中の画像を変化させるだけで、さまざまな世界への扉を象徴できる。

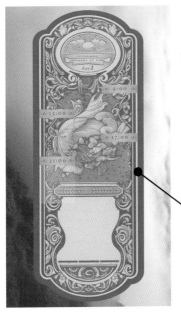

POINT

一般的には横型ディスプレイに合わせて横型のデザインが多いが、チャットやキーパッドを開く場合や、スマホなどの狭い画面では、縦型のほうが範囲を有効活用できるケースもある。

check

縦型のデザインでは、いくつかのシチュエーションやシーンをまとめて、ひと目で状況がわかるよう経緯や時間経過を演出しやすい。全身の立ち絵も映えるが、上下移動のスクロールを強いるのはほどほどに。

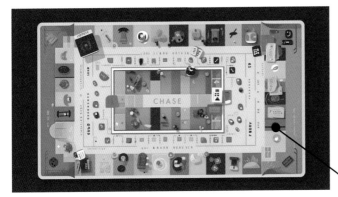

POINT

ルームはチャットパレットと立ち絵をセットする空間として機能するだけでも十分だが、マップをボード化し要素を規則的に配置することで、よりゲームらしい雰囲気を楽しむことができる。

check

グリッドを活用し、ボードゲームの盤面のように、目的地や障害物、資源やアイテムなどの要素を取り入れた例。プレイヤーが目標を達成するために戦略を立てる手がかりになる。

Ch.2-1-10 ✦

◈ 頒布用素材 3

その他の画像

オンラインセッションでは、展開に合わせて、キャラクターやマップ、アイテムの画像を利用し臨場感を演出することがある。多くの場合セッションルームに表示されるが、PLに共有できればその限りではない。オフラインではキャラクターコマとして使えるフィギュアやカードボードが売り出され、コレクションアイテムとしても人気だ。

POINT ✦

色彩や衣装、表情でキャラクターの性質を伝えるNPCやPCのビジュアルがあることで、物語やキャラクターへの感情移入を促す。PCの見た目はPLが考えることが多いが、立ち絵が同梱されているシナリオもある。また展開に合わせて切り替えられるよう、同じキャラクターの差分が用意されていることがある。

check

特にモンスターは、言葉の描写だけでは各々が異なるイメージを想起することがある。特徴や生態を明確に伝えるビジュアルを用意することで、より具体的な印象に残るシーンを共に作り上げることができる。

POINT ✦

探索マップとして具体的な地図や間取りで構造とスケールを提示する（2-1-8）以外にも、風景や建物のビジュアルを表示させたり、展開に沿ったデザインに切り替えたりすることで各シーンの舞台を提示できる。

check

探索や戦闘などセッション中に状況を共有し、スムーズに進めるためにまとめた画像をマップシートと呼ぶ。システムやシナリオにより必要な要素は異なるが、コマを置いたりアイコンを切り替えたりすることで、フェーズの進行やシーンの管理、PCごとの状態が一覧できる。

POINT ✦

ゲームの世界観に合わせたアイコンをデザインしてみ
よう。シナリオに関連する武器や回復アイテムをシンボ
ル化したり、組織や勢力のアイデンティティや特徴
をエンブレムに落とし込んだり、建物のミニチュアイラ
ストを用意して簡易的なマップを配置できるようにした
り、さまざまな使い所が考えられる。

check

世界観の表現が難しければ、汎用アイコン作っ
てみよう。マップピン、虫眼鏡、HONo.や時間
帯、ダイス判定やキャラクターのステイタスなど、
色彩や質感、囲みの形状を工夫して視覚的に
区別できるようにする。

POINT ✦

場面スチルは、そのシーンで起こる出来事を表
現するために用いられる。具体的な描写が求
められるため、実際のセッションと齟齬が生じ
る可能性があり、イメージを限定したくない作
品には向かない。

check

場面スチルの視点を工夫しよう。シーンに
よっては、キャラクターの視野に合わせて
描くことで、プレイヤーがよりリアルな状況
をイメージできる。目的によっては、鳥瞰図
のような視点から描き出すことで、プレイ
ヤーに距離感を掴んでもらうことができる。

POINT ✦

機能的な画像のほかにも、セッションを彩る装
飾素材、ルームに花が舞ったり光が明滅したり
といった動画による演出も進んでいる。クオリ
ティの高いセッション素材はゲーム体験を向上
させるが、汎用素材をむやみに組み合わせて
も没入感には繋がらない。シナリオとの連関や
デザインの一貫性を重視しよう。

check

セッション素材のデザインに取り掛かる前
に、どのような目的でどのような効果を狙っ
ているのかを明確にしよう。これにより、デ
ザインの方向性ははっきりし、効果的な素
材が生まれやすくなる。

Ch.2-2 ✨

動画による演出

TRPGでは、動画を活用することで、より没入感のある体験を提供できる。適切なタイミングで動画を使うことで、BGMと同様に、またはBGMとの相乗効果で、PLたちの感情を刺激することができる。ただし、過剰な演出は逆に興を削ぐため注意が必要だ。まずはシンプルなアニメーション素材の制作から挑戦してみよう。

サンプル作品制作・提供：喪花

❖ APNG素材のデザイン

アニメーションGIFより高画質な動画素材として、近年よく用いられるファイル形式、APNG（Animated Portable Network Graphics）。LINEのアニメーションスタンプなどもAPNGで作られている。

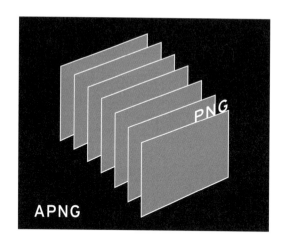

APNGのデザインのコツ

APNGは、アニメーションGIFに比べてファイルサイズが大きくなるため、アニメーションの簡略化が重要になる。シンプルなデザインを心がけることが、軽量で高品質なアニメーション素材の実現に繋がる。適切な再生速度に設定すること、また、心地よいイージング（動きの加減速）を追求することで、アニメーションの効果を最大限に引き出すことができる。

APNGとは

APNG（エーピング）はPNGと同じ形式で、アニメーションをサポートしている画像フォーマットだ。複数の画像を1つのファイルにまとめ、連続的に表示することでアニメーションを作成することができる。Web上での表示にも対応しており便利だが、動画ファイルとして扱われるため、ファイルサイズが大きくなる場合がある。表示できる環境は広がっているが、使用する際には確認が必要だ。

APNGの作成手段

APNGの作成手段には、コマごとに用意したPNG素材を、無料のアプリやサービスを介してAPNGに変換する方法と、Adobe After Effects、Blender、AviUtl、Clip Studio Paintといった映像・アニメーション制作に特化したソフトウェアを利用して、動画をAPNGに書き出す方法の2通りがある。各自の表現や制作環境に合う方法をとればよい。

装飾APNG

セッションルームにもAPNG素材が用いられる。ダイスロールやキャラクターアニメーションなどセッションにおける明確な役割を持った素材の他にも、前景が動いたり、テロップが流れたり、コマ置き場が回転したりといった装飾パーツとして人気だ。セッションには直接影響しないが、舞台を華やかに彩る。ただし、常に視界で動いていると集中力を削ぐこともあるので、静止画も準備するなど配慮したい。

➡ セッションルームに利用できる装飾パーツの例

各種APNGを配置して作成したセッションルームの例。パーツを変形させて床や奥行きがあるよう見立てることもできる。

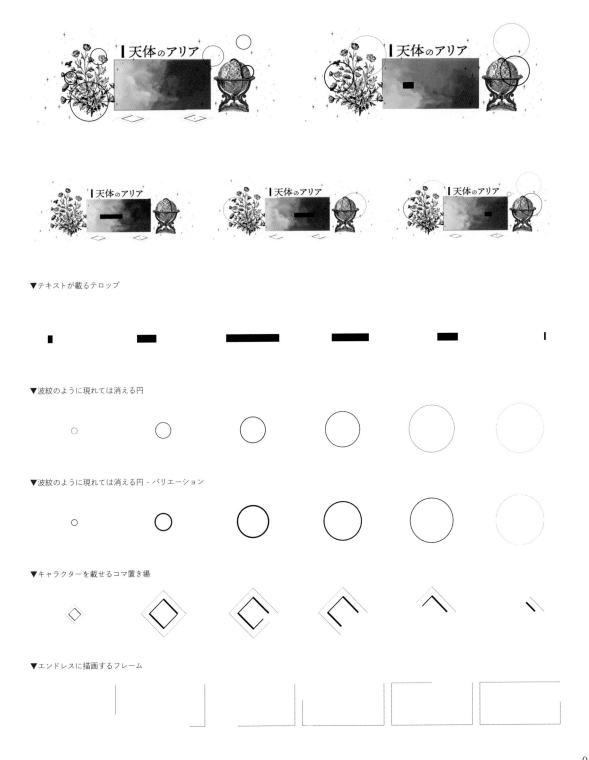

▼テキストが載るテロップ

▼波紋のように現れては消える円

▼波紋のように現れては消える円 - バリエーション

▼キャラクターを載せるコマ置き場

▼エンドレスに描画するフレーム

❦ 動画素材の使いどころ

多くの動画素材は演出のため、雰囲気を盛り上げるために用いられている。具体的にどんな場面で動画素材が活用できるか見ていこう。

モンスターやNPCの演出

PCが対峙するモンスターや神話生物、NPCの様子を動画で挿入することで、より臨場感のあるセッションが実現する。具体的な特徴やバトル方法を動画で紹介し、PLの理解を深めることもできる。また、NPCが喋ったり行動したりするアイコンを作成し、セッションルーム内に表示するなど、キャラクターの性格に合わせた動きを付与することで、生き生きとしたシーンが演出できる。

マップの演出

マップをアニメーション化することで、マップの特徴を強調することができ、PLは自分が操作しているキャラクターが舞台を動き回る様子をより直感的に理解できるようになる。例えば、戦闘シーンでキャラクターが移動するたびに地面が揺れたり、逃げるシーンで橋が崩れ落ちたり、迷うシーンで扉が現れたりといった物語の展開に合わせて表示を変え、ストーリーの演出ができる。

シーンチェンジの演出

シーンの切り替えに動画を使うことで、物語への没入感を高めることができる。次の場面へと移るタイミングや方法は、ストーリーを進める上で重要な要素であり、GM（KP）の判断によってコントロールされる。よく用いられるエフェクトとして、フェードインやフェードアウトなどいくつかの型があり、シーンの間、またシーンの開始時や終了時に表示される。目的は、切り替えを自然に、もしくは劇的に見せることにある。

オープニングの演出

オープニングに動画を用いることで、開始前から期待感や興奮を引き出し、固有の空気を作り出すことができる。セッションへの熱意やコミットメントの向上に繋がるだけでなく、セッション後もそれぞれが物語の世界観に浸ることができる。参加者の用意したキャラクターイラストなどを利用したい場合は、事前に合意をとり、使用した素材の著作権や利用範囲を確認する必要がある。

スキルの効果や状態の演出

スキルや魔法の効果を動画で表現することで、よりリアリティのあるシーンを演出することができる。多くの場合、状態は言葉で表現されるが、例えば魔法やトラップが発動した際には、鮮やかな光や爆発、煙、霧といったエフェクトアニメーションを使用することで、セッションにインパクトと緊張感を与えることができる。PCがダメージを受けた場合に、血しぶきや状態異常を表現することも可能だ。

タイトルロゴの演出

シーンの演出以外にも、例えばセッションルームのタイトルロゴやその背景に動画を使うことで、静止画では表現できない視覚的な魅力を持ったデザインに仕上げることができる。静止画よりも動画のほうが情報が多いため、具体的なモチーフのないシンプルな背景であっても、伝えたい雰囲気を色やテクスチャの変化に込めることができ、また動きによって目に留まりやすくなるため、注意を引ける。

トランジションのアイデア

トランジションは、シーンチェンジを滑らかに繋ぐための手段のひとつだ。カーテンの幕が上がる、血が滴り落ちる、頁が捲られるといった物理的なモチーフで繋ぐ短いアニメーションのほか、ホワイトアウトやブラックアウト、幾何学的なグラフィック、組み変わるタイポグラフィで表現するなど、さまざまなバリエーションが作成できる。海外の映画やドラマのタイトルシークエンスやモーショングラフィックスが非常に参考になる。

ロゴの背景に利用できるアニメーションの例

マーブルに混ざり合うグラデーション動画を背景に、タイトルロゴを配置した例。セッションルーム上で重なりを設定して表示することも可能。

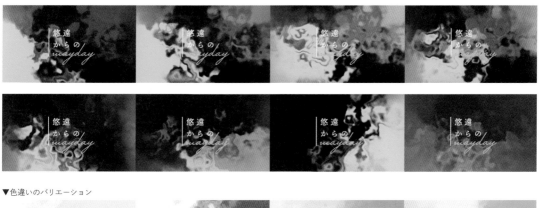

▼色違いのバリエーション

シーンチェンジに利用できるトランジションの例

上記のアニメーション＋ロゴに、ホワイト-インのトランジションを重ねた例。

グラデーション動画にブラック-アウトのトランジションを重ねた例。見えなかったものがシーンチェンジで現れるといった演出も可能になる。

TRPG素材 -YURAMEKI-（APNG素材）使用

Ch.2-3

セッションツールほか

ここまでTRPGでデザインされている要素の役割と表現のパターンをみてきたが、オンラインセッションを想定した準備ができるよう、最後によく使われているツールやサイトを紹介する。遊び手としては、馴染みのあるツールを使い続けるかもしれないが、作り手として、技術が日々進化していることを念頭に、新しいツールや新しい機能にアンテナを張っておこう。

✤ セッションツール

背景やキャラクターの設定、チャットパレット、ダイス機能等を備えたウェブベースのツール。マップやカード、アイコンなどの画像、BGMやSEを配置することで、キャラクターが置かれている状況をわかりやすく伝え、演出することができる。ココフォリア、ユドナリウム、TRPGスタジオ、Tekeyのほか、特徴の異なるさまざまなツールが開発・公開されている。

❖ CCFOLIA（ココフォリア）

背景、前景の設定が可能で、世界観の表現を背景で、場面演出を前景で行うなど、シナリオのトーンとゲーム性を両立した盤面が作成できる。アカウントを作成することでサーバー上に各盤面を保存できるため、複数回におよぶセッションで便利。「キャラクター保管所」や「いあきゃら」のキャラクターシートのインポートも可能。チャットパレットにコマンド入力することでダイスを振り、取り込んだキャラクターのステータスに応じた技能行使ができる。日々新機能が試作・実装されており、目覚ましい勢いで進化しているツールだ。

❖ Udonarium（ユドナリウム）

3D表示が可能で、設置するオブジェクトに高さのデータを持たせることができる。キャラクターの駒をジオラマのように配置できるため、オフラインセッションに近い表現が可能で、ダンジョンの壁や階段といった立体マップを表現するのにも向いている。ユドナリウムがオープンソースで公開されているため、マーダーミステリー用にソースを改良して作られた「マダミナリウム」などいくつかの派生ツールが存在する。

❖ TRPGスタジオ

テキストセッション専用のオンラインツール。CRPGの会話シーンのような画面表示が特徴で、ゲーム化や動画化にも向いている。自分で作成した画像素材が取り込めるのはもちろん、公式素材としてキャラクターと背景画像が豊富に用意されている。キャラクター画像は表情差分、背景画像は昼・夜の差分などがあり、初心者でも手軽に場面演出が可能。

❖ Tekey

テキストセッションに特化したオンラインツール。テキスト表示の演出方法が多彩で、文字の色分けや表示速度変更、音声読み上げ機能を備えている。コマンドの入力でダイスを振るほか、画像の表示、BGM・SEを流すなどさまざまな機能を制御できる。チャットパレットや画像が細かくフォルダ分けできるため、GMはあらかじめ文章やコマンドを入力してセッションの準備しておき、テキストのみとは思えない作り込んだ演出も可能になっている。

音声通話・チャットツール

ボイスセッションやテキストセッションを行う際は、ボイスチャット、テキストチャット、画面共有機能を備えた「Discord」などのチャットツールを使用すると便利だろう。

Discord

Discordはサーバーと呼ばれる目的やテーマごとに分けられたグループを作成できる。さらにサーバー内に作成できるチャンネルごとに閲覧範囲を決められるため、GMとプレイヤー、特定のプレイヤー同士のチャット、秘匿HOの配布などに有用だ。ダイスボットやタイマーや日程調整などさまざまなbotを導入することで機能拡張できる。またSNSのようにも利用されており、TRPGのプレイだけでなく、プレイヤー同志の交流も活発に行われている。さまざまなコミュニティ（Discordサーバー）があるため覗いてみてほしい。

シナリオ保管・投稿・頒布サイト

作成したシナリオは、個人サイトで公開するほか、プラットフォームで頒布したり、マーケットプレイスに出品する選択肢がある。

BOOTH

BOOTHはイラスト、音楽、ゲーム、小説、素材データなどのデジタルコンテンツから、同人誌、グッズなどのフィジカルコンテンツに至るまで幅広く頒布・販売できる、創作物のためのマーケットプレイス。TRPG作品やセッション用素材が数多く登録されており、サークルごとの新作・アップデート通知や作品ごとのデータ再DL、発送代行をお願いできる倉庫サービスといった、さまざまな機能が揃っている。

TALTO

「TALTO」はCCFOLIAが開発したTRPGに特化したオンラインマーケットプレイス。TRPG関連のデジタルコンテンツ（ルールブック、シナリオ、サプリメントなど）を保管・販売できる。シナリオの投稿に加えて執筆機能を備えており、Web上で執筆から公開まで完結できる。

キャラクターシート保管ツール

プレイヤーがキャラクターシートを作成・保管できるツール。URLを共有することで、GMや他のプレイヤーがキャラクター設定を確認することができる。各種TRPGに対応した「キャラクター保管所」や、クトゥルフ神話TRPGに特化した「いあきゃら」などがある。

キャラクターイラスト作成ツール

PCやKPCの立ち絵やキャラクターアイコンなどを用意する場合は「Picrew」、「CHARAT」などのキャラ画像メーカーを使用して、手軽に作成することができる（利用可能範囲はイラストごとに異なるので注意する）。利用者は好みのメーカーを使って、顔のパーツ（目、鼻、口、ほくろ、メガネなど）、髪型、服装、装飾品や小物などを組み合わせてキャラクター画像を作成する。また、クリエイターとして自分のイラストを使った画像メーカーを作成・投稿することもできる。

デザインの アイデア

Chapter 3

前章では架空の作例をもとにデザインのポイントを解説したが、この章では、人々を魅了する実際の作品を紹介する。キずけ制作者の作品しイッリビューも、螫いし見所の多いシナリオ作品群を、さらに国内のTRPG本体、立ち絵やルーム、海外のTRPGをデザインの視点からガイドしていく。

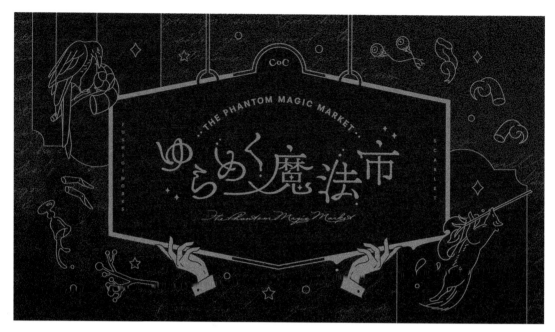

▲ ココフォリアルーム

▲ トレーラー

◆ SCENARIO ◆　クトゥルフ神話TRPG

TITLE ➡ 『ゆらめく魔法市』

シナリオ：イチ（フシギ製作所）／ デザイン：あけ

7歳の誕生日、なかなか家に帰って来ない冒険家の父から一通の手紙が届く。「まもなく市場が開く。じきに僕の友達が迎えにくるはずだ」。──ようこそ、ここは人ならざるものが商うところ。奇跡に災い、なんでもござれ。夢にゆらめく魔法市。これは「あなただけの魔法」を作り上げる物語。トレーラーは魔法市の路地の看板をイメージし、作品に登場する人や物がファンタジックかつダークに表現されている。シナリオ内でキャラクターが目にする魔法をプレイヤーがそのまま味わえるようにココフォリア素材も充実しており、わくわくするデザインに仕上がっている。

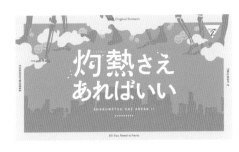

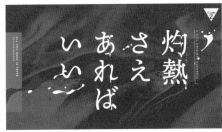

▲トレーラー

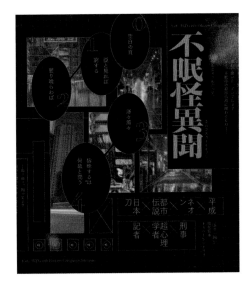

▲トレーラー

✦ SCENARIO ✦ 　クトゥルフ神話TRPG

TITLE ➡ 『灼熱さえあればいい』

シナリオ：イチ（フシギ製作所）/ デザイン：あけ

8月も終わったというのに、教室に差し込む夏の日差しは未だ強い。あなたたちは大学の電気もついていない教室で暇を持て余していた──。ミュージシャン、キリト（ORIGAMI Ent.）の楽曲『凪』をテーマソングに制作された『Trilogy2』企画シナリオ第二弾。晩夏の大学生たちのうだるような熱を、くすんだ色どうしを高コントラストに並置して表現した。また、古今東西に存在する「たのしい」の内に潜む狂気を、歴史的資料から引用した踊る人々の絵と、現代的な都市を練り歩く骨の入り混じった行列であらわしている。

✦ SCENARIO ✦ 　クトゥルフ神話TRPG

TITLE ➡ 『不眠怪異聞』

シナリオ：ユーガタ（薄明堂）/ デザイン：あけ

平成32年2月、不眠市。この市に流布する都市伝説が、とある事件を皮切りに人々を脅かし始めていた──。平成×ネオン×都市伝説×日本刀をテーマにした全5話のキャンペーンシナリオ。事件を追う探索者たちを駆り立てる、雑多で蠱惑的な架空の日本都市を、ネオンピンクで構成された新聞の紙面とそれを覆う噂話の伝聞で表現している。デザイン制作時にはシナリオが未完であったため、サイバーパンク映画などからデザインのインスピレーションを得て、構築したトレーラーイメージを通してシナリオの世界を深めていく相互反復的なプロセスで制作された。

あけ

シナリオのトレーラー、表紙や本文のレイアウト、イラストから動画まで、TRPGにまつわるグラフィックなら何でも手掛けている、デザイナーのあけさん。本業もグラフィックデザイナーであり、本名名義でも、アメリカでグラフィックデザイナーとして働いている。TRPGのデザインは「遊び場である」という彼女に、TRPGのデザインの秘訣と今後の展望を聞いた。

TRPGのデザインに携わるようになった個人的な動機やきっかけ、経緯について教えてください。

コロナを機に仕事が在宅になって時間ができた中で、個人的な興味でTRPGを遊び始めたところ、シナリオライターさんたちと仲良くなって、自分用に作っていたココフォリアの部屋などのデザインを目に留めてもらい、そこから個人的に依頼を受けてデザインをするようになりました。

TRPGにまつわる制作物をデザインする楽しみや魅力は何ですか？

ビジュアル以外の言語で創作している方々が紡ぎ出す物語や世界観に直接触れ、一緒にものを作れるのが魅力です。遊びながら作っていくということ、それをいろんなジャンルで、いろんなメディアに展開できるというのがすごく楽しいと感じています。

トレーラーのデザインにおいて、特に重視していることや、貫いているこだわりはありますか？ また、こだわりが発揮できたお気に入りの制作物があれば、詳細を教えてください。

トレーラーをシナリオの世界へのドアとして捉えているので、入り口に立ったときに何がぼんやり見えるのか、どんな予感を感じたいのかを考えて作っています。また、シナリオ通過後に振り返って見たときにも、ここのシーンを表現していたんだなという発見とともに別の角度から見てもらえたらいいなと思います。

そのためにはモチーフの抽象化が大事な気がしていて、『玻璃の国のかげろう』というシナリオのトレーラーでは、「これはなんだろう？」と興味を惹かれつつ、わからないから体験してみたい、と思える抽象度を実装できたかなと思っています。

この水晶のモチーフはCinema 4Dという3DCGソフトで作っています。文字ごとCinema 4Dの中に突っ込んだので、宝石の屈折率で文字も影響を受けています。最初は読みにくいんじゃないかと思って提案に出すのを迷ったんですけど、これがいいと選んでいただけました。私の中のシナリオのイメージに近い案だったので、とても嬉しかったです。

普段はどんなツールを使っていますか？

ツールは何でも使います。Glyphs（グリフス）も使いますし、InDesign、Illustrator、Photoshop、リソグラフの印刷も。フシギ製作所のイチさんとやっているBGM Collectionのプロジェクトでは、After Effectでモーショングラフィックスを作って、それをフレームごとに小さくリソで印刷して、拡大してスキャンして、また動画にすることで独特の質感を作っています。

トレーラーをデザインする場合、どのようなオーダーが制作しやすく、また取り組みがいがあるでしょうか？

できればシナリオをテストプレイの段階でもいいので一度遊ばせていただいて、そのときに頭に浮かんだもの、見えた景色をもとにデザインするのが一番好きではあります。そうでないときはシナリオの雰囲気やモチーフ、シナリオを通過した方が覚える感情などをヒアリングして作ります。これは個人的な傾向ですが、こういうビジュアルが欲しいという具体的なラフや要望をいただくよりは、こういうシナリオでこういう世界観なんだという文章から想像してビジュアル化するほうが作りやすいんです。ある程度幅をもって任せてもらえるオーダーで、提案に驚いてもらえるほうが嬉しくて、わたしはいつも2〜5案くらい提案して選んでいただいています。

エディトリアルデザインで気を配っていることはありますか？

TRPGのシナリオって情報の種類が多いんですよ。誌面の仕事でもこんなに情報の種類が多いものってめったに扱わなくて、それが楽しい部分でもあり難しい部分でもあります。段落スタイルをどう表現し分けたら、ぱっと見たときに情報の分類が伝わるかなというのを気にしています。

それがシナリオのテーマ性と絡んでいたらよりいいなと考えていて、たとえば最近作った本だと、シナリオのテーマが「流れ星」や「軌跡」だったので、情報の種類を段落の位置を変えることで視覚的な流れをつけました。そうすることで、情報の切り替えが伝わりやすいだけじゃなく、軌跡というコンセプトも表現できて、余計な装飾をしなくても見やすくまとまりました。

遊びの延長線上であるとのことですが、同時にビジネスの機会でもあると思われますか？

大きくなってきている業界でどうやったらマネタイズできるのかということを、システムを作る人もシナリオを書く人も絵を描く人も、皆が考えている段階だと思います。デザインに関しては、正直にお答えすると、BtoCのシナリオライターさんなどとは違って、個人の作家さんなどから受注する形になるので、どうしてもやりとりの金額は限られたものになります。打開策のひとつとして、汎用的な素材をデザインして売る方も増えてきていますよね。

一方、私はTRPGを自由にデザインできる遊び場として捉えています。なので、TRPGに関わるデザイナーさんが増えてきた中で、改めて自分が何をやりたいかなって考えたときに、ビジネスよりも優先して、TRPGとデザインが交わる領域を拡げていくことに繋がる活動をしたいなと考えています。

たとえばわたしはアメリカにいるので、こちらで盛んな海外TRPGとどういうふうに連関を持てるかな？とか、またTRPGと演劇、映画、ゲームなど他のメディアを掛け合わせている方々とも繋がっていけたら嬉しいです。また、今は多くの方がクトゥルフ神話TRPGを中心に遊んでいますが、インディーズなTRPGももっといっぱい出てきたら嬉しいなと思っていて、そういう新しい挑戦をする人たちと一緒に新しい礎を作っていく方向を模索中ですね。

また、私は「TRPG×デザイン」コミュニティの運営もしていて、人数的にも話題の内容的にも最近本当にデザインへの関心が高まってきたのをひしひしと感じるんですけど、だからこそ今デザインのフィールドにいる私たちは、次何をしたらもっと面白くなるだろうっていうのを考え始めるときなのかなって思っています。

どのような未来を見据えていますか？ デザインに関連して目下関心のあるモチーフや、深めていきたいテーマなどがあれば、教えてください。

個人としてはもう少しデザインを勉強したいと考えていて、大学院への進学を目指しています。今後はより、リサーチベースなデザインをやっていきたいです。

たとえば、波形やノイズといった世界をつくっている自然現象の根本的な動きを可視化していけば、言語に関係ないいろんなひとが理解できるメタファーになり得るんじゃないかなと考えていて、そういった仕組みと造形について思索していきたいです。

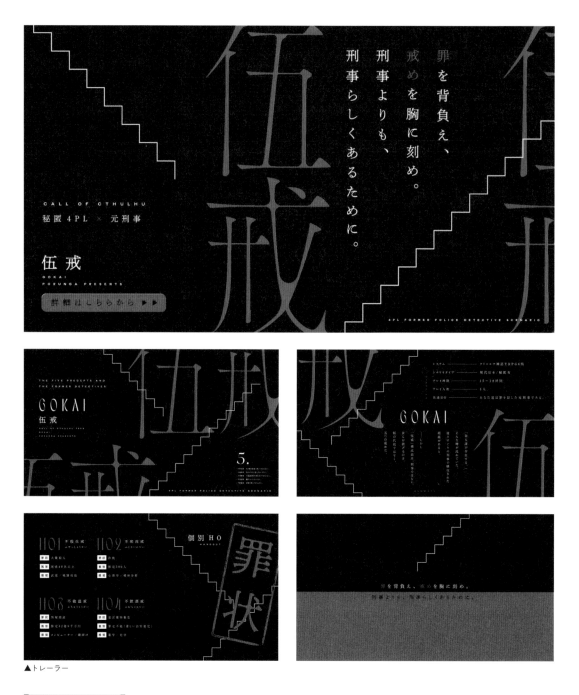

▲トレーラー

TITLE ➡ 『伍戒』 シナリオ：ぽるんが / デザイン：ネズ (nzworks)

「第五課が存在する」。そんな噂が流れていた。選りすぐりの刑事で構成された組織があると。しかし「伍戒」構成員は刑事ではない。彼らが掲げるのは桜の代紋ではなく、五つの戒めだ——。過去に罪を犯してしまった元刑事たちがアンダーグラウンドな裏社会で、表では裁けない悪を捌いていくストーリー。トレーラーは「地下に降りる階段」をモチーフに、どんどんと下っていき、4枚目で最下層に到達する構成をとっている。背景はざらついた砂目のテクスチャを用いて、暗くもエッジの効いたかっこいいハードさを表現。尖りのきいた明朝体のロゴを繰り返し使用することで、探索者に「戒め」という言葉の重々しさを感じさせることを目指した。

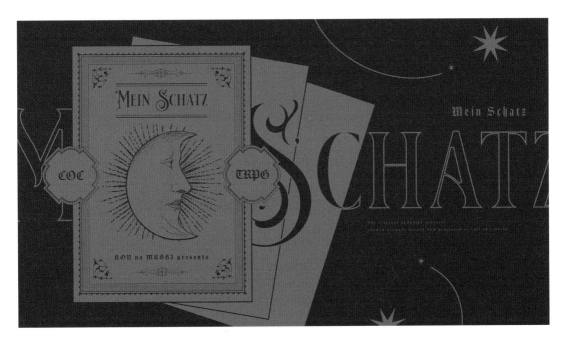

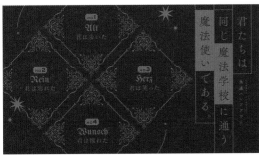

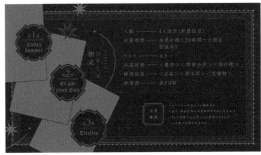

▲トレーラー

✦ SCENARIO ✦　📜クトゥルフ神話TRPG ✦━━━┅━┅

TITLE ➡ 『Mein Schatz』

シナリオ：本ノ虫 / デザイン：ネズ(nzworks)

たった一つの魔法を、君は知っている。それがたった一つの救い
であることも――。架空の魔法学校を舞台とした全3章のキャン
ペーンシナリオ。トレーラーは「3冊の魔導書」をモチーフに「魔法」
「レトロな西洋ファンタジー」をテーマに制作された。配色は金と濃
い目のブルーグレーで、少しくすんだ深みのある色を使用すること
でクラシックな伝統のある魔法学校をイメージさせる。4枚のトレー
ラーに統一性を持たせ全体をシックにまとめているが、次々とレイ
アウトを変えていくことで、シナリオの楽しさや賑やかさを表現する
よう工夫されている。円状に配置された星は魔導書に描かれた月
と関連するとともに、杖を振った時の魔法の軌跡を表している。

nzworks

✦ INTERVIEW ✦

TRPGに限らず、同人作品から商業作品までクオリティを落とすことなく圧倒的な作品数を手掛けている、デザイナーのnzworksさん。創作者に向け全方向からかゆいところに手が届くデザインを提供しつつ、PLとして遊ぶ際のクリエイティブも手を抜かない。とにかく皆が口を揃えて「速い！」「凄い！」と称えるネズさんに、デザインのコツを聞いた。

◆ TRPG関連のデザインに携わるようになった個人的な動機やきっかけ、経緯について教えてください。

　元々デザイン全般が好きで、デザイナーになる前から趣味で個人制作を楽しんでいました。TRPGのデザインに携わるようになった経緯としては、私がよくTRPGを一緒に遊ぶ友人たちの中にシナリオを自身で手掛けている方が多かったので、ルームデザインの延長でシナリオの告知用画像も個人的に作らせてもらっていました。ありがたいことにそれをきっかけに、お仕事としてシナリオライターさんからデザインのご依頼をいただく機会が増え、以降はトレーラーやロゴデザインに本格的に携わらせていただいています。

◆ TRPGに限らず、書籍の表紙デザインやタイトルロゴなどを多数手掛けられていますが、TRPGのデザインならではの面白味があれば教えてください。

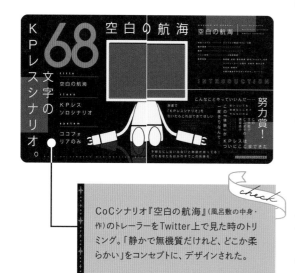

CoCシナリオ『空白の航海』(風呂敷の中身・作)のトレーラーをTwitter上で見た時のトリミング。「静かで無機質だけれど、どこか柔らかい」をコンセプトに、デザインされた。

check

　トレーラーもルームも縦横比が定まっていないのが1番の特徴だと思います。トレーラーは横長のものが主流ではありますが、スマホユーザーを意識した縦長デザインもよく見かけますし、ルームデザインについても同様です。表紙デザインは縦横比がほぼ固定されていて、ある意味でレイアウトのパターンが存在していることが多いのですが、TRPGのデザイン関連はまだ型が存在しないため、面白くも難しい部分だな、と感じています。

　またトレーラーデザインは扱う文章量が多く、広告の要素を含むため、チラシやDMの作成経験があったら活かせそうだなとも思います。ネタバレをすることもできないので、どこかにキャッチーでインパクトのあるポイント(キャッチコピーであったり、強烈なメインビジュアルであったり)を設けることも重要だなと感じます。

◆ こだわりが発揮できたお気に入りのトレーラーがあれば、詳細を教えてください。

　『空白の航海』という作品のトレーラーが気に入っています。このシナリオは、ZIPファイルをココフォリアにドラッグ＆ドロップすることで自動的に部屋が生成され、その部屋の中にある指示に従うだけで遊ぶことができる「KPレスシナリオ(PL一人でプレイできるシナリオ)」です。その性質上、シナリオに関わるあらゆる要素がネタバレとなっており、プレイ前に参照できる情報がとても少ない作品でもあります。

　よって、「概要が全くわからなくても遊びたい」と思わせるための「キャッチーさ」を重視してデザインしました。

　その手段として、タイムラインを流し見しているような層にも手を止めてもらえるよう、「Twitter上でサムネイルを見た時に、3枚の画像が繋がって1枚のトレーラーに見える」という手法を採用しています。

　中央のキャラクターは床に鏡面のように反射するつくりにすることで、シンプルな画面の中に質感を生むようにして

います。

3枚目の「テストプレイヤーの感想」群も手段のひとつです。記載できる情報が少ない分、テストプレイヤーからの感想を実際にアンケートして記述することで、間口を広げて敷居を下げたいと考えました。

「68文字のKPレス」というテキストはトレーラーの中で最も大きくレイアウトしているキャッチコピーです。一体どういうことなのか、実際に遊んで実感していただければ幸いです。

✦ ご自身でもTRPGを遊ぶ身として、セッションルームや立ち絵に凝る傾向について、どう思われますか？

TRPGというのは元来シナリオとダイスさえあれば遊べるものなので、セッションルームのデザイン性やキャラクターイラストに関しては全くの不要だと思っています。

ですが、ルームデザインやキャラクターイラストのクオリティは、高いほどシナリオへの没入感が高まり、TRPGというゲームの特殊性のひとつでもある「一度きりの体験」をより豊かにしてくれるものだとも思っています。その「体験」をより濃密で素敵な思い出にするために、デザインやイラストがあると、プラスでいいな、という考えです。

✦ セッションルームを作る際に、こうするとそれっぽくなる！というコツや、ここに嵌ると難しいのでほどほどに！といったポイントがあれば教えてください。

立ち絵（キャラクターイラスト）を置く場所を意識して作ると良いかなと思います。特に実際に立ち絵を置いて全体の仕上がりを見ながら作るのはマストです。

素材を使いすぎると配色やレイアウトの問題で収拾がつかなくなってしまうこともよくあるので、慣れないうちはシンプルイズベストを意識してキーカラーや要素を2〜3つに絞って制作し、慣れてきたら扱う要素を増やしていく、というのも重要です。

一番大事なのは「そのシナリオに合ったセッションルームを作る」ことです。たとえオシャレで見栄えするお部屋だったとしても、たとえばギャグ系のシナリオなのにエモーショナルな雰囲気ではプレイ体験に見合わない、自己満足のお部屋になってしまいます。シナリオをよく読み込んでイメージを抽出し、「そのシナリオに合っていて、強い没入感を感じることができるルームデザイン」を目指していくのが良いと思います。

✦ 自分で動かすキャラクターの立ち絵と、依頼を受けて描く立ち絵に、こだわりの違いはありますか？ 発注者にどこまでのキャラクターイメージがあると作りやすくなるでしょうか。

やはりご依頼で描く立ち絵に関しては数段丁寧に段階を踏んで作っています。自分の立ち絵は拡大するとアラが目立つ仕上がりになっていることも多いのですが……。

ご依頼の場合は自分だと作ることがないようなキャラクターデザインなどをご所望いただけることが大半なので、資料をたくさん見ながら血肉にしつつ作業させていただいています。イメージに関してはキャラクターの髪型・身長・体型・およそ年齢などの外見的特徴はもちろん、おおまかな服装のイメージや性格・背景があるととてもありがたいです。それらの要素を統合して「こんな服を好みそう」とイメージを膨らませることが多いです。

✦ カスタムできるデザインパーツなど、素材も積極的に頒布・販売されていますが、遊び手側のデザインがどのように発展することを望んでいますか？

TRPGに限らず、あらゆる場面において、日々少しでも世界のデザイン力が上がったらいいなと常々思っています。

ですが、自分でデザインしたい人ばかりではないので、お部屋を飾りたいけどパーツを作るのが苦手だという方には、自由に組み合わせてオリジナルなルームデザインを構築できるパーツ素材を、そもそもルームデザイン自体が面倒ですぐにシナリオを楽しみたいという方には、セットを読み込むだけで簡単にルームデザインを構築できる素材を用意していて、ユーザーそれぞれの素敵な体験づくりに寄与できたらいいなと考えています。

最近はデザインパーツを配布されてる方が本当に増えたので、選択肢が無限に広がって、とても良い時代になったなと思っています！

▲ココフォリア用部屋素材 #07 ブラウザ

▲ココフォリア用部屋素材 #5 ジェネラル

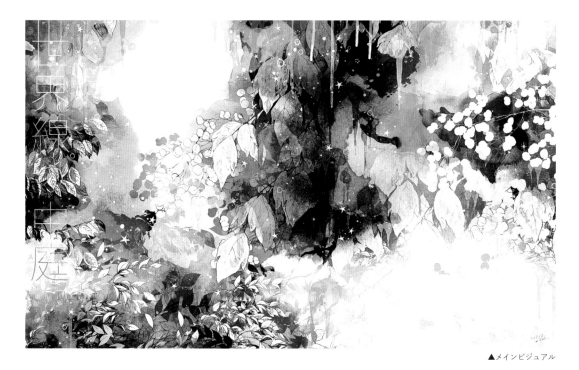

▲メインビジュアル

TITLE ➡ 『世界線の中庭』 シナリオ：ハッカ雨 / デザイン：ハッカ雨

春に芽吹く種のように、君は目を醒ましました。君の世界はこの中庭と家と君自身。それで記憶は途切れている。記憶喪失の探索者と、上階に住んでいる相手役。二人はともに中庭に降り積もる季節を眺め、意識を遡っていく——。中庭で植物を世話しながら、徐々に謎を解いていく全6章構成のシナリオ。メインビジュアルは緑と探索者たちの時間が幾重にも重なっていく不思議な中庭をイメージして制作されている。中庭で庭仕事をする探索者たちの雰囲気をビジュアル面でも楽しめるよう、クォータービュー風の中庭の俯瞰図が素材として同梱されている。別売の素材集（『世界線の中庭 -造園型録-』）を使用すると、インテリア配置ゲームのように自分だけの中庭を作ることができる。

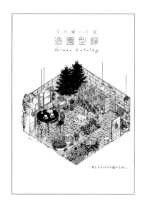
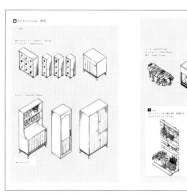

▲▼素材集と素材パーツ（一部）

世界線の中庭
Courtyard Space Opera

Call of Cthulhu

▲タイトルビジュアル

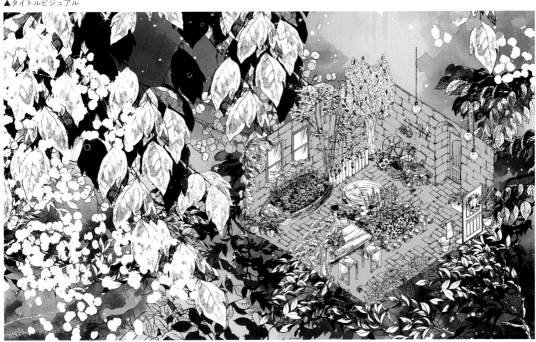

▲ココフォリアルームサンプル

ハッカ雨

✦ INTERVIEW ✦

謎を抱える中庭で記憶を手探りしながらも、あるがままの暮らしを紡ぐ、長期シナリオ『世界線の中庭』を手掛けた、ハッカ雨さん。美しい線画イラストで生み出される透徹した世界観は、メルヘンながらも陰影に富んでいる。海辺に住み、本業では漫画アシスタントを務めるという彼女の造詣の根を辿った。

◀ TRPGのサークルを始めた動機やきっかけについて教えてください。

「こんなシナリオで遊びたい！世の中にないから自分で作るしかない！」という衝動からでした。初めて世に出した『ぎこちない同居』の執筆当時は、カップリング（うちよそ）やKPCといった遊び方がまだ界隈で確立されておらず（私が知らなかっただけかもしれませんが……）、もっとクトゥルフしながらいちゃいちゃしたい！という純粋な気持ちで制作しました。TRPGは以前から好きでしたが、本格的にハマったのはニコニコ動画のゆっくり系のリプレイ風動画からです。

◀ かねてから文筆にも親しまれていたのでしょうか？前例のない新しい形のシナリオを創作するうえで苦労した部分、工夫した部分があれば教えてください。

大学では文章を書くことを専攻していました。が、実践的な創作物の添削を受けたりしていたわけでもなく、大学時代はオタク活動にいそしみ漫然と過ごしていたように思います。大学では技術というよりは、創作を行ったり鑑賞するにあたっての物の見方が養われたように思います。

シナリオの制作において、特別な苦労はありませんでした。それまでも同人活動として漫画を大量に描いてきており、その出力方法を変えてゲームシナリオを書いているイ

メージです。

漫画とTRPGシナリオの大きな違いは「物語はGMを通して語られる」という点です。作品はダイレクトにPLに届くわけではありません。GMに物語をより良く解釈してもらうための説明や読みやすい文章量は、今でも塩梅を探っています。

◀ 自然をモチーフにした世界観が特徴的ですが、クリエイションにおいて影響のもととなっているもの、インスピレーションを受けるものはありますか？

ムーミンシリーズの小説・アニメの影響が最も大きいと思っています。素朴な生活、ワクワクする冒険、美しい自然。幼少期に触れ、強烈な原体験となっています。幼い頃に常夏の島に住んでいたことがあり、海が好きなのはそのためです。逆に、寒い季節や土地には漠然とした憧れや幻想を抱いています。

◀ 『世界線の中庭』が、どういった思考過程を経て立ち上がったのか教えていただけますか？

三鷹の森ジブリ美術館には中央に井戸のある中庭があり、その場所の籠った雰囲気が着想の始まりだったように思います。この中庭は地下1階にあたる低い場所にあり、余計に「囲まれて外界から隔絶された」空気があるのです。

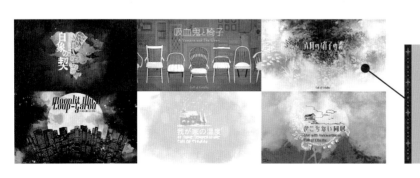

check

サークル「ハッカ海岸」として発表しているCoCシナリオ群。モノクロをベースに、光や湿度・温度を感じさせるタイトルビジュアルが印象的だ。

ペン画素材は印刷も可能な高解像度の透過PNG。立ち絵置き場に使いやすい枠付き縦長サイズのミニ背景をメインに、背景に大きく使える枠なしの背景画、枠のみなども同梱している。

check

『花鳥海月』は、特定のシナリオをイメージしたのではない、自然の景色を中心としたペン画の素材集。画像を一覧できるPDFも付属し、TRPGに限らず画像素材として利用できる。

素敵ですね。特別な空気感のある中庭に長居したくなる気持ち、わかります。植物の設定や造形は、現実に即したものなのでしょうか？

　花は人並みに好きでしたが、育てたことはほとんどなく、『世界線の中庭』は一から調べながら執筆しました。シナリオを書いたことで愛着が湧き、最近では自分でもベランダ園芸を楽しんでいます。後から見返してみると、実践での園芸知識と、空想の状態で書いていた『中庭』の情報とでは差異があるところもあります。フィクションならではの演出やご愛嬌と思っていただければ幸いです。

シナリオに紐付いた素材集を利用することでPCの作る中庭が実際に可視化される、面白い仕組みです。シナリオ作成当初からパーツを素材集として発表することは決めていたのでしょうか。

　はい。早いうちから決めており、半年以上かけて少しずつ植物を練習したりパーツを描き溜めたりしていました。『世界線の中庭』はTRPGサークルとしては初めて紙の同人誌も出すことを決めていた作品でした。そのため、より特別なことをしてみようと思った次第です。

特定のシナリオに紐付かない各種ペン画の素材集も発表されています。ご自身が遊ぶときに「こんな素材があると利用しやすい / 利用したくなる」と感じるポイントがあれば教えてください。

　幅広いシナリオに合う、シンプルなものが好きです。トレーラーやシーン背景を綺麗に収められる飾り枠、プレイルームにずっと表示しておけるパーティクルのようなAPNG素材などは定期的に探しています。自分のペン画素材と組み合わせることも多いので、漫画や西洋挿画的なタッチの

ものがあると飛びついてしまいます。

モノクロームのペン画が印象的ですが、ペン画に合わせるおすすめの差し色や、よく使う色の傾向があれば教えてください。

　私のペン画は線が太めではっきりしているので、色味を抑えたグレイッシュ〜ダルトーン、あるいは色の主張が強いビビッド〜ディープトーンが合うように思います。透明水彩風の滲みも、よく使用しています。

ご自身で着彩をされる場合は、どんなツールを使われていますか？ タッチ別にアプリケーションなどを使い分けていますか？

　デジタルツールは、ほぼCLIP STUDIOを使っています。しばらく前からPhotoshop用のブラシも読み込むことができるようになったので、利用できるブラシが増えて助かっています。

　水彩風の塗りの際には、アナログの水彩を読み込んだブラシや画像素材と、クリスタの水彩ツールを組み合わせています。あれこれ使い分けるのが苦手なのでクリスタに一本化したいのですが、細かな色調整やフィルターなど一部の加工はPhotoshopに分があり、使い分けています。

現在特に関心のあるモチーフや、夢中になっているセルフプロジェクト、これから描きたいテーマがあれば教えてください。

　2023年は鉱石にまつわるTRPGシナリオをまずまとめる予定です。そこに登場する鉱石を、ペン画でも魅力的に伝えたいと思っています。今もっと描きたい、練習したいのは食べ物です。

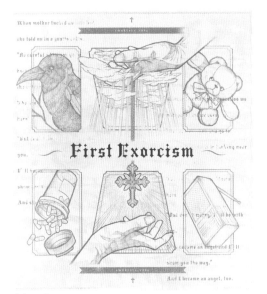

▲トレーラー

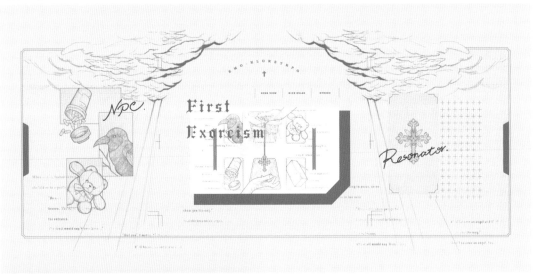

▲ココフォリアルーム

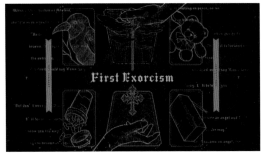

▲トレーラー動画

TITLE ✦➡ 『First Exorcism』

シナリオ：アキエ（ねこずし卓）／ デザイン：necoze（ねこずし卓）

「天国に行くときは気を付けて。入り口付近は悪魔が潜んでいるからね」。ある日、共鳴者は近所に住む変人ヘブン神父に「私の後を継いでエクソシストになってほしい」と言われ、「悪魔が棲む屋敷」の調査に行くことになる——。「天国」をテーマにしたエモクロアTRPG企画『SEVENTH HEAVEN』参加シナリオ。トレーラーの色味はこれまで作者が制作したシナリオとの差別化を図り、エクソシストのイメージとして緑を採用した。補色の黒とピンクは悪魔をイメージしている。モチーフの描写が細かいタッチのため、四角形で区分けしてデザインにまとまりを出している。

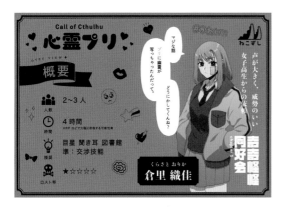

▲トレーラー

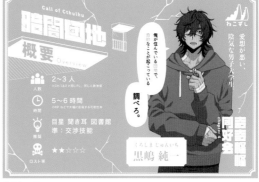

▲トレーラー

▲タイトルビジュアル

▲チャプター - タイトル

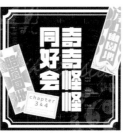

▲タイトルビジュアル

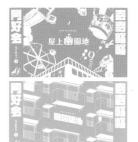

▲チャプター - タイトル

SCENARIO　クトゥルフ神話TRPG

TITLE ➡ 『奇奇怪怪同好会　chapter1＆2』

シナリオ：アキエ（ねこずし卓）／ デザイン：necoze（ねこずし卓）／ 一部トレーラー画像：ダニ

SCENARIO　クトゥルフ神話TRPG

TITLE ➡ 『奇奇怪怪同好会　chapter3＆4』

探索者は「奇奇怪怪同好会」に所属している。心霊・オカルト・不可解現象の解決を目的として探偵事務所のように依頼を受け、調査をしているらしい。所属したのはいいが、全く会合の連絡も入らず、詳しいメンバーについても知らされていない。クソダササイトがあり、「警察に相談しても解決しなかった心霊・オカルト・不可解現象を解決します！(^^)！」とでかでかと書いてある──。全5話構成予定のキャンペーンシナリオ。テーマカラーを無彩色で統一し、チャプターごとに有彩色を1色決めてデザインされた。各チャプター固有のタイトルやロゴを入れた際にも大もとのシナリオ名がわかりやすいよう、ロゴデザインに太めのゴシック体を採用している。

ねこずし卓

✦ INTERVIEW ✦

暗く重たいシナリオから爆笑しながら通過できるシナリオまで、幅広い作品を発表している人気サークル、ねこずし卓さん。動画チャンネルで垣間見える、作ること遊ぶことを心から楽しむ様子や気取らない人柄に惹かれ、執筆担当のアキエさん、デザイン担当のnecozeさんに話を聞いた。パッション重視で爆発的にクリエイションが生まれる様は、2人ならではだ。

✦ お二人でTRPGのサークルを始めた動機やきっかけについて教えてください。

necoze：ちょうど2016年頃にTRPGのリプレイ動画が流行り出して、アキエもnecozeも動画のファンとして入り、実際にTRPGを遊ぶようになりました。せっかくだからハマるきっかけになったセッション動画を自分たちも作って発表したいねっていうことで、シナリオ制作以前に動画投稿者のほうに憧れて活動が始まりました。

当初はシナリオはアキエが執筆して、その後のセッション動画をnecozeが作って発表するという分担だったんですが、『海も枯れるまで』というシナリオのデータをわたしが先走って公開用にもらって、ちょうどその年に開催された「アナログゲーム回」というBOOTHさんの即売会で頒布する予定をほとんど勝手に立てたんですね。それを機に、アキエが執筆する、necozeがデザインするという体制になりました。それまではリプレイ動画でしか「ねこずし卓」名義を使っていなかったんですが、頒布のための作業を一緒にするならサークルとしても機能するだろうと。

✦ 当時からルームシェアをしているとのことで、距離感が独特ですね。協働のスタイルについて教えてください。

necoze：初回のテストプレイ以降は、内容に関する相談をアキエから受けたり、たとえばわたしは数字に強いので判定の確率まわりを考えることなどがありますが、シナリオの文字を書くことはありません。ビジュアルに関しては、作ったものをアキエに投げてリテイクをもらって、また投げてリテイクをもらっていうやりとりを密に行っています。

執筆段階でアキエに余裕があればNPCのラフなども準備してくれるので、テストプレイ初回時に見た目がバチバチに決まっていてあとは清書するだけのNPCもいれば、初回には姿形がなくて、テストプレイを重ねるうちに見た目が出来上がっていくキャラクターなどもいます。テストプレイが終わったら、テストプレイ時には準備できなかったけど、こういう画像が欲しいんだよね、これを可視化したいんだよねという構想を受けて、デザイン作業に入る感じですね。

各々力を入れるパートが別なので、緩急がついていいかなと思うんですが、長らく2人でやっているので、1人で作るという感覚があまりわからなくなってるかもしれないです。

✦ お二人にとって、シナリオを世に送り出す際に重視していること、逆に重きを置いていないこと／やらないと決めていることがあれば教えてください。

デザイン面だと、すでにねこずし卓で公開しているシナリオのテーマカラーとはかぶらないようにしています。色がかぶると、先行するシナリオのイメージから期待される内容とギャップが生まれますし、並んでしまうとひと目で判別がつかなくなってしまうので、メインカラーと補助で入れるサブカラーは一緒にならないように気を配っています。そもそもCoCは全体的にダークな色のシナリオが多くなってしまい

▼『First Exorcism』動画トレーラー

ねこずし卓のYouTubeチャンネル。ヘッダーは2人の顔のイラスト。イラストからLive2Dで作成した動くモデルが、配信用アバターにもなっている（左がnecoze、右がアキエ）。

check

各シナリオの動画トレーラーから、シナリオの公開記念配信、リプレイ動画、セッション配信、作業配信、ゲーム配信、VLOGまで充実のコンテンツ。人気の動画は10万回再生を超える。

がちで、だったら白っぽいシナリオを増やそうか、といったTRPGの全体的な傾向ともかぶらない工夫をしています。

シナリオ面では、公開していろんな人に遊んでもらいやすいよう、わかりやすさは目指しつつ、あくまでターゲットは周りの友だちのことを意識して、顔の浮かぶ人たちにまず楽しんでもらえるように心掛けています。

当初伸びたシナリオは陰鬱なものが多くて、やはり重たい作品のほうが人にインパクトを与えるので暗い印象が先行しましたが、ポジティブで笑える作品もたくさん作れたらいいなと考えています。もともとセッションを回すのが好きで始めたので、注意事項が多いシナリオよりは、シリアスな場面があっても楽しく回せるシナリオを増やしていきたいです。

お二人のシナリオには、これでもかというほど素材が同梱されています。素材制作におけるこだわりを教えてください。

やっぱり回す側の気持ちでいるので、素材は「ないよりあったほうがいい派」です。もちろんセッションが楽しめるように、何より元から入っていたら回してくださるKPの準備が楽になって、なおかつ回してるときに「これすごいですね〜」ってPLから言われて嬉しくなるかなと思って、盛り盛

りにしています。自分だったら嬉しいから入れておくね、という勝手なスタンスで考えているので、逆に自分たちがいらないかなって思うものは入れてないんですよね。NPCの表情差分はいらないけど、神話生物の画像を探すのは面倒なのでなるべく描いて入れておこう、自分が大変な素材こそ作っておこう、という気持ちです。

ただ、最近はそれが一般化してきてしまって、本来シナリオがあれば遊べるところを、トレーラーも部屋素材も同梱されていることが増えてきました。良くも悪くもシナリオ頒布に求められるレベルが上がってきているので、作るほうも「これで満足してもらえるかな？」ってドキドキしています。シナリオによっては音楽素材まで入っていて、知り合いに毎回自分が作った楽曲をつけてシナリオを発表される方もいますし、とどまる所を知らないなと。

シナリオを出す身としてではなく遊ぶ身としては、実はそういった素材や準備が足りてなくても充分楽しめちゃうので、必須だとは思わないんです。ただ近年のTRPGは、創作系の絵を描く方が楽しんでいる傾向があるので、デザイン面でも見映えを好んで、当たり前のように素敵な部屋を作って遊んでらっしゃるんですよね。それがシナリオに付いてくると嬉しいし、シナリオを選ぶ基準のようにもなってきて

▼『奇奇怪怪同好会』ココフォリアルーム

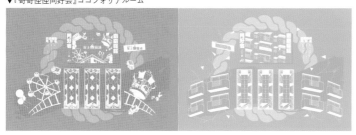

▼『奇奇怪怪同好会』クソダササイト

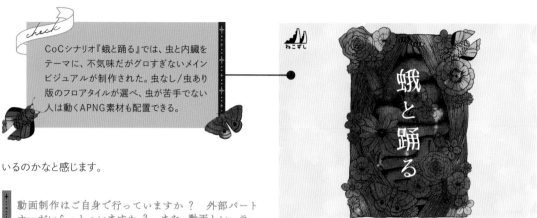

CoCシナリオ『蛾と踊る』では、虫と内臓をテーマに、不気味だがグロすぎないメインビジュアルが制作された。虫なし/虫あり版のフロアタイルが選べ、虫が苦手でない人は動くAPNG素材も配置できる。

ねこずし

蛾と踊る

いるのかなと感じます。

■ 動画制作はご自身で行っていますか？ 外部パートナーがいらっしゃいますか？ また、動画トレーラーの制作において、静止画トレーラーと違い意識しているポイントがあれば教えてください。

一部外注でお願いしたものがありますが、基本的には自分たちで制作しています。トレーラー動画のストーリー仕立てになっているものの構成や音ハメをアキエが、色をつけたり文字を入れたりといったデザイン面をnecozeが担当しています。

動画コンテンツからこの世界にハマったので、リプレイ動画によくあるオープニングやエンディングの延長線上で、トレーラー動画も作ってきたようなところがあります。情報としては静止画で十分なんですが、動画はロマンで好きなように作れるのと、楽しみにしてくれる方がいらっしゃるので、作って楽しい、見て楽しい、という気持ちです。

アキエが具体的なイメージを持ってることが多いんですが、動画ではそれがシナリオ特有のものとは限らず、2人で巷の映像や音楽に触れて「こういう構成アガるよね」「うわやりたーい！」みたいに盛り上がって、「それやるんだったらこれを準備しなきゃね」ってノリで作り出すことも多いです。動画って、静止画で情報を読んで興味が湧いて、もっと知りたいと思った人しか再生しないので、シナリオの雰囲気を掴んでもらったり、遊びたい！のテンションを上げられたら充分なんですね。テキストも演出のひとつで入っていればいいかなくらいの気持ちで、読めないとイライラしちゃうからなるべく大きめにしてるんですけど、あまり意味はないというか、丁寧に情報管理してないです。リプレイや解説の動画はまた別の視点で作ります。

■ アキエさんは執筆時にビジュアルのイメージを持たれていることが多いとのことですが、もともと創作系の執筆経験があったのでしょうか？ せっかくなので、協働作業について、改めてそれぞれの言葉で聞けたらと思います。

アキエ：実は文章の書き方を勉強したことも、何なら活字を読むこともほとんどしてこなくて、ただ脳内の妄想だけで

生きてきました。漫画がアニメ化したらオープニングはこれで、エンディングはこれで、といった展開の妄想をするのが好きで、シナリオではそういった妄想をできる範囲でアウトプットして、共有している感じです。

necoze：例えでわかりやすいのは『蛾と踊る』というシナリオなんですが、これはシナリオが完成する前からアキエに虫と内臓というお題もらって作っていたトレーラーで、蛾の気持ち悪い動きまで共有されました。「これがしたい」っていう部分的かつ決定的なイメージをもらって、「これがしたいんだね、わかった、それをやろう」って自分が具現化することが多いですね。

アキエ：イメージを描いて渡せないときは、Pinterestなどでイメージボードを作って雰囲気を掴んでもらっています。逆に自分の中に何もないときは、necozeの提案が頼りです。

necoze：その場合、方向性が間違っていないかは都度確認するんですけど、わたしもアキエの好きなものを作ろうとしている訳ではないんですよね。公開されたときに正しくイメージが伝わるかが大事なので。わたし視認性と可読性が大好きで、かっこよさももちろん欲しいんですけど、正直スタイリッシュなデザインが得意な訳ではないので、だったらせめて覚えてもらえるように、インパクトを与えられるようにってそればかり心掛けています。

アキエ：彼女のこの感覚が、結局自分も大事だと思っているので。お互いやりたいことがマッチしなかったときには喧嘩もよくしましたが、イメージの共有不足や言葉の解釈の違い、具体的にどこまで任せるかで齟齬が生まれることが多くて、それは無駄だなとお互い学びました。今は持ちつ持たれつで、うまくコミュニケーションをとってやっています。

シナリオのデザイン実例

▲トレーラー

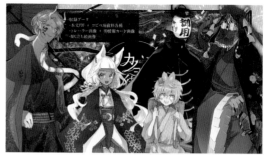

▲NPC素材

▲スチル

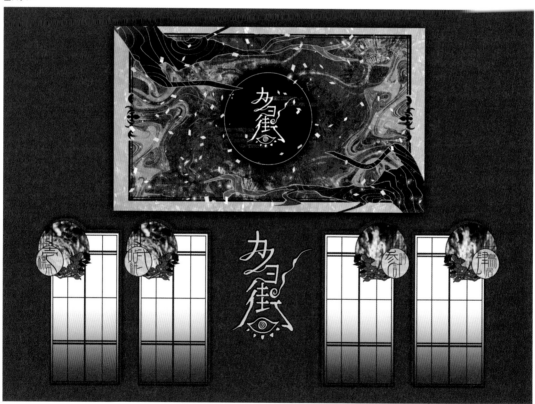

▲ココフォリアルーム素材＋トレーラー

TITLE ➡ 『カノヨ街』 シナリオ：七篠K／トレーラー画像、キャラクターイラスト：畠野おにく／マップ画像：七篠K

日本某所、人ならざるものが息をする街、カノヨ街。そこはすべてのひとがしあわせにくらす場所――。これはそんな蒔絵のように穏やかできらびやかな世界の中、それぞれの秘密を抱えた者たちが四人集まり、互いの道標を照らしていく和風アドベンチャー。和風で華やかな印象を鮮やかに与えるために、メインカラーの数を抑えつつ、異なるモチーフで色合いに細やかな差をつけている。中央に黒色の円を配置し白地のタイトルロゴを配置することで、視線を集めるように意識されている。

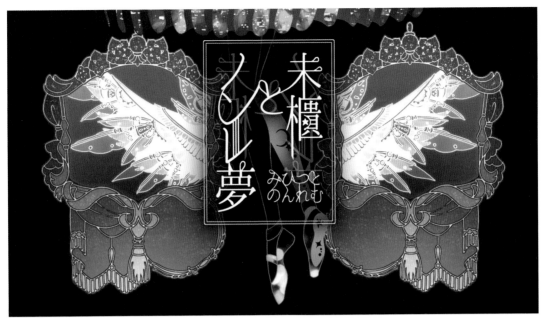

▲トレーラー

▲トレーラー

▲ロゴ

TITLE ➡ 『未櫃とノンレ夢』

シナリオ：七篠K / デザイン：七篠K

日常から最も近い場所にある非日常の「真夜中」を舞台に、キラキラと可愛らしい雰囲気の中、ふたりで夜更かしをする物語。「真夜中におとぎ話のような体験を」というコンセプトと、モチーフである「白鳥の湖」を表現するために、全体的にキラキラした夜空を連想させるデザインとなっている。トレーラーにセッションで使用する画像素材を組み込み、シナリオ素材として使用することもできるようになっている。プレイヤーが「このふたりで冒険がしたい」と思う探索者を持ち寄り夜更かしを楽しめる。

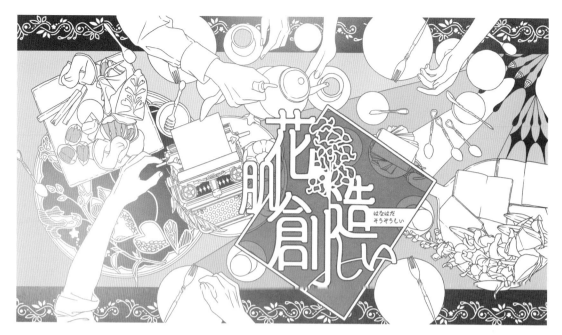

▲トレーラー

▼ココフォリアルーム素材

TITLE ➡ 『花肌創造しい』

シナリオ：七篠K / デザイン：七篠K

解ければ事件、解けねば事故。ミステリと未来予知の渦巻く館に招待された探索者は、どのような推理を奏でるのか──。わいわい盛り上がりながら、推理とダイスロールを楽しむことのできるシナリオ。セッション毎に印象の異なる展開をもたらすこの物語は、まさに参加者によって創造しく奏でられる即興劇である。トレーラーは賑やかで華やかな雰囲気を演出しつつ、多くの登場人物が活躍するシナリオ内容に合わせて人物の手やカトラリー、色彩などを散りばめている。植物をテーマにしたアンソロジー企画のひとつであるため、タイトルロゴにはシナリオモチーフの「金魚草」をあしらっている。

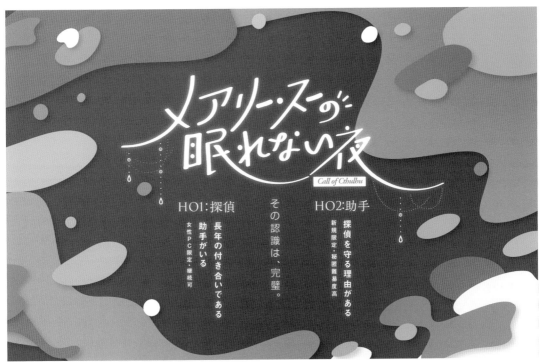

▲タイトル

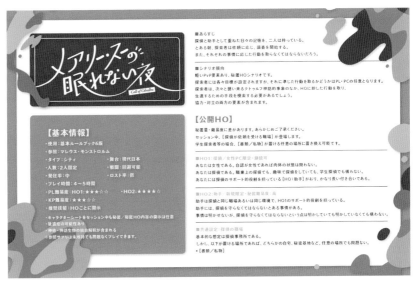

▲トレーラー

TITLE → 『 メアリー・スーの眠れない夜 』

シナリオ：月刊かびや / デザイン：嵐山デザイン

探偵と助手として重ねた日々の記憶を持った2人が、とある朝、依頼に応じ、調査を開始するところから始まる探偵モノCoC。シナリオ作者が制作したデザインの方向性を参考に、デザイナーはシナリオをプレイしてみた後に情報の整理を行い、レイアウトを作成。「眠れない夜」という言葉の印象の割には温かくやわらかな印象を受けたことから、ぐにゃりとした曲線が主体のデザインに決定した。

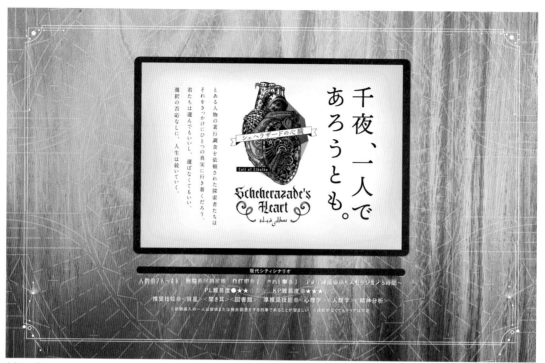

▲トレーラー

▲タイトル

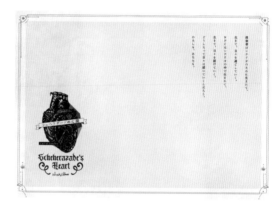

TITLE ➤ 『シェヘラザードの心臓』

シナリオ：せさみ（嵐山デザイン）／ デザイン：嵐山デザイン／ 編集：嵐山デザイン

探索者のもとに舞い込む、何の変哲もない素行調査。それをきっかけにひとつの真実が開示される。探索者は選んでもいいし、選ばなくてもいい。選択の否応なしに物語は続いていく——。シナリオ内に登場するNPCの物語の中に探索者が入り、物語を読み進めていくような体験が味わえるシナリオ。NPCとの対話を重要視しており、物語としての舞台装置ではなくNPCもそこに生きていることを感じられる。『千夜一夜物語』の語り手シェヘラザードからインスピレーションを受けており、物語が綴られた本のようなデザインとなっている。

▲シナリオ中面

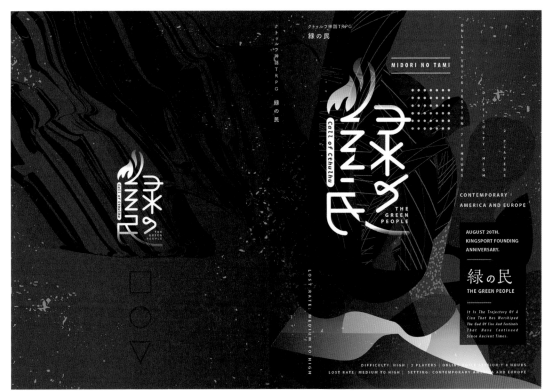

▲書籍版 - カバーデザイン

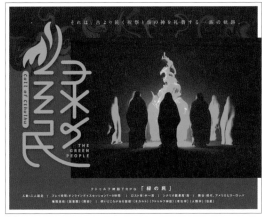

▲トレーラー

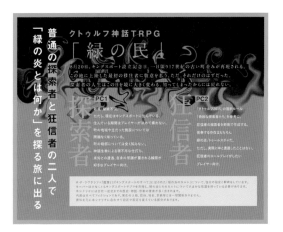

TITLE ➡ 『緑の民』

シナリオ：すみっこ / デザイン：嵐山デザイン

自身が住む町でかつて栄えていたカルトの存在を知らぬ探索者と、緑の炎と港町キングスポートの関係を突き止めた狂信者が遭遇し、ある出来事をきっかけに「緑の炎とは何か」を探る旅に出る物語。「緑の炎」を信仰するカルトが物語のキーとなるため、ロゴは漢字だがルーン文字のような印象を与える作字となっている。書籍版の表紙デザインは、緑という言葉から連想される草のイメージと、「緑の炎」から炎にも草にも見えるデザインとなっている。

TITLE ➡ 『爛爛』

シナリオ：つきのわむく（つきめぐり）／ デザイン：つきのわむく（つきめぐり）

ドイツを舞台に、特殊な眼を持つ古物研究家と記憶喪失の探索者の出会いから始まる全4話キャンペーンシナリオ。実際にドイツを観光しているようなリアルな描写や、難易度の高い戦闘、また個性的なNPCも多く登場する。「義眼」がテーマとなっており、トレーラーデザインでは、彩度の高い青色、黄色でポップさを与えつつも、実写の眼を用いることによりクトゥルフ神話の不気味さやカルティックな印象、わくわくと不穏さ、不明さを持たせている。卓内で使えるコンセプトアートやポスター、シナリオの世界観を補強するスチルなども豊富に付属している。

▼ コンセプトアート

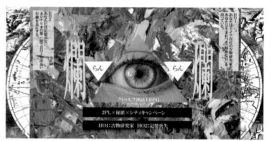

▲ トレーラー

▼ ポスター

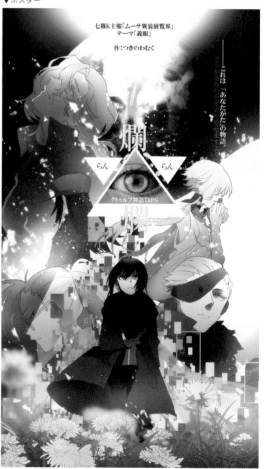

▲トレーラー

▼ポスター

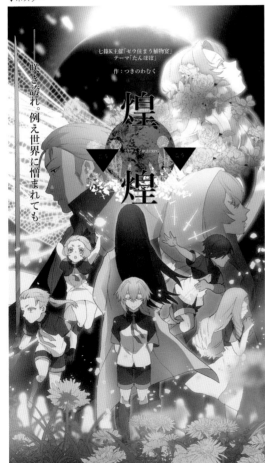

TITLE ➡️ 『煌煌』

シナリオ：つきのわむく（つきめぐり）／デザイン：つきのわむく（つきめぐり）

『爛爛』の続編。数百年後の地球を舞台に、探索者たちは旧神の血を継ぐ者「神器」となり、体に咲く黄金の花々を武器に戦う全4話キャンペーンシナリオ。旧神や邪神たちの戦いやクトゥルフ神話における歴史を踏襲した特殊な世界観のもとで、『爛爛』から続く壮大な物語となっている。エンド分岐やルート分岐も多くあり、卓によって違う雰囲気を味わえる。トレーラーは黄金の花たんぽぽと、暗黒に包まれた地球をモチーフに、前作の『爛爛』よりもダークな印象ながら、黒と金色を基調にしたシンプルで上品なデザインに仕上げている。

▼コンセプトアート

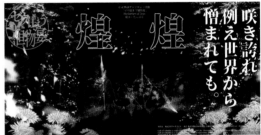

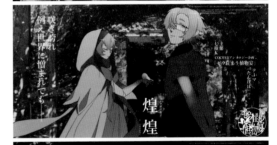

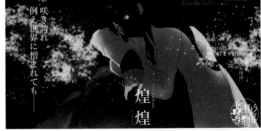

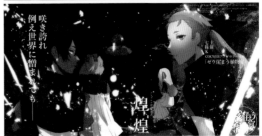

▲書籍版 - 表紙・裏表紙

▲書籍版 - シナリオ中面

▶『返照する銀河』トレーラー

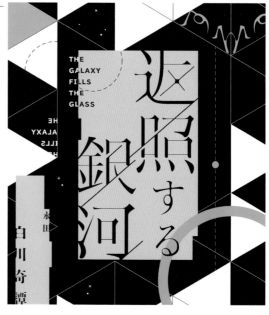

✦ SCENARIO ✦　📜 クトゥルフ神話TRPG

TITLE ▶━━ 『サイモン・スタンホープの研究』

シナリオ：永田和希（白川奇譚）／ 表紙デザイン：永田和希（白川奇譚）／ 本文デザイン：近々（白川奇譚）／ イラスト：あかねこ（白川奇譚）

目が覚めると無機質な部屋に拘束されていた。ここはどこか？自分の身に何があったのか？「たった1人で謎の研究所を探索する」というテーマの1人用シナリオ。何が起きているのか、どこから何者に見られているのかわからない不安。容赦のない展開や正体不明の何かと対峙しなければならないことを、グリッチや曲線によるSF的要素と不気味なホラーが同居したような表現で、「歪で怖い」と感じさせるデザインに仕立てている。シナリオ内では施設内に設置されたカメラやモニターが多く登場するため、グリッチのほか繰り返されるイラストやタイトルロゴを取り入れて、故障したディスプレイを表現している。書籍版には同じくカルトを題材にしたシナリオ『返照する銀河』、2つのシナリオに共通する登場人物、世界観のまとめも収録されている。

TITLE ➡ 『骸に花』

シナリオ：近々(白川奇譚) / 素材(タイトルロゴ、イラスト、コンセプト)：近々(白川奇譚) / デザイン(再構成、色彩等)：永田和希(白川奇譚)

窓から見える枝垂桜が不気味なほどに美しいシェアハウスに引っ越してきた探索者たち。これから和気あいあいと新生活を楽しむはずが、この家は、なにかおかしい——。トレーラーは「骨」「嵐」「窓から見える枝垂桜」をコンセプトに作成し、ロゴは「骨」をモチーフに、「嵐」として花札の柳にインスピレーションを受けた雷の形などを取り入れている。徐々に明かされるシェアハウスの歴史を感じられるよう、トレーラーの配色は日本画風のグラデーションを用い和風感を持たせ、資料には色褪せた古い文庫本のイメージをまとわせている。

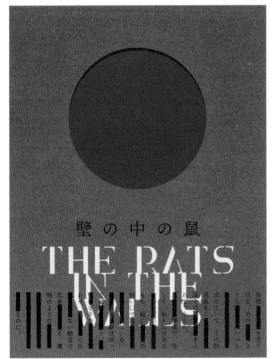

▲トレーラー

TITLE ➡ 『壁の中の鼠』

シナリオ：近々(白川奇譚) / デザイン：近々(白川奇譚)

ラヴクラフト全集1巻『壁のなかの鼠』を元にしたシティシナリオ。富豪からの調査依頼、歴史のある館の調査、地元住民の間で伝わる噂、情報を集めて謎を解くといったクラシックで王道な探索が楽しめる。コンセプトは「穴」「海外のペーパーバック小説」「2色刷りのようなイメージ」で、トレーラーはラヴクラフトの独特な世界観、怪奇小説の雰囲気を出すため主張の強い赤と青の2色で構成している。大きく余白をとった円は赤と青の境界でハレーションを起こし、ぽっかりと浮かぶ不気味で奇妙な穴として不安な気持ちを想起させる。原作が小説であるので書籍の表紙のように見せるため、ノイズやグラデーションで面に落ちる影を表現している。下部の文章は一部を伏せ、虫食いされた「穴」のような表現になっている。

▲書籍版 – 表紙・裏表紙

▲書籍版 – シナリオ中面

▶トレーラー

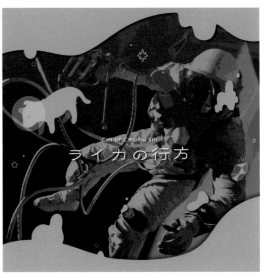

✦ SCENARIO ✦ クトゥルフ神話TRPG ✦━━━✦

TITLE ➡ 『ライカの行方』

シナリオ:ちぉの / NPCイラスト：lili / デザイン：ちぉの

あなたは宇宙飛行士になることを夢見る学生だ。ある日知り合いの天文学者から「不思議な輝きを放つ隕石を発見した」という連絡があなたの元へと届く──。ロゴはふにゃりと潰れた不安定な作字がなされ、キャラクターである学生の幼さ、可愛らしさを表現している。メインビジュアルはモノクロの写真とイメージカラーの黄色で構成され、宇宙飛行士が漂う様子は、宇宙空間であり水中にも見えるようにデザインされている。黄色の柔らかさがポップさを、まるで溺れているような浮遊感がじっとりと何かがゆっくりにじり寄ってくる嫌な感じの恐怖、不安感といったクトゥルフ神話のダークな側面を表現している。

▲データ版 - シナリオ表紙

▲ココフォリアルーム素材

▲トレーラー

✦ SCENARIO ✦ クトゥルフ神話TRPG

TITLE ➡ 『2カンデラの葬送』 シナリオ:ぢおの / NPCイラスト：lili / デザイン：ぢおの

冬が始まる前の海辺の灯台。最後の灯台守はたった1人で灯台を、海を、火を守り続けている。朝日が深い霧に溶けはじめる朝の5時、「匿ってほしい」。裸足の訪問者はそう言った——。シナリオの舞台である、静かで暗い、闇の広がる冬の海の静けさと、物悲しさを表現するために、全体的にコントラストの低いデザインとなっている。ロゴデザインも使用色に合わせてシックで落ち着いた印象の作字がなされ、タイトルの「2カンデラ」に合わせて、文字の線の一部が二重になっている。

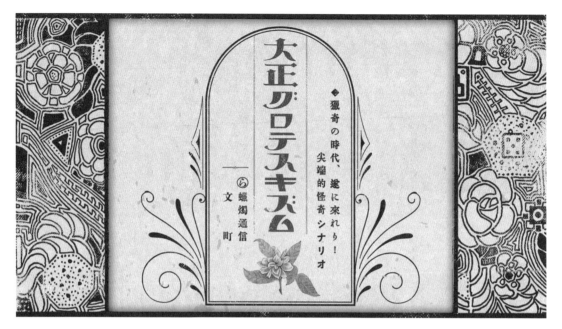

▲トレーラー

TITLE ➡ 『大正グロテスキズム』

シナリオ：文町（らふそく通信）／ デザイン：竹田ユウヤ（K.K.69）

大正十三年九月。大震の傷跡も癒えきらぬ帝都東京で、それでも
人々はたくましく暮らしていた。ある日、精神科医と小説家の二人
は、朝刊に掲載された尋ね人広告に見覚えのある名前を発見す
る——。関東大震災後の時代の熱や、日々を生きる市井の人々の
匂いや体温などを生々しく表現するため、大正時代をイメージした
広告等で頻繁に用いられる、華やかで記号的ないわゆる「大正浪
漫っぽい」フォントや装飾をなるべく使わずに、当時の印刷物の慣
例や定番を収集して再現されている。全体の彩度とコントラストが
抑えめなので、SNSなどの小さなサムネイルでも目を引くように、4
枚目は他のトレーラーとルールを変えたデザインになっている。

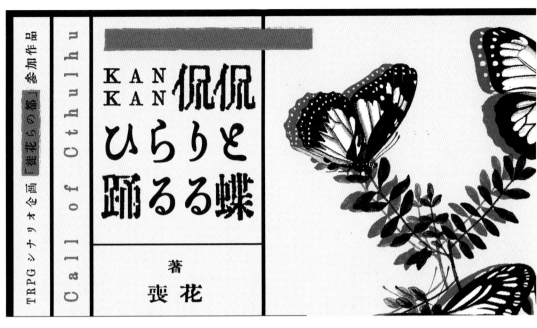

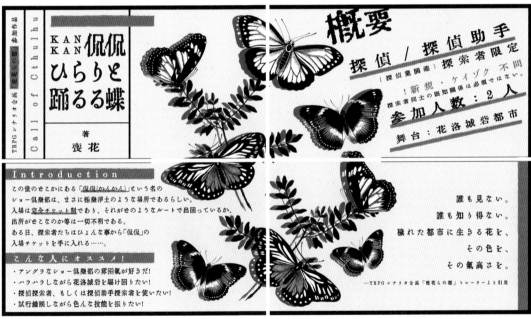

▲トレーラー

TITLE ➡ 『侃侃ひらりと踊るる蝶』

シナリオ：喪花 / デザイン：喪花

この世のどこかに、美しい踊り子たちの最高のショーと美味い酒を楽しめる、極楽浄土のようなショー倶楽部があるらしい。ある日、ひょんな事からの入手困難な入場チケットを手に入れた探索者たちは、怪しくも魅惑的な「侃侃」へ足を踏み入れる──。トレーラーはTwitterでの告知を前提に4枚組で構成されている。朱色、黒、黄味の強い象牙色を主に使用し、数種類の蝶々とざらつきを感じるデザインが、探索者たちが訪れる違法建築都市の無秩序を表現している。

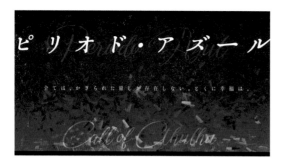

▲トレーラー

▲シナリオ表紙

▲ココフォリアルーム素材

✦→ SCENARIO ✦　クトゥルフ神話TRPG ✦

TITLE ➡ 『ピリオド・アズール』

シナリオ：ともん(待機™) / デザイン：ともん(待機™)

あなたたちは美術館で働く学芸員だ。通常業務に加え、閉館後の夜の美術館で見回りを行っている。逃げ出した作品がある？それはいけない！二人で捕まえなければ──。トレーラーは「夜の美術館」をメインテーマに、タイトルと関連付けて濃い青の油彩風の背景に。パッと見た時にも拡大せずに情報や雰囲気がわかるように、シンプルなロゴデザインと読み飛ばされにくい情報量に絞っている。

▲トレーラー

◆ SCENARIO ◆ 🎲 クトゥルフ神話TRPG ◆ ─────────────────────────

TITLE ➡ 『レプリカントの葬列』

シナリオ：〇助（多箱屋商会）/ トレーラー、ロゴ、ページデザイン：〇助（多箱屋商会）/ イラスト：みくろ / 音楽：Track by 5atsuki、Word by すぎうらきり
と

あなたたちは2人組の怪盗だ。親しき中にも礼儀あり。君たちが定めたたった一つの約束事。それは「過去の詮索をしないこと」である
──。絵画専門の怪盗と贋作師の物語で、トレーラーはシナリオ序盤のポップさやコメディ要素を表現するためメインカラーを黄色に。一
方でクトゥルフ神話のホラー要素を表現するため、「美しいけどどこか怖い」といった美術作品を見た時に感じる恐れ、無機質でどこまでも
白い壁が続いてゆく物悲しい美術館のイメージも付加され全体が構成されている。シナリオをイメージしたテーマソングも付属している。

遊び手が生み出すデザイン

TRPGのデザインは、遊ぶ側のデザイン抜きには語れなくなってきている。立ち絵と呼ばれるキャラクターグラフィックを持ち寄るPL、部屋と呼ばれるセッションルームの構築に凝るGM（KP）が爆発的に増えた。物語をビジュアルで補強する手段が浸透したことで、遊び手が作り手になるという、TRPGの特殊な発展性がデザインにおいても加速している。

✦ 洗練されていく立ち絵とセッションルーム

立ち絵はセッションルームに配置されるのが基本だ。ルールブックにもキャラクターがイラストで例示されることがままあるが、実際のPLが立ち絵を用意することで、物語や各シーンを視覚的に想像し、各キャラクターを動かしやすくなるだろう。特にCoCなど、シナリオ外でもキャラクターを継続し育てることを楽しむ層にとって、視覚的な設定はとても重要になる。

選択肢としては自分で描く／イラストが得意な方に依頼するほか、簡易的にイラストパーツを組み合わせる画像メーカーや立ち絵素材を利用して好みのキャラクターを持ち寄ることも可能だ。気合いの入ったPLは、小物や衣装のバリエーション、表情差分（コアな方は戦闘差分や発狂差分など）を用意して臨む。

セッションルームはココフォリアなどのセッションツール上に構築される。シナリオのイメージに合う空間に仕立て、シーンによって切り替えたり動かしたり、BGMやSEを流したりといった演出を加え、没入体験を高めることができる。素材を利用してデザインされることが多いが、背景からタイトルに至るまですべて手描きする強者なども現れている。

一方で、シナリオに同梱される公式ルーム素材も充実してきており、シナリオを問わない汎用ルーム素材の頒布も増え、zipファイルのドラッグひとつで部屋の立ち上げが叶う例も少なくない。

紙とペンとダイスが揃えばプレイできるTRPGにおいて、立ち絵やセッションルームはおまけ要素に過ぎない。しかし今回紹介するのは、特異なクオリティと熱意でデザインを楽しむ遊び手＝作り手たちである。

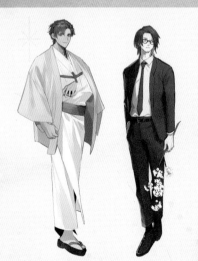

CoCシナリオ『蛇の恋』（トロ川・作）のためにKPゆっ子氏とPLツネヨシ氏が用意した立ち絵。

シナリオ『蛇の恋』（トロ川・作）のためにKPゆっ子氏が用意したセッションルーム。

KPCとPCの立ち絵が配置されたセッションルーム。

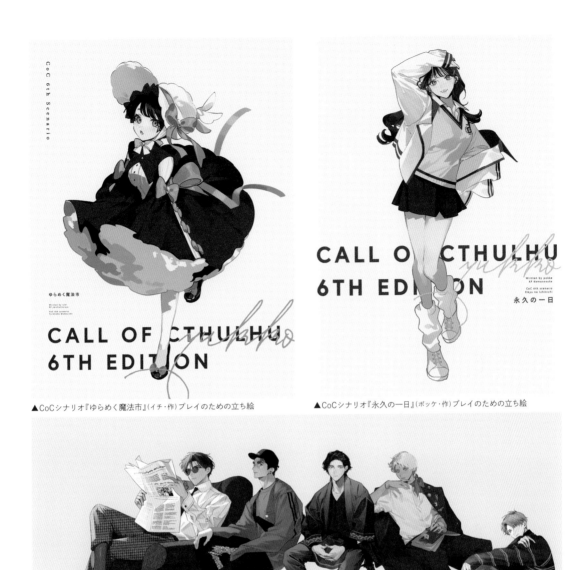

▲CoCシナリオ『ゆらめく魔法市』(イチ・作)プレイのための立ち絵

▲CoCシナリオ『永久の一日』(ポッケ・作)プレイのための立ち絵

火海　　　　　　　喜月のN　　　　　　　２カンデラの葬送　　　　　墓穴に納まる　　　　　夜半の口寄せ

▲各種立ち絵の集合

探索者イラストだけでなく、プレイするシナリオのロゴやセッションルームのデザインまで楽しんでいる、ゆっ子さんの美麗な作品。

105

▲CoCシナリオ『異説・狂人日記』(文町・作) プレイのための立ち絵

▲CoCシナリオ『NOBODY*2』(サシキ・作) プレイのための立ち絵

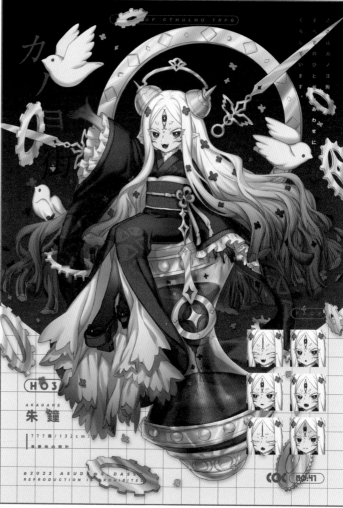

▲CoCシナリオ『カノヨ街』(七篠K・作) プレイのための立ち絵

▲各種立ち絵の集合

❖ ILLISTRATION ❖

シナリオやHOに合わせて、小物や表情差分など見れば見るほど楽しい探索者を描くasudaさんの作品。

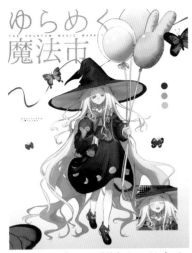

▲CoCシナリオ『ゆらめく魔法市』(イチ・作) プレイのための立ち絵

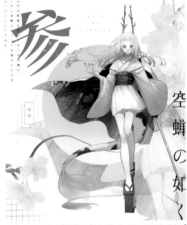

▲CoCシナリオ『空蝉の如く』(トドノツマリ海峡・作) プレイのための立ち絵

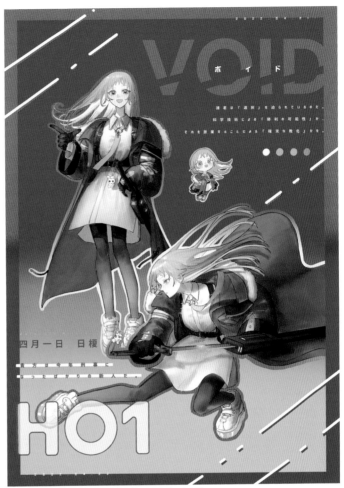

▲CoCシナリオ『VOID』(みゃお・作) プレイのための立ち絵

▲各種立ち絵の集合

軽やかな線が特徴的な空色の空さんの作品。3Dモデルや動く神話生物などのセッション用素材や、自作のシナリオも公開している。

▲CoCシナリオ『星が並ぶ時』（もそ・作）プレイのための立ち絵

▲CoCシナリオ『聖ベルナデッタの公演』（さとう鍋・作）プレイのための立ち絵

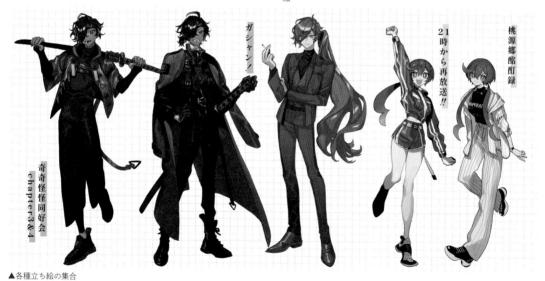

▲各種立ち絵の集合

ファッショナブルでカラーのある探索者が印象的なダニさんの作品。ねこずし卓配信用の立ち絵やルーム素材のデザインにも携わっている。

生きるとは、抗うということ。
白銀の床を踏みしめ、歩くということ。
手を取り合い、共に和を尽くということ。

▲CoCシナリオ『極夜行』(鳩の雑貨屋・作)プレイのための立ち絵

▲オリジナルの探索者「星一太」キャラクターデザイン

▲CoCシナリオ『ライカの行方』(右折代行屋・作)KPのための立ち絵

▲CoCシナリオ『ライカの行方』(右折代行屋・作)KPのためのイメージカット

絵描きの子清さんが描く探索者たち。卓抜な男性キャラクターの描き分け、創作の民族衣装のデザインは見応えたっぷりだ。

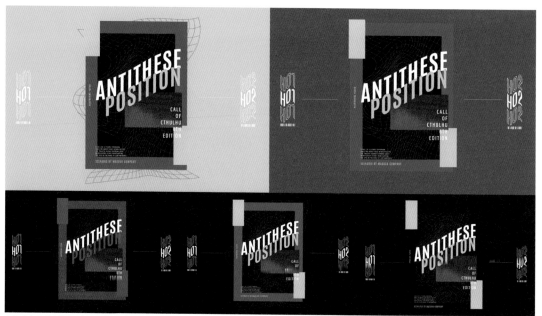

▲CoCシナリオ『アンチテーゼ・ポジション』(まお子・作)KPのためのココフォリアルーム

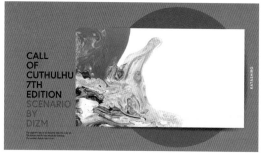

▲CoCシナリオ『カタシロ』(ディズム・作)KPのためのココフォリアルーム

▲CoCシナリオ『死さえも二人を分かたない』(popo・作)KPのためのココフォリアルーム

✦ SESSION ROOM ✦

立ち絵も提供してくれたゆっ子さんによる、セッションルームのデザイン。シナリオをリスペクトしながら独自のデザインに落とし込んでいる。

▲CoCシナリオプレイ用ココフォリアルーム素材 vol.2

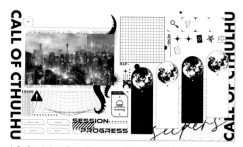

▲CoCシナリオプレイ用ココフォリアルーム素材 vol.1

✦ SESSION ROOM ✦

シナリオによらず素敵なセッションを実現するための、汎用素材を頒布しているrrrrさんの作品。カラーバリエーションも豊富。

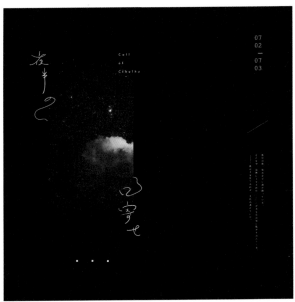

▲CoCシナリオ『夜半の口寄せ』(トロ川・作)KPのためのココフォリアルーム

▲CoCシナリオ『灰になってよかった』(凡人・作)KPのためのココフォリアルーム

手描きのタイトルロゴや作字、タイポグラフィーに挑戦しているはちむぎさんの作品。縦横比を固定しないルームデザインも魅力だ。

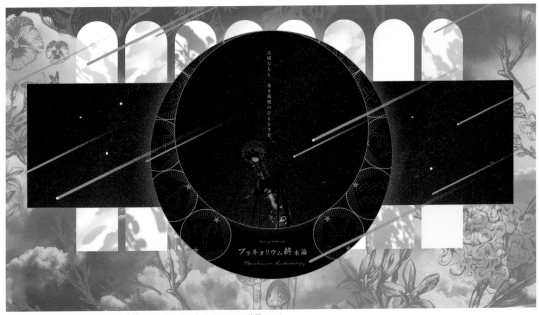

▲CoCシナリオ『プラネタリウム終末論』(凡人・作)KPのためのココフォリアルーム

装飾的で美しいセッションルームをデザインする、ぬさんの作品。素材の使い所を極め、光と影で包み込むようデザインされている。

国内のTRPG

クトゥルフ神話TRPGの人気が独特の趣を与えている日本のTRPGシーンだが、日本のTRPGデザイナーも次々と独自の世界観やシステムを持つ作品を生み出し、日本のカルチャーを反映することで、親しみやすい多様なゲーム体験を提供している。今回は、新たにTRPGをデザインするにあたって参照したい、挑戦的な作品を紹介する。

✦ TRPGの新しい景色

　日本独自のTRPGの歴史は、1980年代から始まる。海外の作品が邦訳されたことでTRPCが人気を集め始め、国内のゲームデザイナーやクリエイターたちが独自のTRPGを開発するようになった。1989年に日本初のオリジナルファンタジーTRPGとして『ソード・ワールド』が発売されたのを幕開けに、さまざまな国産TRPGが誕生する。

　1990年代に入るとジャンルやシステムが多様化し、1993年に発売された『トーキョーN◎VA』は、サイバーパンクの世界観に日本ならではのアイデアを盛り込んだ作品として注目を浴びた。1990年代後半にはブーム自体に陰りが見えたが、2000年代に入ると、インターネットの普及によってTRPGの情報が容易に入手できるようになり、『アリアンロッドRPG』や『ダブルクロス』、『シノビガミ』、続く2010年代には『マギカロギア』や『インセイン』など、ここに挙げ切れない多くの人気作が誕生した。2020年代にかけては、動画の広まりとセッションツールの整備により、新たなプレイヤー層を獲得した。

　国産TRPGは、設定やシナリオの物語性が高く評価され、緻密なストーリー展開やキャラクター間の関係性、成長や感情の機微を重視する作品が多く、システムもそれを助けるよう練られている。また、アニメやマンガの影響を受けた美麗なイラストや魅力的なキャラクターデザインが採用され、作品の個性を印象づけるとともに、ゲーム世界への没入感を高めている。

　リプレイや配信など、プレイするだけでない、読む/観る楽しみが、TRPGシーンの相乗的な活性化に繋がっていることも見逃せない。定期的に開催されるイベントやコンベンションでは作り手と遊び手が一堂に会してゲームを楽しむことができ、オンライン上でのイベント、フォーラム、グループ等も活発に運営されている。ここ数年で驚くべき発展を遂げたオンラインセッションだが、コロナ禍が明け、オフラインならではの体験が練られることによって、さらに多様化し新しい景色を見せてくれるはずだ。

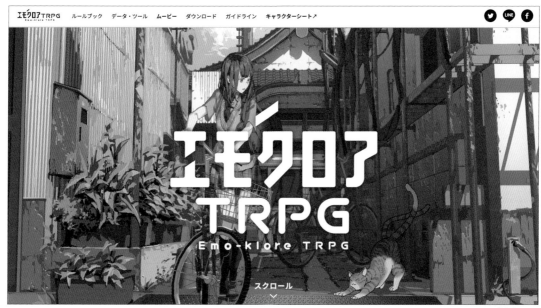

▲トップビジュアル

◀イントロダクション

✦ RULEBOOK ✦

TITLE ➡ 『エモクロアTRPG』

企画・制作：ダイスタス・チーム ／ システム原案：まだら牛 ／ テーマビジュアル：平の字 ／ ロゴデザイン：木緒なち ／ Webサイトデザイン：da-ya

私たちの暮らす現代日本とよく似たもうひとつの世界。ここには超常の存在……《怪異》たちが人々の傍らに確かに存在する。近づいた人の感情を変異させるその特異な性質から、「エモクロア」（エモーショナル＋フォークロア）……とも呼ばれている──。PLは影響を受けやすい共鳴感情を3つ設定した「共鳴者」を作成し、《怪異》と対峙し物語を紡いでいく。本作は、ルールブックやキャラクターシート、特殊カードといったセッションのための各種サポート＋ツール、二次創作のためのクリアなライセンスガイドラインを備え、Web上の共有資源として提供されている。注釈など初心者にも易しい特徴的なUIで、既存のルールブックとは一線を画す新たなオンライン体験を切り拓いた。

▲ルールブック

▲表紙

▲巻頭ビジュアル‐イントロダクション

▲巻頭ビジュアル‐キャラクター

❖ RULEBOOK ❖

TITLE ➡ 『ケダモノオペラ』

ゲームデザイン：池禄リョーマ / メインアート：ながべ / ロゴ・装丁：團夢見(imagejack) / 編集：山口胡桃(株式会社アークライト)

暗黒童話ナラティブTRPG『ケダモノオペラ』。闇の森に棲息する人喰いの怪物と人間が出会ったとき、生まれる悲喜劇や如何に——。本作は、PLが思い思いの「善悪を超えた」「超常的な力をもつ」ケダモノとして振る舞い、倫理や常識に囚われない自由な物語展開を提案ができるのが特徴だ。巻頭にはケダモノとケダモノが人間に擬態した疑似餌とよばれる姿が並び、人智が及ばない絢爛な世界観を伝えている。情報ページは、読者が文字を読まずとも視覚的に構成を記憶・判別できるよう、中見出しの位置とフォントサイズをフレキシブルにして各ページに表情がつけられた。また、圧迫感をなるべく与えないよう、情報の境界を示す際に枠線で四方を囲わない方針がとられている。セッションにとどまらない物語／イラストの創作も推奨されており、ゲームシステムを超えておとぎ世界の事典のようにまとめられている。

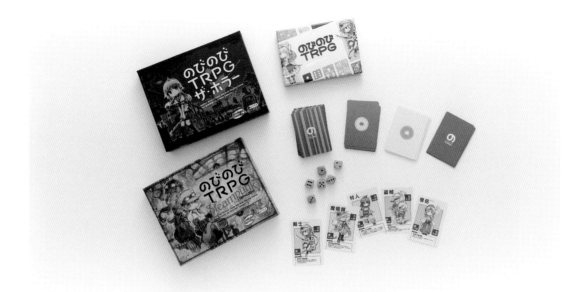

▲『のびのびTRPG オリジナル』-パッケージの内容物、『のびのびTRPG ザ・ホラー』『のびのびTRPG スチームパンク』

▲『のびのびTRPG オリジナル』- キャラクターカード

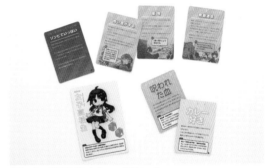

▲『のびのびTRPG ザ・ホラー』- 各種カード

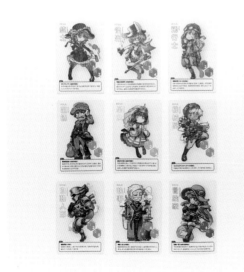

▲『のびのびTRPG スチームパンク』- キャラクターカード（片面）

╂ TABLETOP GAME ╂

TITLE ➡ 『のびのびTRPG　オリジナル』

ゲームデザイン：今野隼史 / イラスト・デザイン：今野隼史

TITLE ➡ 『のびのびTRPG　ザ・ホラー』
　　　　『のびのびTRPG　スチームパンク』

© 2018 FRONTIER PUB / Arclight, Inc.

ゲームデザイン：今野隼史(辺境紳士社交場) / イラスト：今野隼史(辺境紳士社交場) / グラフィックデザイン：TANSAN / 編集：刈谷圭司、田中秋帆

偉大なる初心者に捧げる、簡易にして究極のTRPG──。会話とダイスで物語を紡ぐ深遠なるゲーム〈TRPG〉を、予習も事前知識も必要のない、コンパクトなカードゲームに落とし込んだ意欲作。従来のTRPGで多く見られた、原色・ヒロイック・ごつごつした雰囲気を避けて、誰でも気軽に楽しく遊べそうな、可愛らしく、手に取ってわくわくできる外観にまとめられた。個人制作された『のびのびTRPG オリジナル』の好評を受けて、商業（アークライト）版『のびのびTRPG ザ・ホラー』『のびのびTRPG スチームパンク』『のびのびTRPG ソード／マジック』が発売された。

▲裏表紙・表紙

▲中面

TITLE ➡ 『信長の黒い城』

ゲームデザイン：朱鷺田祐介 / アートディレクター：加藤数磨

この世界は本能寺の変が起こらず、信長がすべてを炎に包んで焼き尽くし、滅ぶことが確定している。PLはその未来を覆し、本能寺の変を起こして信長を倒すため戦国の世を駆け巡る──。織田信長が本能寺で死なず、真の天魔となった闇の戦国時代を舞台にした、戦国ドゥーム・メタル・ファンタジーTRPG。本作はスウェーデンで生まれたTRPG『Mörk Borg』（p.128）のサードパーティライセンスに基づき、同システムのルールを拡張して作られた。『Mörk Borg』で衝撃を受けた常識を打ち破るレイアウトをリスペクトし、過激でアートピースのようなデザインに仕上がっている。

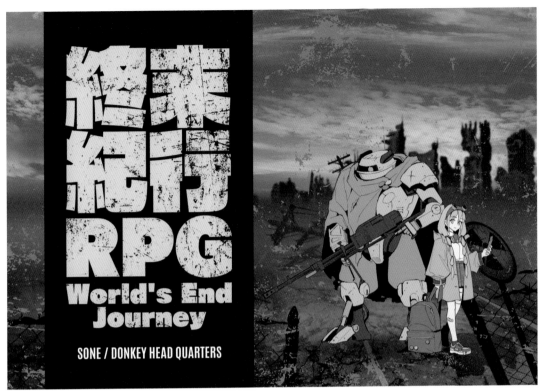

終末紀行RPG
World's End Journey

SONE / DONKEY HEAD QUARTERS

▲カバービジュアル

CONTENTS

終末紀行RPG
World's End Journey

人間とロボット
ふたりで旅した
終末後の世界

▲ルールブック

2-6：旅人のロールプレイ

『終末紀行』はテーブルトーク・ロールプレイング・ゲーム（TRPG）だ。卓上（テーブル）で会話（トーク）し、ことごと（ロールプレイ）とは何か？ さまざまな役割があるが、『終末紀行』においては「その旅人の物語を演じること」といっていい。それはつまり、プレイヤーが「現在演じられている状況に対し、旅中の旅人がどう思い、何を考えて、行動するか」を描くことで、やりかけは様々だ。

問題する

プレイヤーが自分で、旅人の感情やふるまいを自由に描写する。「自分の旅人はこう思ったので、このように行動する」のように、直接的には「これが「ロールプレイ」の一番と内容だ。

「セリフを言う」

旅人の主観的なプレイヤーがそのまま演技する。旅情演技のようなうなりがあり、現象を演じるプレイヤーとして、旅人という役を演じるのは…

「演出する」

旅人をとりまく周辺の環境や情景の描写も「ロールプレイ」の一種として利用できる。たとえば「旅人が降り立った写真は荒涼としており、すでに建物も、産も荒れ、旅人の姿を覆ってしまうほど…

実際のゲームにおいては、これらは複雑さわれる、特定の状況で「ロールプレイ」することで、旅人は利益を得ることも、ただ、それ以外の環境

でも、機械同士に付き合ってもらい、たい。それは『終末紀行』の特徴の世界だ。より優れ得たものだが、ゲームの世界でも「無敵キのことに大いに実現するために…

2-7：旅の終わり

『終末紀行』は、「ふたりの旅」を扱うゲームだ。旅人のロールプレイを、周囲の環境とのロールプレイで表現する。周りの群と行方のないふたりになっても遅けて…

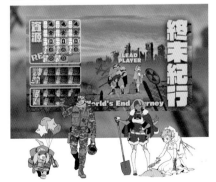

▲ココフォリアルームと立ち絵

TITLE ➡ 『終末紀行RPG World's End Journey』

ゲームデザイン：SONE（DONKEY HEAD QUARTERS）/ 旅人イラスト：ほいみん

人類滅亡後の終末世界を舞台に、冷凍睡眠から目覚めた「人間」と、その機械の相棒「ロボット」のペアが、身を寄せ合ってあてもなく旅をするTRPG。枯渇する資源。過酷な環境。荒廃した世界にはびこる凶暴なミュータントや殺戮ドローン。苦難の旅路と、絶望的な孤独の中で育まれる、ささやかな絆の物語——。極太でポップなタイトルロゴと、どこか淡々とした可愛らしい旅人イラストが、サバイバルでありつつもハードすぎない雰囲気を醸し出している。オンラインセッションルーム（ココフォリア）上で動かすことを前提にシステムが練られ、付属のセッションルームはそのまま配信に載せられるようデザインされた。

1. 備わるもの
2. 持つもの
3. 考えるもの
4. 支えるもの
5. 創るもの
6. つとめるもの
7. 整えるもの
8. 求むもの
9. 探すもの
10. 果たすもの
11. 変えるもの
12. 眠るもの

AI ASK You / Question sheet 01
Game designed by Akasi.

▲ココフォリアルーム

AI ASK You

Solo Journaling Game
"あなた"と対話するTRPG / 1人用

▲メインビジュアル

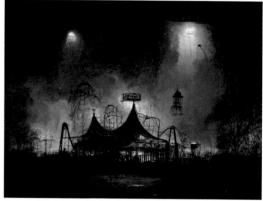

▲マップ

◀カード

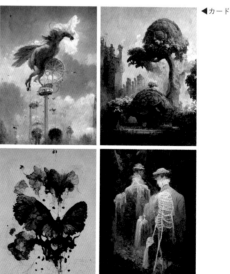

✦ RULEBOOK ✦

TITLE ➺ 『AI ASK You』

シナリオ：朱石 / アートディレクション・レイアウトデザイン：朱石 / アートデザイン：Midjourney version3（AI作画ツール）

──ようこそ、AIの作った美術館へ。わたしはもっと、人間のことを知りたいのです。あなたのことを、教えてくれませんか？──
「AIとの対話」をテーマに、「絵画を見て、質問を選び、どう思ったかを書く」だけで完結する、シンプルで自由度の高いソロジャーナル。AIにキーワードを与えて絵が出力される様子を見て、「逆にAIが人間に質問をしてきたら、どんな答えを返すかな？」と発想したことからこのシステムが生まれた。ほぼすべての絵画（画像）がAI（Midjourney）によって作成され、ルールブックのテキストも、美術品の展示説明のようで、かつAIの返答のようにどこかそっけない印象が出るよう練られている。メインビジュアルでは、見る者によって表情を変える女神のような石膏像の絵をAIに出力してもらい、AIの理性的なイメージや基本的とされる美、静謐さが出るよう色調やレイアウトが加筆修正された。

118

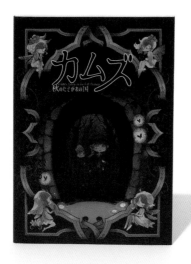

▲『カムズ』『ストーリーズ・アントールド』表紙

▲『カムズ』中面

✦ RULEBOOK ✦

TITLE ➡ 『カムズ　秋のたそがれの国』

著者：てす、るう / イラストレーター：山田2ハル / 編集：らっこやく

「秋の世紀」が訪れ、妖精や怪物、魔法や幻想の存在が人々の前に現れるようになった世界を舞台とした、プレイヤー2人用のダーク・ファンタジー＆メルヘンTRPG。表紙は、バディ感を醸すため、人ならざる世界に迷い込む「ヘンゼルとグレーテルのような」兄妹を据え、「可愛いけど、クラシカルで、少し不気味」を意識して古典美術のデザイン・色味を参照して描かれた。

✦ SUPPLEMENT BOOK ✦

TITLE ➡ 『ストーリーズ・アントールド』

著者：てす / イラストレーター：山田2ハル / タイトルロゴデザイン：デザうち

『カムズ』のシナリオアンソロジーを軸に構成されたサプリメント・ブック。『カムズ』と地続きの少し進んだ時代の設定で、くすんだ彩色写真のようなカラーテイストが効いている。

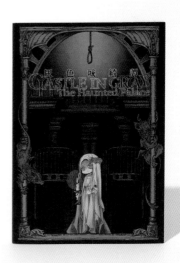

▲『灰色城綺譚』表紙

✦ RULEBOOK ✦

TITLE ➡ 『灰色城綺譚』

著者：てす / イラストレーター：山田2ハル / 編集：らっこやく

「灰色城」と呼ばれる、呪われた、悪意持つ城館を舞台に、ゴシックファンタジー＆ホラーの悲劇をテーマとしたプレイヤー3人用のTRPG。〈囁き〉と呼ばれる秘匿ハンドアウトを手に、想いと呪いの狭間でPLの三角関係はもつれていき、多くの場合は悲劇的な結末、あるいはメリーバッドエンドと呼ばれるほろ苦い結末を迎える。表紙には、「不気味な城の広間からこちらを誘う幽霊の女」が描かれ、不敵な笑みを浮かべている。

かりかりうめ

退廃的でダークな童話のような世界観のオリジナルTRPGを果敢に生み出しているサークル、かりかりうめさん。ナラティブに練られたシステムとそれを盛り上げるゴシックで愛らしいイラスト、読みやすいエディトリアル、貫かれたトーン＆マナー、ひと目見れば遊べる気がする特設サイトに至るまで、秀逸な設計の背景にある思想を紐解いてもらった。

■ オリジナルのTRPGの制作を始めた動機やきっかけについて教えてください。

てす（メインゲームデザイナー）：2016年の冬コミで、らっこやくと話していて、作ることになりました。かりかりうめは元々、商業TRPGのリプレイやシナリオ集の同人誌を作っていたサークルです。同年の夏コミックマーケットで六畳間幻想空間さんの『歯車の塔の探空士』が発表されていて、それに感銘を受けていたので、自分たちでも何か作ってみないか、というのがらっこやくの提案でした。それを聞いた僕は「山田2ハル（メインイラストレーター）がイラストを描いてくれるならいいよ」と答えたのですが、すると彼はその場で電話をかけて確認をとって、山田2ハルが「いいよ」と言ってくれたので作ることになりました。3分くらいの出来事でした。

らっこやく（サークル代表）：実のところ、かりかりうめのメンバーでオリジナルの作品にチャレンジしたいという考えは2015年頃から持っていました。弊サークルのそれまでの同人誌でもすでに、独特の雰囲気を気に入ってくださる読者さんがいましたので、この強みをさらに活かすにはやはりオリジナルだろう、と。あとは、てすが言ったように『歯車の塔の探空士』の登場と実際に遊んでみた時に受けた衝撃が、一歩を踏み出すきっかけになりました。

■ サークルのメンバーは固定ですか？ 役割分担などがあれば教えてください。

らっこやく：現在は基本的に4人の固定メンバーで活動しています。メインゲームデザイナーのてす、イラストレーターの山田2ハル、広報とライティングのgobuの3人と、私らっこやくがDTPと各種雑務といった感じです。その他には、『カムズ』でシナリオと世界設定の一部のライティングを担当したるう、『ストーリーズ・アントールド』以降タイトルロゴのデザインをしているデザうちさん、装飾イラストパー

ツデザインの春芽萌太郎さんなど、毎作品、いろいろな方にお手伝いいただいています。

■ 紹介させていただいた作品たちは、どこか不気味な陰鬱さをまといつつ、おとぎ話のような世界観が特徴です。制作のインスピレーションとなったものはありますか？

てす：『カムズ』は、明確にレイ・ブラッドベリの影響を受けています。『塵よりよみがえり』と『何かが道をやってくる』が特に色濃いと思います。

『塵よりよみがえり』には、不思議な能力や魔力を持つ「一族」が集まる館が出てくるのですが、そんな館を避難所にしていた者たちが、再び人間の世界に現れたら、というのが『カムズ』、秋のたそがれの国の世界観の中核を作っています。『何かが道をやってくる』は2人の少年が主人公で、まさにそういう者との出会いに直面するお話なので、これもはっきり影響が見てとれると思います。また、『何かが道をやってくる』の原題の「Something Wicked This Way Comes」が作品タイトルに引用されています。その他、アーサー・マッケンの『白魔』や、J・S・レ・ファニュやテオフィル・ゴーティエなどの幻想小説がイメージのもとになっています。

『灰色城綺譚』については、エドガー・アラン・ポーの『アッシャー家の崩壊』を外して語ることはできません。サブタイの「The Haunted Palace」は、作中で披露される詩の題名からとっています。陰鬱なアッシャー家の屋敷を読者の脳裏に積み上げ、まざまざと描き出してから、それを最後には跡形も残さず消し去るカタルシス、そして『アッシャー家の崩壊』というタイトルを提示した時点で読者との間に交わされる共犯関係……そういったものが、ハンドアウトやタイムリミットの明確なシステムに反映されています。さらに、ゴシックのイメージや呪われた城館というテーマ

POINT

オムニバスの美しい表紙。作中ゲームの絵画を見る、別の作中ゲームの人物が描かれており、装飾枠に生と死のモチーフが、タイトルロゴに各話のモチーフが組み込まれている。

check

『モノローグ・ダイアログ』は1人用のソロ・ジャーナリングRPGを2編、2人用の対話型RPGを2編収録した、掌編集。どれもどこか陰鬱な雰囲気を持ったメランコリック・ファンタジーの世界を舞台にしている。

を固めるために、ホレス・ウォルポールの『オトランド城奇譚』、ジャン・レーの『マルペルチュイ』、シャーリィ・ジャクスンの『丘の屋敷』『ずっとお城で暮らしてる』、スティーヴン・キングの『シャイニング』などを参考にしました。

古典的な海外小説、幻想・怪奇譚が好きなたちなので、各作品にもそれらの要素が取り込まれています。かりかりうめ作品の世界観に独自性があるとするなら、他のTRPGで参考にされがちな、マンガやアニメ、ラノベ、ゲームなどの流行ものをそれほど重視していないから、ということがいえると思います。ただし、それらが嫌いなわけではないですし、個人的なバイブルのひとつである、きゆづきさとこの漫画『棺担ぎのクロ。～懐中旅話～』(芳文社)は、『カムズ』にも『灰色城綺譚』にも影響を及ぼしています。

一貫したイラストレーションや、カードやマーカーなど各種ツールのデザインも魅力です。イラストの制作は、どのタイミングからどのように始まるのでしょうか。

てす：経緯でも触れましたが、最初から、山田2ハルのイラストありきで企画が走り出しています。それについては、心底恵まれていると思います。世界観を作る際にも、ラフイメージを提出してくれていて、かなり早い段階からやり取りをして方向性を共有しています。具体的なカードやマーカーについても、ゲームのシステムをデザインする段階から、「こういうものを作ってもらうことは可能か」と打ち合わせをしています。難しければ代替案を考えたり、外部のデザイナーを頼ったりします。

灰色城綺譚もカムズも、オフラインセッション用の印刷物やオンラインセッション用のマップシート類などサポートが充実していて、それぞれの特設サイトを見れば、システムや世界観が端的にわかるように表現されています。こうしたサイトにおける情報提示の形式や素材のまとめ方は何かを参考にされましたか？

gobu（広報・ライティング）：紹介用の特設サイトは『カムズ』と『灰色城綺譚』どちらも私が作りました。私は今でもコードの書き方もわからないくらいの素人ですが、STUDIO（https://studio.design/ja/）というサービスを活用して構築しています。コンセプトを「作品の紹介や導入として使えるサイト」と置きつつ、複雑にならないよう、1ページに収まるシンプルなデザインを目指しました。

ページの構成に関してはコンセプトが似たタイプのサイトを何個か見て回り、それらを参考にしながら決めていきました。最も参考にしたのは、実は恋愛アドベンチャーなどのノベルゲームのサイトです。ノベルゲームはゲームシステムの紹介がほとんど必要ないものが多く、全体としてシンプルな作りでできている一方で、作品の世界設定やアピールポイントなどユーザーが気になる部分を端的に伝えられるようになっています。TRPGには細かいルールがありますが、今回制作したサイトは作品の雰囲気を伝えることを目的としていましたので、参考にするには丁度良かったですね。

また、私の肌感ではありますが、最近のTRPGユーザーさんはゲームのシステム部分よりもストーリーテリング遊び

の要素や、作品の雰囲気を重視する方も多いように思います。そのため、ノベルゲームのサイトを参考にしたのは間違いではなかったのではないかと考えています。

　文字はなるべく減らし簡潔にしたいと考えていましたので、基本情報を除き、各作品の「世界設定と雰囲気」、「特徴的なシステム」の2点に載せる情報を絞ることにしました。

　「世界設定と雰囲気」についての説明的な文章は、両作品ともに冒頭にイントロダクションとして置いただけでそれ以降ではしていません。それは、てすの考える世界はTRPGの中では珍しく、言葉で説明しても伝わりにくいと思ったからです。そこで、山田2ハルのイラスト素材とフレーバーテキストをセットにし「挿絵」のように配置することで具体的・視覚的に作品の雰囲気を理解できるように、また読んでいて飽きないように工夫しました。

　「特徴的なシステム」に関しては、自分がプレイした際に魅力を感じたルール部分に重点を置いて書いています。たとえば、『カムズ』の「伝承と解釈」のルールはとても魅力的ですが、同時に独自性が高いため文章や言葉として説明を受けただけではイメージが湧きにくいです。そこでサイトでは具体例と処理の手順を提示することにしました。実際のセッションではもう少し込み入ったことをしますが「どんなことをするか」がわかりやすくなり、このシステムの魅力を伝えられているのではないか、と考えています。

　サイトで公開している各種ファイルは、オンラインセッションで必要となるであろうものをピックアップしてあります。元々かりかりうめはオンラインセッションで遊ぶのがメインのサークルです。マップシートは実際に遊んだ時に準備したものや、各ツール用に調整したものを公開しています。ただ、ユーザーさんがSNSで発信している様子をみると、皆さんはより使いやすくカスタマイズしたり、凝ったデザインの自作のシートを使ってらっしゃるケースが多いので、公開しているシートも改善する余地はありそうです。

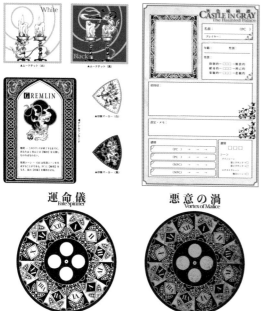

▲『灰色城綺譚』- 特設サイト、各種ツールイラスト

▲『カムズ』- 判定ツールイラスト

◆ オリジナルのTRPGシステムを作る楽しみはどこにあると思いますか？

てす：自分自身の世界を打ち出して、そこに人を招いて遊んでもらえるのはとても楽しいと思いますよ。読んでもらえるだけでなく、セッションをした、自分でシナリオを書いた、カードや小物、オンラインなら部屋のデザインに凝ってみた……そんな反響や、情熱を傾けてもらえるのは、思いがけなく、本当に嬉しいものです。同人ならではのところでは、商業と違って「できるだけ多く売る」ことを目標に掲げる必要がないので、自分の好きなものを突き詰めて作ることができるのは、大きな楽しみだと思います。

らっこやく：これはオリジナルTRPGシステムに限った話ではありませんが、やはり自分たちが面白いと思える作品を作り、それを手に取ってもらえた時に大きな喜びを感じます。それはオフラインイベントであっても、SNSでの購入報告であっても変わりません。自分たちが少なからず命を削って生み出した物に価値を見出してもらえたのだと思うと嬉しいですね。

◆ オリジナルのTRPGシステムを作るハードルはどこにあると思いますか？ これから挑戦する方に向けて、アドバイスがあれば教えてください。

てす：普通はイラストと紙面レイアウトで苦労するのだと思います。僕の場合、そこはやってもらえるので……。現実的な問題として、「内容がよければ手に取ってもらえて、遊んでもらえる」とは楽観視できない状況になっていると思います。同人TRPGといえど、年々クオリティは上がっていく傾向にありますし、発表される作品点数も増えていっています。そんな中で、誰に、どうやって自分の作品を届けるのか、が課題としてついて回るはずです。幸いにして、CoCブームはいまだ冷めやらず、TRPGのユーザーという意味での裾野は以前よりも大きく広がっています。また、そのファン層も決して一枚岩ではありません。

したがって、自分の好きなものを好きなように作ったからといって、同志がそこにまったくいない、ということは考えにくいです（「できるだけ多く売るのが目標」なら話は違いますが）。一貫性のある狙いとデザインを持ち、潜在的にそれを求めている誰かに「見つけてもらう」ことが、オリジナルTRPGを作って頒布するうえでの重要事項です。

らっこやく：私が『カムズ』を企画した2017年当時はまだ「同人誌といえば物理本」という時代でしたので、各人が印刷したときに読みやすいレイアウトへ落とし込まなければならず大変苦労しました（今でも毎回頭を悩ませていますが……）。

しかし、今はデジタルコンテンツとしての配布が当たり前になり、使いやすいイラスト素材が配布されていたりと、本文を彩る方法も無数にありますので、ゲームとしてのワンアイディアさえあれば、作品を作り発信することは容易になっているのではないでしょうか。A4紙1枚でルールが完結するTRPGを作られている方もいらっしゃいますし、工夫次第でハードルの数はいくらでも減らせると思います。

◆ インディーズの国内TRPGで、好きな作品があれば教えてください。

てす：Symbol-House／殻付飛鳥さんの『イフ・イフ・イフ』が大変よかったです。すっきりと見やすい紙面レイアウト、ターゲットが明確かつ広いコンセプトが現代的で、見習うべきところが多かったです。

◆ ありがとうございます。サークルとしてこれから挑戦したいこと、続けていきたいこと、またTRPGの業界がこうなったらいいな／なるだろうなといった展望があれば、ぜひ聞かせてください。

てす：ここ数年はコロナ禍でイベントへも行きづらかったことで足踏みが続いていたのですが、そろそろ本腰を入れて、新作TRPGをお届けしたいと考えています。業界に関していえば、TRPGを取り巻く環境は常に変わり続けています。CoC界隈では人口の多さによって、次々と新しいものが生まれていますし、マーダーミステリーなど、TRPGと隣接したジャンルの動きも活発です。

ユーザーのプレイスタイルも、セッション環境も変化していくなかで、僕が望むのは、とにかく「健やかであってくれ」ということに尽きます。TRPGユーザーが爆発的に増えた結果、今まで以上に、各人のスタイルや求めるものの違いで、価値観のすれ違いは多くなっていくでしょうが、それぞれがそれぞれの場所でTRPGを好きでいられるなら、それに越したことはないと思います。

らっこやく：新作のリリースはもちろんですが、かりかりうめの既存作品も長く楽しめるものになるようにしていきたいです。『カムズ』や『灰色城』のサプリメント（『ストーリーズ・アントールド』『灰色城追想』）はそういった意図もあって企画しました。正直な話、同人作品のサプリメントというのは本当に数が出ません。それでも、私たちが追加のルールとシナリオを提供することで、少しでも遊びの幅を広げることができれば、という想いがあります。

かりかりうめは、マイペースなメンバーで構築されているサークルですので、今後も自分たちが長く続けられるペースで活動していきたいと考えています。

海外のTRPG

近年では海外の独立系TRPG作品にアクセスしやすくなり、私家翻訳されて
遊ばれるだけでなく、正式な邦訳版のリリースが相次いでいる。ここからは、
立役者の一人であるMontro氏に、デザインで注目すべき未邦訳（執筆時点）の
作品をガイドしてもらおう。

Montro

海外のTRPGの日本語版翻訳・出版を行う、株式会社マールストロムの代表取
締役社長。翻訳家としても活動している。また、Twitterを中心に、海外のイン
ディーズTRPGを日本語で紹介する活動を行っている。翻訳物としてはマールス
トロム刊行の『Liminal』のほか、グラフィック社刊行の『ザ・ループTRPG』翻訳
チームに参加、FrogGames刊行の『Kutulu』の翻訳監修、『北方の国家懸案
消えた兵士たち』の翻訳を手がけた。

Profile

多様化するルールブック

　海外のTRPGは多様性に満ちている。文字通り海の向こうでは、英語を共通言語と
して、さまざまな国の文化を背景に持つデザイナーたちが、互いに影響を与え合いなが
ら、毎日のように新たなTRPGを生み出しているのである。近年では、欧米だけでなく、
南米や東南アジアなど、一昔前にはあまり注目されなかったような地域のTRPGデザイ
ナーたちも、優れた作品を世に送り出し始めている。インターネットの普及によって、世
界中の人々が気軽に繋がることができるようになった今日、TRPGのデザインは、言語や
国境の壁を越え、世界中のあらゆるカルチャーと融合しながら、未だに進化し続けてい
るのだ。

　海外のインディーズTRPGの事情は、日本とは少しだけ異なっている。依然として紙
媒体のルールブックも好まれているとはいえ、商業やインディーズを問わず、電子版
（PDF）のルールブックも広く普及し、製作費用をクラウドファンディングで調達するという
動きも一般的になってきた。実際、ここ数年のTRPG関連のクラウドファンディングの動き
は活発であり、中には数億円規模の資金を集めるTRPGプロジェクトも少なくない（SFホ
ラーTRPGである『Mothership』は、2021年に行ったクラウドファンディングプロジェクトで1億円以上を集めた）。
つまり、個人や小規模のサークルにおける、TRPG制作のハードルは以前より格段に下
がっているのである。もし自分たちの周辺コミュニティにおいては、TRPGの認知度が低
かったとしても、インターネットを通じ、世界中のプレイヤーに向けて個人がTRPGをリリー
スすることができる時代になったのだ。

　さて、海外のTRPGの持つ多様性というのは、デザインの面においてもよく表れてい

る。たとえば、海外のTRPGでは、ルールブックのレイアウトについて、画一的な様式が存在するわけではない。B5サイズのルールブックから、横長のブックレット型、リーフレット型、レターサイズ、名刺サイズのものまでさまざまだ。確かに、ルールブックに関しては、実用的な面から考えても、整理され可読性の高いレイアウトであることが望ましいだろう。しかし、海外のTRPG、ことインディーズにおいては、単なるルールブックとしてだけではなく、その作品全体の世界観を表現し、奇抜で、視覚的にも読者を喜ばせるような工夫を凝らしたアートピースのような作品も数多く存在する。

　たとえば、資金力が乏しかったり、自分でイラストを描くことが難しい個人のTRPGデザイナーたちは、フリー素材を用いたコラージュやフォトバッシュといった技法を好んで使用する傾向にある。コラージュとは、異なるイラストを組み合わせることで、素材本来のイメージとは違った雰囲気のイラストを作り出す技法である。一方でフォトバッシュとは、写真を加工して、背景イラストなどを作る技法である。両者に共通しているのは、著作権の保護期間が切れた昔の絵画や写本の挿絵、ライセンスフリーの写真などが素材として利用されるということだ。

　そしてもう一つ、近年ではアートワークそのものの美麗さとは別に、思い切った紙面レイアウトなどによって、オリジナリティを際立たせようとする潮流もある。中でも、アートパンクTRPGと銘打ち、多くのインディーズTRPGデザイナーたちに衝撃を与えたスウェーデン発のTRPG『Mörk Borg』は異彩を放っている。同作のアートデザイナーであるJohan Nohr氏は、その独特のアートセンスもさることながら、絵画や古書の挿絵を用いたコラージュ技法なども駆使する、まさに今の時代を牽引するデザイナーといえるだろう。ちょうど日本でも、上記の『Mörk Brog』の影響を受け、そのサードパーティライセンスを元に制作された『信長の黒い城』のアートワークの中で、フォトバッシュの技法が活かされている。

　海外のTRPGを知ることは、世界中に星の数ほどいる鬼才たちの頭の中にある、驚くべき発想力の数々に触れるということでもある。自らの腕に彫られたタトゥの柄を、そのままダンジョンとしてトレースするデザイナーや、表紙と裏表紙にVHSの画像をプリントし、ルールブックそのものを一昔前のホラービデオのパッケージのように見せかけた作品など、ここでは語りきれないような奇抜なアイデアが詰め込まれた作品が、世界にはたくさんあるのだ。今回ご紹介する作品は、そんな傑作たちのほんの一部ではあるが、これを機に海外のTRPGに少しでも興味を持ってもらえれば幸いだ。

Montro

▲表紙　　　　　　　　　　　　　　　　　　▲中面

TITLE ➡ 『MÖRK BORG』

ゲームデザイン：Stockholm Kartell and Ockult Örtmästare Games ／ テキスト：Pelle Nilsson ／ アート＆グラフィックデザイン：Johan Nohr

何もかもが型破りなダークファンタジーTRPG。ヘヴィメタルの陰鬱なイメージを表現し、その終末的な世界観だけでなく、荒々しいレイアウトと過激なアートワークによって、多くのプレイヤーの度肝を抜いた。前衛的なデザインながらも、黄色を基調とした特徴的なカラーリングや、ページ毎に様変わりするタイポグラフィなどは計算され尽くしており、まさにアートパンクと呼ぶのに相応しい作品となっている。

▲表紙　　　　　　　　　　　　　　　　　　▲中面

TITLE ➡ 『Into the Odd Remastered』

ゲームデザイン：Bastionland Press ／ テキスト：Chris McDowall ／ アート＆グラフィックデザイン：Johan Nohr

スチームパンク的な世界観が魅力のインダストリアルホラーTRPG。元々はインディーズTRPGだったが、新装（Remastered）版では、『Mörk Borg』で一躍有名になったスウェーデンの鬼才Johan Nohr氏によってアートワークが一新された。読みやすいエレガントなページレイアウトを貫きながらも、絵画や写真のコラージュを基調とした、奇妙でOdd（不気味）なイラストで、その世界観を遺憾なく描き出している。

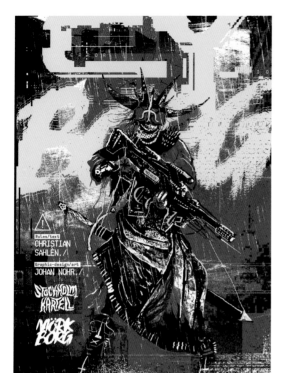

▲表紙

TITLE ➤ 『CY_BORG』

ゲームデザイン：Stockholm Kartell / テキスト：Christian Sahlén / アート＆グラフィックデザイン：Johan Nohr

『Mörk Borg』を元に、新たにサイバーパンク的な世界観で作り直されたTRPG。色彩が豊かになっただけでなく、最低限の可読性を保ちながらも、大胆なデザインで世界観を最大限表現するなど、格段に洗練されている。ノンブルのフォントデザインがページ毎にほぼすべて異なるなど、細部にもアートデザイナーであるJohan Nohr氏のセンスが光っている。

▼中面

TITLE ➡ 『Wicked Ones』

ゲームデザイン：Ben Nielson ／ イラストレーション：Victor Costa

プレイヤーたちがモンスターとなって、冒険者たちを迎え撃つためにダンジョンを構築するというTRPG。まるでダンジョンの中にいるかのようなページデザインが没入感を高めてくれる。各所に登場するモンスターイラストは、恐ろしくもどこかコメディタッチに描かれており、ゲーム全体のトーンが、暗すぎるわけでもコミカルすぎるわけでもない絶妙なバランスに整えられている。

▼表紙

『Wicked Ones』は、ほぼすべてのページが意図的に埋められている。「無駄なスペースのない充実した本が好きだが、余裕を持たせることとのバランスをとるのに苦心する」と話す作者のBen Nielson氏に、『Wicked Ones』の特徴的な見開きを挙げて、デザインプロセスを振り返りつつ分析してもらった。

check

▼中面

01 ／ シンプルな表紙だが、プレイヤーが巧妙な罠や待ち伏せを仕掛け、役割を反転させて悪党に挑んでいく様子を表現した。また、冒険者たちが「正しいこと」を行っているように見えても、陰湿で危険な印象を与えるように注意した。オークは楽しそうに仕事をしているようだ。

02 ／ 各章は、一枚絵のイラスト、アイコン、章題で始まる。 リードとして、ゲーム内でPCが発言しそうなセリフを掲載した。扉の要素は各章のトーンを設定し、明確で視覚的なブレークポイントを与えている。羊皮紙を模した明るいページが多い中で、あえて暗い背景を据えている。

03 ／ ベースのレイアウトは、サイドバーグラフィックで閉じられた感を演出した。右上の柱（フラッグ）は目的の章を探すのに便利だ。文字間隔にも気を配り、統一感を持たせている。 フォントはヘッダーにKruger Caps、テキストにBitter、タイトルにBlood Crowの3種類のみを使用。

04 ／ 各章の終わりには、再び暗い背景でリプレイを掲載した。これは各章の始まりと終わりを同じ暗さにして、視覚的に明確な区切りができるようにしたものだ。 ダイアログでは、プレイヤーがPLとPCとしての発言を切り替えながら自然に会話する様子が再現されている。

05 ／ この本では私の「3つの法則」という考えに基づいて、1つのルールが紹介されるたびに、どのように異なる方法で使われるかを3つの例で示している。赤い囲みは、作者（私）が読者に直接語りかけ、何が起こっているのか、メカニズムと背景を説明するためのものだ。

06 ／ ゲーム中のダイスロールの種類はすべて同じビジュアルで、重要なルール（帯枠）とプレイの対話例（点線枠）の両方を強調するために、特定の囲みを設けた。

07 モンスターになりきるのは、多くの人にとって初めての経験だろう。プレイヤーが基本的なアーキタイプにとらわれないよう、できるだけ多くの選択肢やアイデアを提示した。こうすることで、フィクションの語り口が豊かになり、キャラクターがよりリアルに感じられるようになる。

08 キャラクターのプレイブックは、アビリティやキャラクターのオプションが明確に示され、プレイするのが楽しみになるような大きなアートピースにフォーカスしている。これらのページは、プレイヤーの心を掴み、プレイブックを選択させるフックとなることを意図している。

09 ポーションのページは、d66テーブルをGMの道具（ランダムにロールできる）として、また、一度にたくさん（36も）の異なる例を提供する方法として使用したよい例だ。

10 神の魔法と暗黒の神々のページでは、シンボルや信奉者が神聖視しそうなアイテムなどを組み合わせることで、プレイヤーがキャラクターを構築するためのフィクションの小道具を提供する。すべてが使われるわけではなくとも、可能な限り多くのものを与えることが助けになる。

11 これもプレイヤーオプションのページだが、ダンジョンテーマに関して、メカニクスに特化した部屋をフィクションやナレーションの中でどう生かすかの例を多く提示した。プレイヤーにロールプレイを促し、面白いシーンを作り出すのに役立ててもらうためだ。

12 全ページにわたって多くの挿絵を掲載しているが、これらはほとんど世界観を構築するために使用されており、長い説明文の冗長さを解消してくれる。また、Victor Costaの画風をアピールし、「ダンジョンライフ」がどのようなものかを感じさせる絶好の機会でもある。

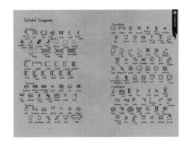

13 絵を描くのが苦手な人が多いため、ダンジョンの描き方のわかりやすいガイドを作ることに細心の注意を払った。これはその一例だ。最終的には絵を描くことに自信を持ってもらいたいが、誰かに代わりに描いてもらってもいいんだよ、ということも併せて伝えるようにした。

14 -15 最後の2ページは、視覚的に学習する人がいることに着目している。仕組みを図解することで、長いパラグラフや例で説明するよりもずっと人々の頭の中に定着しやすくなる。説明が好きな人もいれば、図解が好きな人もいるし、プレイ例が好きな人もいる。この種のルールブックをレイアウトする際には、本が何よりもまずゲームのプレイ方法を教えるためのマニュアルであり、さまざまなタイプの学習者がいることを知ることが非常に重要である。私が教師として、また教科書の出版社で働いていたことが、デザインの考察に大いに役立った。

◀中面

◀中面

▲表紙

▲表紙

TITLE ➡ 『The Dying World』

ゲームデザイン：Rae Nedjadi

崩壊の危機に瀕した多次元宇宙を救うため、PCたちがさまざまな世界を駆け巡るというTRPG。ゲームプレイにタロットカードを使うのも本作の特徴の一つであり、随所にタロット的なイメージが散りばめられている。古紙をイメージさせる本文背景に対して、神秘的で鮮やかな色使いのイラストが対照的に用いられており、お洒落なヴィンテージ感を演出している。テキストの重要箇所に色とりどりのマーカーを引くという工夫も、世界観と上手く調和している。

TITLE ➡ 『Changelings』

ゲームデザイン：Paweł Domownik

人間の体を持って現代社会に舞い戻った妖精、チェンジリングとなり、罪のないの人々のために問題を解決するというアーバンファンタジーTRPG。ファンタジーを思わせる妖精的な要素には、古い絵画や写本の挿絵を、現代都市的な要素には、実際の写真を用いることで、幻想と現実が交わる絶妙な世界観を表現している。コラージュやフォトバッシュを効果的に使用し、全体がスクラップブック的なレイアウトになっているのも面白い。

▲表紙

▲中面

▲表紙

▲中面

TITLE ➡ 『Un lieu paisible』

ゲームデザイン / アートワーク：Mina Perrichon

家の精霊（守り神）となって素敵な家をしつらえ、そこへやってくる悲しい気持ち抱えた人間たちを慰めるというフランスのTRPG。霊は喋れないが、知恵を絞ってなんとか人間を怖がらせることなく、慰めてあげようとする。暖かなイラストと色使いのセンスが光っている。セクション毎にページの背景色を分けているため、ページ番号を覚えなくても視覚的にどこに何が書いてあるかを覚えやすいデザインになっている。

TITLE ➡ 『CHOROGAIDEN』

ゲームデザイン：Willow Jay

レトロチックな日本風ホラーTRPG。町で起こる奇妙な事件を追っていくうちに……というジャパニーズホラーゲームを題材にした作品。外国のアーティストならではの、さまざまなリスペクトから随所に散りばめられた謎の日本語がまた良い雰囲気を作っている。全体的に古いゲームボーイの画面をイメージしており、2000年代初頭の日本のホラーゲームの精神が、現代に蘇ったかのような作品に仕上がっている。

▲表紙　　　　　　　　　　　　　　　　▲中面

TITLE ➡ 『Egophagous』　ゲームデザイン：six legs games｜Maciej Krzyżyński／編集：Katarzyna Krzyżyńska、Jim Hall

特定のルールに依存しない、システム不問のアドベンチャーモジュール。多発する行方不明者の謎を追って、深い森の中へと足を踏み入れていくというややホラー系のシナリオだ。菌類をモチーフにしており、ルールブックは森や菌類の毒々しさを感じさせる白と青緑系の色彩で統一されている。全体のレイアウトとしてはシンプルだが、イラストやマップの線、ときに黒字に青緑色のテキストを組み合わせることにより、探索者たちを不安にさせるような不気味なトーンを演出している。

▲表紙　　　　　　　　　　　　　　　　▲中面

TITLE ➡ 『NOVA』

ゲームデザイン：Spencer Campbell、Gila RPGs／アート：Eddie Yorke／レイアウト：Julie-Anne Munoz

太陽が失われた未来を舞台に、特殊なスーツを身に纏い戦いを繰り広げるSF-TRPG。ルールブックは黒石を基調としながらも、タイポグラフィには七色が使用されている。これは、わずかな光しか残されていないという、本作のコンセプトを巧みに表現している。ロボットものとしてスピーディーな戦闘を繰り広げることができるのも本作の特徴も、スピードを感じさせる思い切ったスプラッシュ的なデザインとして落とし込まれている。

▲表紙

▲中面

TITLE ➠ 『CBR+PNK』 ゲームデザイン：Emanoel Melo ／ カバーアート：Luis Melo ／ 編集：Ray Chou

大企業から雇われた「ランナー」として活躍していたPCが、この業界から足を洗うために、最後の大仕事に身を投じるという設定の単発型のサイバーパンクTRPG。近年では、制作コストやプレイの手軽さの面から、このような折り畳めるリーフレット型のルールブックを作るインディーズTRPGは多い。リーフレットでは規格として3面x3面となることが多いが、その少ないスペースを使っていかに世界観とルールを表現するか、で個性が出るのだ。

▲中面

TITLE ➠ 『Of Promises & Paper Airplanes』 ゲームデザイン：Ar-Em Bañas

離れ離れになってしまう恋人たちが、ある約束を交わし、最後の日に空港で紙飛行機を折って別れの挨拶を交わすというTRPG。プレーンレイアウトのルールブックは一枚（両面）とシンプルだが、紙面には折り線が入っており、実際にゲームを進めながら、ルールブックそのものを紙飛行機として折り進めていく。1工程折り進める度に、2人の出会いや約束の内容を思い出していくシステムで、ゲームの進行と物理的な動きがリンクするようなデザインとなっている。上記はプレーンレイアウトのパーフェクトガイドとして機能するイラストレイアウト版。

Operator manual

rallyraid roleplaying
by will jobst

▲表紙　　　　　　　　　　　　　　　　　　　　　▼中面

TITLE ➤ 『TORQ: rallyraid roleplaying』

ゲームデザイン、ライティング、レイアウト：Will Jobst / 編集：Seb Pines / 撮影：Ben Garbow / イラスト：Gabriel Reis

なんらかの惨禍によって文明が崩壊した後の世界で、ドライバーとして世界を旅したり、荷物を届けたりするTRPG。ゲームコンセプトとしては、A地点からB地点へ向かう道程を描くものだ。ハンドルを模したキャラクターシートをはじめとして、ルールブックには車やドライブを連想させるイメージが詰め込まれ、見ていて飽きることのない表情豊かな作品となっている。

TRPGと
ゲームジャムの文化

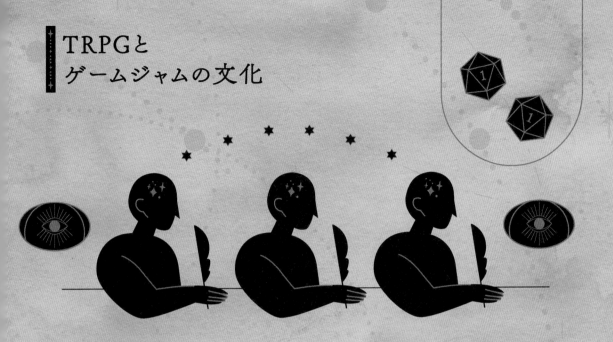

　ゲームジャムという文化をご存じだろうか？　これは、ゲームクリエイターたちが集まり、特定の期間内に、お題に沿ってゲームを作成するというイベントだ。主にデジタルゲームの分野で活発なイベントであったが、近年ではアナログゲーム界隈でも大きな盛り上がりを見せている。

　海外のインディーズTRPG界隈では、このゲームジャムが頻繁に開催されている。たとえば、「1ヶ月間でホラーを題材とした、10ページ以内TRPGを作成する」というジャムや、「IKEAを題材とした、Mörk Borgのハック作品を作る」ジャムなど、その種類も多彩だ。

　TRPGの汎用ルール作品の存在も、このジャムの盛り上がりを後押ししている。汎用ルール作品とは、誰でも自由に商用作品を作ることのできるライセンスで、TRPGのルールやシステムの枠組みだけを公開している作品のことである。このような汎用ルールのひとつを使用して、新しいTRPGを作ろうという動きは、海外ではよくあることだ。

　2022年9月。筆者は海外の「Breathless」という汎用ルールの翻訳許可を得て、「ブレスレスジャム」[*1]というイベントを日本で開催した。これはBreathlessのルールを使用して、1ヶ月間でオリジナルTRPGを作ろうというイベントだ。Breathlessそのものは無料公開されているものであり、応募資格も必要ない。ただレギュ

レーションに沿って、ココフォリアのシナリオ投稿サイト「TALTO」で自身の作品を公開すればよいだけだ。結果として、1ヶ月の間に80を超える作品が、ブレスレスジャムに参加した。つまり、国内で1ヶ月の間に80以上の新作インディーズTRPGが公開されたことになる[*2]。TRPGを作ってみたいが、システムを考えるのが大変だと思っている人たちもきっと多いだろう。今回のジャムに関しては、はじめにルールの大枠が提供されてたことが、作品の作りやすさに繋がっていたのだろう。

　日本のTRPG界隈でも、こうしたゲームジャムの文化が受け入れられていくことで、TRPGをデザインするということが、もっと身近になっていくのかもしれない。

*1　ブレスレスジャムページ
　　https://campaign.talto.cc/breathless-jam/

*2　TALTOの該当作品ページ
　　https://talto.cc/c/breathless

Chapter 3で紹介したシナリオは、以下に記載する作品の二次創作物を含みます。

参考書籍（五十音順）：
『アリアンロッドRPG 2Eルールブック』菊池たけし / F.E.A.R.（KADOKAWA/富士見書房）
『暗黒神話TRPG トレイル・オブ・クトゥルー』ケネス・ハイト（グループSNE）
『ウォーハンマーRPGルールブック』（ホビージャパン）
『OCTOPATH TRAVELER TRPG ルールブック&リプレイ』久保田悠羅 / F.E.A.R（スクウェア・エニックス）
『ガンアクションTRPG ガンドッグ・リヴァイズド』狩岡源 / アークライト（新紀元社）
『虚構侵蝕TRPGルールブック』千葉直貴 / 泉川瀧人 / 卓ゲらぼ（新紀元社）
『Kutulu』Mikael Bergström（FrogGames）
『クトゥルフ神話TRPG』サンディ・ピーターセン / リン・ウィリスほか（KADOKAWA/エンターブレイン）
『サイバーパンクREDルールブック』（ホビージャパン）
『ザ・ループTRPG』FRIA LIGAN AB / Simon Stålenhag / 朱鷺田祐介（グラフィック社）
『新クトゥルフ神話TRPG ルールブック』サンディ・ピーターセン / ポール・フリッカー / マイク・メイソンほか（KADOKAWA）
『ストリテラ オモテとウラのRPG』瀧里フユ / どらこにあん（KADOKAWA）
『ソード・ワールド2.5ルールブック』北沢慶 / グループSNE（KADOKAWA）
『DARK SOULS TRPG』加藤ヒロノリ / グループSNE（KADOKAWA）
『ダブルクロス The 3rd Editionルールブック』F.E.A.R. / 矢野俊策（KADOKAWA / 富士見書房）
『ダンジョンズ&ドラゴンズ ダンジョン・マスターズ・ガイド』（ウィザーズ・オブ・ザ・コースト）
『トーキョーN◎VA THE AXLERATION』鈴吹太郎 / F.E.A.R.（エンターブレイン）
『トラベラー』（ホビージャパン / 雷鳴社）
『忍術バトルRPG シノビガミ 基本ルールブック』河嶋陶一朗 / 冒険企画局（新紀元社）
『バディサスペンスTRPG フタリソウサ』平野累次 / 冒険企画局（新紀元社）
『ふしぎもののけRPG ゆうやけこやけ』神谷涼 / 清水三毛 / インコグ・ラボ（新紀元社）
『星と宝石と人形のTRPG スタリィドール』古町みゆき / 冒険企画局（新紀元社）
『魔道書大戦RPG マギカロギア 基本ルールブック』河嶋陶一朗 / 冒険企画局（新紀元社）
『マルチジャンル・ホラーRPG インセイン』河嶋陶一朗 / 冒険企画局（新紀元社）
『ログ・ホライズンTRPG ルールブック』橙乃ままれ / 絹野帽子 / 七面体工房（KADOKAWA / エンターブレイン）
『ロードス島戦記RPG』水野良 / 安田均（KADOKAWA）

マーダーミステリーの
デザイン

Guide
to
Murder Mystery Graphic Design

❀ マーダーミステリーとは

近年、日本ではマーダーミステリーが盛り上がりを見せている。マーダーミステリー（以下マダミス）とは一般的には、ひとつあるいは複数の事件を解決するために謎解きや推理を楽しむゲームである。起源は欧米のパーティーゲームだが、中国で独自の進化を遂げ、ボードゲームの1ジャンルとして確立された。パッケージ版、データ版のほか、店舗公演型など凝ったパフォーマンスを含むイベントとしても楽しまれている。

「マーダー（＝殺人）」と付くように、架空の殺人事件を題材にしたミステリーが主で、一般的にはNPCが死亡し、PCが犯人は誰かを推理していくシナリオが多い。一方で、誰も死なない事件があったり、世界観によっては魔法や超能力を使えたりと、TRPG同様さまざまなジャンルに派生している。

参加者はそれぞれ役割を持ったキャラクターになりきり、ロールプレイで物語を紡いでいく。個々の思惑を抱えながら自身の目標を達成するために立ち回り、ゲームの終了間際にプレイヤー全員で投票や最終行動を行う。こうしたキャラクターを演じながら会話で物語を創り上げるTRPGの要素と、犯人役とその他の役がいて議論し投票によって総意を決定する人狼ゲームの要素から、マダミスはTRPGと人狼を掛け合わせたゲームと呼ばれることもある。

TRPGとマダミスの境界線を厳密に定めることは難しいが、TRPGとの主な違いは、キャラクターメイキングの自由度にある。マダミスでは基本的にキャラクターの人格やライフパス、さらには事件発生当時に何をしていたかといった行動履歴がハンドアウトに記載されている。そのためキャラクターの個性や行動原理などを読み解き演じる必要があり、台本を配られる俳優のような気分が味わえる。プレイヤーの振る舞いがインタラクティブに物語の進展に大きな影響を与え、それによって結末が変わる点は共通するが、マダミスではキャラクターメイキングの負担は軽減され、まるで自分が推理小説の登場人物になったかのようなゲーム体験が楽しめる。一方で、証拠品やマップなど要所でビジュアルが必要になり、コンテンツサイドで実装すべきデザインがTRPGより明確にあるといえよう。

マーダーミステリーの遊び方

マダミスは参加者が役割を演じながら推理力を駆使して事件解決を目指すゲームだ。多くの場合、プレイヤーキャラクターの中に犯人が紛れ込んでいるため、全員が嘘をつくことのできるシナリオが多く、証拠を集め、議論をしながら物語を進めていく。

システム・シナリオの選択

遊びたいシナリオを選ぶ。公開されているシナリオの設定（舞台、ストーリーのさわり、登場人物など）、難易度を確認して、参加者の傾向や人数に合うシナリオを用意するか、シナリオに合わせてメンバーを募る。プレイヤー以外に進行役を担うGMが必要なシナリオとそうでないシナリオがあるので注意したい。

ハンドアウトの選択

プレイヤーは事前に公開されている登場人物情報を元に演じるキャラクターを選択する。

ゲーム開始

自身のキャラクターの目標や事件前後の行動などが書かれている個別ハンドアウトを読み込み、キャラクターの設定物語における役割を把握する。全員で共通情報や資料を読み、ゲームの流れとルールの確認を行って議論に入る。

真相解明のための議論

プレイヤーはキャラクターとしてロールプレイをしながら議論し、キャラクターごとに持つ異なる情報をパズルのピースのように繋ぎ合わせながら真相を解明していく。議論時間には制限があり、全体議論のほか、数名ずつの密談が設けられていることもある。

役割ごとの立ち回り

犯人は無実を装い、疑いを逸らすために嘘をついたり、他の容疑者の疑わしい点を追求したりする。また他の者たちも自分が犯人でないことを証明するために、証拠や情報を用いて他のプレイヤーを説得する必要がある。犯人の味方をする者や探偵役が紛れていることもあり、役割に応じた行動や発言を上手に演じることが、ゲームを盛り上げる要素の一つとなる。

証拠の収集・追加情報の配布

カード等を選択して証拠を収集するフェーズがある。証拠には各自の持ち物や凶器といった物的証拠や周囲の人々の証言などが含まれ、プレイヤー同士で証拠やアイテムの譲渡・交換、共有が可能なケースがある。また、初期に配られた情報以外にも情報が追加されたり、それによって目標が変更されることがある。GMがいる場合はGMがシナリオの展開や証拠の提示、追加情報の提供を行う。

推理と犯人の特定

収集した証拠と議論内容をもとにそれぞれ事件の真相を推理する。シナリオによっては推理発表を経て、自分が犯人だと思う人物に（もしくは自身の目標に合わせて）投票を行う。

結果発表とエンディング

投票結果を集計し、エンディングを決定する。GMがいる場合は投票の進行や集計をサポートする。エンディングは犯人に最多票が集まったか、キャラクターがそれぞれの目標を達成したかなど、複数の条件をもとに分岐が設けられていることが多い。

マダミスにおける勝利

マダミスにおける勝利は、犯人の特定や犯人としての逃亡、個人の目標の達成だけでなく、エンディングの内容がキャラクターにとって良い結果であることも含めて判断される。プレイヤーは自分のキャラクターにとって最善の結果を目指し、それが良いものとなるかを自身で考察する必要がある。

終了後の感想交換

ゲームが終了後は参加者同士で感想戦をする。真相が開示され、各々の行動の背景や隠していた目標、どのような選択肢をとったのか、どのように物語に関わっていたかを振り返る。

❖ これがあれば遊べる ❖

マーダーミステリーで準備するもの

マダミスは時間とメンバーが確保できればオフラインでもオンラインでも遊べる。前提として、オフラインの場合はセッションができる場所、オンラインの場合は、セッションツールが快適に動くデバイスや通信環境、ヘッドセットなどを用意する。

▮ シナリオ

シナリオにはハンドアウトやマップやカード、トークンなど多くの内容物が含まれることがあり、GM必須のシナリオでは事前準備やゲーム中に複雑な処理を必要とするケースもある。GMは一通り内容に目を通しておき、プレイヤーに配布するものとそうでないものを把握する。マダミスは、犯人やギミックがわかってしまうと二度と遊ぶことができない。参加者たちがネタバレを踏まないよう注意しつつ、共通の設定、ルール、ゲーム進行はできるだけ参加者全員で読み込めるようにする。

▮ 事前読み込み

シナリオによっては、事前に個別ハンドアウトを読み込んでからゲームを開始することを推奨するものがあり、セッション当日ではなく数日前に各種資料が配られることがある。参加者全員であらかじめ配役を決め、準備期間を与えることで、各々が自分が演じるキャラクターを読み解き、キャラクターのイメージやロールプレイを作り込むことができる。この際、プレイヤーによって与える準備時間にムラが生まれないようアナウンスや配布タイミングに注意する。

▮ タイマー

マダミスではフェーズごとに制限時間が設定されている。延長や休憩なども分単位で測ることが多いので、タイマーを準備しよう。オンラインセッションでは参加者が個別にタイマーを準備するのではなく、GMがタイムキーパーを行うか、参加者全員で残り時間を確認できるツールを使うと便利だ。

▮ 密談スペース

シナリオによってはプレイヤー同士が秘密裏に相談したり情報共有する場が必要になる。オフセでは密談をしているプレイヤーの声が他のプレイヤーに届かない環境、オンセでは個別に通話できる環境を用意しよう。

▮ 筆記用具・メモ

マダミスでは、各キャラクターが持つ情報が異なるため、見聞きした情報を整理し、推理するためにメモをとることが多い。特に密談や各自が調査結果を持ち寄る議論では断片的な情報が飛び交い、その場で裏を取ったり記憶しておくのが難しい。いつ誰がどこで何をしていたかという、事件に関わりそうなタイムライン（時系列）を詰める際に、表を作成するケースもある。オンラインではメモアプリで代用できる。

▮ 参考資料

GMはGMガイドやGM用台本、プレイヤーは個別ハンドアウトや共通情報、ルールやゲーム進行などをいつでも確認できるよう、手元に用意しておくとよい。

▮ BGM・SE

物語を盛り上げる適切な音楽や効果音を用いることで、より没入感を高めることができる。音素材がシナリオに同梱されている場合もあるが、手軽に利用できるBGMやSEのDLサイトがたくさんあるので、GMがテーマやシーンに合う好みのものを見繕ってセットしておくとよい。

▮ 飲み物や軽食

各自飲み物や軽食を用意しておく。オフラインセッションの場合は会場が飲食可かあらかじめチェックしておこう。マダミスでは議論時間が設定されているため、休憩時間もゲーム進行に組み込まれていることがあるが、進行表にない場合は参加者全員で話し合い、無理のないよう適宜休憩を挟む。

マーダーミステリーの用語集

▌ キャラクターシート / ハンドアウト

プレイヤーが演じるキャラクターの詳細が記載された資料。通常、ゲーム冒頭で配布され、ゲーム中の立ち回りや推理の基盤となる情報が読み取れる。基本的には秘匿すべき情報が含まれるので、他のプレイヤーに見せることはできない。

▌ 共通情報

プレイヤー全員が共有する情報。事件の概要や被害者の状態、舞台設定、用語集などが含まれる。

▌ タイムライン

ゲーム内の出来事や行動を時系列に並べたもの。事件発生前後はキャラクターが各々自由に行動しているため、タイムラインを精査することで、犯行時刻や犯行現場の特定、各キャラクターのアリバイの確認・証明などに繋がる。

▌ トリック

犯人が犯行を隠蔽するために用いる手法。アリバイ偽装、証拠隠滅、事件の状況操作などが含まれる。

▌ ギミック

ストーリーや設定、システムに組み込まれた仕掛けや特殊ルール。ギミックがトリックや登場人物の能力にかかっている場合もあれば、ゲームのルールや展開自体が特殊な場合もある。

▌ フェーズ

ゲームの進行における特定のタイミングや区切り。制限時間とその時間内にできる行動が定められている。

▌ 調査フェーズ

証拠品や手がかり、アイテムなどを取得することで情報を集めるフェーズ。多くの場合、カード状の情報札に手がかり記載されており、トークンを払って順番に取得していくため、それぞれが異なる情報を手に入れる。

▌ EXカード

調査時に入手できるカードの中でも重要な手がかりとなる可能性があるカード。特定の条件を満たすことで取得できることが多く、イベントが起こることもある。

▌ トークン

証拠品やアイテムと引き換えられる調査ポイント。トークンを使用して特殊能力を行使したり、他者のアイテムを奪ったりする場合もあり、用途は多岐にわたる。

▌ 全体会議フェーズ / 密談フェーズ

全体会議は全キャラクターが集まり、情報共有し議論する。密談は特定のキャラクターで組み分かれ、個別・秘密裏に議論することができる。

▌ 投票フェーズ

犯人だと思われるキャラクターに投票するフェーズ。または自身のキャラクターのミッションを達成するように投票する。

▌ アクションフェーズ

キャラクターが特定の能力を行使できるフェーズ。固有の能力や、ゲーム中に入手したアイテムを使ってアクションが行える。必ずあるわけではなく、特定の条件を満たすことで発生する場合もある。

▌ 推理導線

犯人特定や事件解決に至るまでの思考の流れや推理過程、または推理に有用な情報や証拠品などの要素のこと。ゲーム終了後の解説資料の中でどのように推理すれば犯人特定や事件解決に至るかが解説される場合がある。

▌ ミスリード

故意に誤った情報を流すことや、誤った方向へ誘導する手がかりや情報。

▌ 白 / 黒

白は無実、黒は有罪を意味する。容疑者の中で無実であると確信できるキャラクターを「確白」と呼ぶことがある。犯人だと疑うことや、無実のキャラクターを故意に犯人に見せかけることを「黒塗りする」などという。あくまで不確実な情報を元にした仮説である点や、プレイヤーが自身から疑いを逸らすために意図的に行うことがあるため注意する。

▌ 立ち回り / ムーブ

プレイヤーの動きや振る舞い、戦術。

▌ メタ / メタ要素

「メタ」はゲームのルールや設定を超えた情報のこと。「メタ読み」「メタ推理」「メタ発言」はゲーム内の情報以外の経験則から推測したり、プレイヤーの普段の傾向を利用した考察をし発言すること。マダミスでは基本的には禁止されている。また、自分のHOをそのまま読み上げたり、「〜と書いてある」という発言を行うことも、ゲーム内のキャラクター（PC）としての発言ではなくゲーム外のプレイヤー（PL）の発言となるため注意したい。

マーダーミステリーの
デザインのポイント

Chapter 4-5

この節では、マーダーミステリー特有の要素と表現のパターンをみていく。TRPG同様、マダミスにも実際には型などなく、現在の傾向から抽出したに過ぎないが、制作の足がかりにしてもらえると嬉しい。TRPGの「Ch.1 デザインの基本」「Ch.2 デザインのポイント」も併せて参照してほしい。

Ch.4-5-1

タイトルビジュアル

マーダーミステリーのタイトルビジュアルは、タイトルを印象づけると同時にゲームの
第一印象を与え、興味を引く役割を持つ。ギミックや推理重視なのか、情報操作や駆
け引き重視なのか、感情やストーリー重視なのかといったテーマや傾向に応じた顔を
据えることで、マッチするユーザーにリーチする。

POINT

一枚で効果的なタイトルビジュアルを構成するためには、作品の特徴が
画に盛り込まれていると望ましい。テーマや舞台・時代設定、ファンタジー
らしさやSFらしさ、和製ホラーらしさやデスゲームらしさといったジャンル
を示すモチーフや装飾で、遊び手を適切に誘おう。

check

フィルムノアール調のデザインで、犯罪現場に立つ探偵らしき存在を顔
にした例。光景から海外を舞台にした推理モノであることを伝えつつ、
事件へ探偵が関与している可能性を排除しない。またクロスワードパズ
ルや暗号を示唆するモチーフがデザインに組み込まれ、謎解きが好きな
プレイヤーに挑戦しようという気概を与える。

それはひとつの賭けだった。

5人用マーダーミステリー

Shadow
of City

Murder Mystery

果てし

なき追憶

4人+
GM

時間
90分

密談
あり

POINT

マーダーミステリーではキャラクタービジュアルがあらかじめ設
定されているため、登場人物の顔をタイトルビジュアルに持っ
てくるのも手だ。全員横並びにすると説明的になり視線が分散
してしまうが、誰かに、または特定のシチュエーションにフォー
カスしたデザインは、PLの想像力を掻き立てる。

check

マダミスでトレーラーのセットまで用意することは稀だ。キャラ
クター作成のあるTRPGほど詳細なレギュレーションはない
が、プレイ人数、GMレスか必須か、想定プレイ時間といっ
た情報を併せて記載すると親切だ。アイコン化してまとめる
ことで、省スペースでしっかり伝わる。

❖ 頒布用コンテンツ 2 ❖

導入

ここでいう導入とはあらすじのこと。マーダーミステリーでは、事件のさわりや予兆が語られ、あらかじめ共通情報として配布される。多くの場合、シナリオ頒布時に事前公開されており、プレイする作品を選ぶ判断基準となる。シナリオの世界観やポイントとなるキーワードが盛り込まれ、事件の直接的な手がかりとなることもあり重要だ。

POINT

導入がシナリオのフォーマットでレイアウトされ、共通ハンドアウトとして事前に配られたり、ルールブックの冒頭に含まれる場合、全体を表示させたときに文字が小さくなりがちだ。サムネイルとして抜き出されることも前提に、シンプルな構成とデザインを心掛けよう。

check

事前情報として、シナリオ概要とセットで導入を提示する例。十分な余白をとって、テキストを段落に分け、背景の色味やテクスチャは控えめに。キャッチーな導入を優先し、情報の流れを意識しよう。通常、この後に登場人物紹介や舞台設定、ゲームの流れなどが続く。

【あらすじ】

20世紀ロンドン。探偵が懇意にしている病理医のもとで、あるはずのない屍体が発見された。

ロンドン警視庁の血気盛んな捜査班は、眼の前で現れては消え、現れては消える屍体に翻弄される。

陰で糸を引く黒幕を誘き出すため、花形刑事と探偵は、ある作戦で不可能犯罪に挑むが──。

【シナリオ概要】

シナリオ概要

5人用マーダーミステリー

タイトル：Shadow of City（シャドウ・オブ・シティ）
システム：マーダーミステリー
傾向：パズル、謎解き要素有り
プレイ時間：3.5時間（感想戦込み）
プレイ人数：5人（GMレス可）
使用ツール：Discord＋ユドナリウム

※配布物が多いため、Discordで個別チャネルを設けることを推奨します。

Shadow
of City

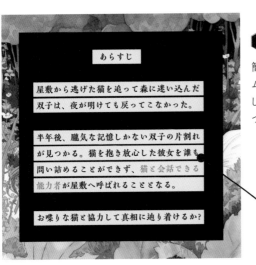

あらすじ

屋敷から逃げた猫を追って森に迷い込んだ双子は、夜が明けても戻ってこなかった。

半年後、朧気な記憶しかない双子の片割れが見つかる。猫を抱き放心した彼女を誰も問い詰めることができず、猫と会話できる能力者が屋敷へ呼ばれることとなる。

お喋りな猫と協力して真相に迫り着けるか？

POINT

簡潔な導入テキストであれば、画像で提示することができる。サムネイルとして表示させることを前提に、小さすぎたり細すぎたりしないフォントを選ぶ。背景色と文字色は、コントラストを保ちつつ、デザイン的にはタイトルビジュアルと連関をもたせるとよい。

check

重要なポイントやキーワードを強調するために、テキスト装飾を施した例。他にも文字サイズを変える、括弧類で括る、斜体にするといった強弱をつけるいくつかの手段が考えられるが、読み飛ばされてはいけない要所を目立たせる手段であり、過剰な装飾は逆効果だ。重要な言葉にのみフォーカスしよう。

Ch.4-5-3

❖ 頒布用コンテンツ 3 ❖

キャラクター選択

マーダーミステリーでは、ゲームの冒頭または事前に、用意されたプレイ人数分のキャラクターが紹介され、できるだけ公平なプロセスで配役を決める。キャラクターの公開情報の程度はシナリオによって異なるが、配役の妙がセッションを盛り上げるため、どこまで可視化するかは大きなポイントとなる。

POINT

TRPGのように象徴的なHOを提供することで、キャラクターの風貌や細かい設定はPLに委ねつつ、能動的な選択を促すことができる。基本的には秘匿HOの情報が正のため、表面的な見せかけの役割をキャラクター選択時に示すこともある。

check

テキストのみの紹介で、選択画面の背景にシナリオに連関する（具体的に誰を指すのかわからない）イメージを据えた例。キャラクターの刷り込みが重要になるため、わかりやすい役割と人物像を示そう。キャラクターが言いそうな名言やキャッチフレーズをHOに取り入れることでも、キャラクターの役柄をより具体的に伝えることができる。

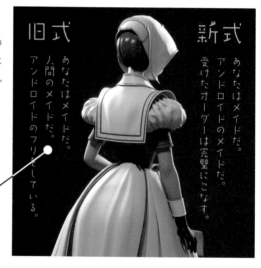

旧式

あなたはメイドだ。人間のメイドだ。アンドロイドのフリをしている。

新式

あなたはメイドだ。アンドロイドのメイドだ。受けたオーダーは完璧にこなす。

POINT

表情などからイメージを限定させないよう、キャラクターの顔を伏せてシルエットで選択させるシナリオも多いが、魅力的なキャラクターイラストが用意できるのであれば、頒布時に公開しておくことでプレイの期待感が高まり、作品を選んでもらう大きな要素になる。

check

共に物語を創り上げる個性的なキャラクターが一堂に会することで、セッションの一体感に繋がる。各キャラの公開情報をカード化する場合も、一枚にまとめた選択画面を別途作り、全体を見直せるようにしよう。NPCのイメージもあると効果的だが、PCとして選択できないことを明確に示す必要がある。

1 アメリア、寡黙／気まぐれ

2 ソフィー 器用／気配り

3 ジャン タフ／リーダー

4 リリー 楽観／のびのび

5 オリバー 慎重／エリート

Ch.4-5-4 ✦

ハンドアウト

マーダーミステリーのハンドアウトには、PCの行動を左右する重要な情報が詰まっている。年齢や職業や見た目といった人物設定だけでなく、今日の人物像に至る背景や生い立ち、当日のタイムライン、目標や行動指針などがまとめられ、長くなることも多い。プレーンテキストでは目が滑ってしまうので、視覚的な操作が必須になる。

POINT ✦

表紙（1枚目）は、配役の確認や誤配布のワンクッションも兼ねて、キャラクター名やキャラクターイラストを据える。2枚目以降は、作者などの第三者視点あるいは自己視点で語られるキャラクターの紹介が始まる。冒頭に、犯人であるか否かが強調されていることがある。

check

一方的に内情を知られる人物に感情移入するのは容易ではない。心情の言語化だけに頼らず、個性を立たせる工夫をしよう。キャラクターの容姿や特徴をイラストで表現したり、固有のカラーテーマやアイコンを取り入れたり、ゲーム内での役割を視覚的に伝えることで、まずは体裁から入りやすくなる。

POINT ✦

タイムラインとキャラクターミッションは多くのシナリオハンドアウトに共通する要素だ。初見でこれらを完全に記憶するのは難しいが、要所の書体やあしらいを変えるなどしてデザイン的に強調することで、優先して確認するよう促し、プレイ中も瞬時に見返しやすくする。

check

最終的なミッションだけでなく、タイムラインや行動指針がサマリーとして端的にまとめられていると記憶しやすく、PCを動かしやすい。サマリーは、箇条書きにするなど本文とスタイルを変えて情報を整理し、飾り罫で囲む、背景の色を変えるといったあしらいを加えて目に留まるようにしよう。

Ch.4-5-5

読み合わせ資料

マーダーミステリーには共通の台本があり、キャラクターになりきってセリフを読み合わせるパートが存在する。シナリオによっては事件の開幕や自己紹介だけでなく、進行フェーズごと、結末ごと、またキャラクターごとのエンディングに応じて台本が配られる。PLが混乱しないよう、明確なナビゲーションが必要だ。

POINT

読み合わせは醍醐味であると同時に煩わしさも伴うものだ。特にオンラインでは同期的に全員で同じ資料を目で追い、タイミングを見計らって発声しなくてはならない。シナリオに選択肢や分岐が複数あり、台本に時と場合によって飛ばすページなどが含まれると同期の難易度が上がる。

check

GMが指示しやすくなるよう、現在位置のNo.や栞代わりのマークをトップに据えよう。このとき、PDFなら枚数とページNo.を一致させることで必要のないものを見てしまうミスが減るほか、リンクで飛べるようにすることもできる。1シーンが1ページに収まるようにデザインするとより明快だ。

POINT

各自が読むべきセリフを見逃さないよう、セリフ前に発言者名やキャラクターの顔を据えたり、直前の文中で発言者がわかるようにしよう。キャラクターごとに色を設定して、文字色を変えるのも有効だ。発言者がわかりづらいと、混乱して流れが止まることがある。

check

キャラクターアイコンと吹き出しをつけて、セリフ部分のスタイルを大きく変えた例。読み合わせの中で場所の移動が生じたり、月日を跨いだりするときは、文章だけに頼らず、見出しやアイコン、写真やイラストを挿入することで、いつのシーンか、何が起きているのかを明確にすることができる。

◆ 頒布用コンテンツ 6 ◆

GMガイド

マーダーミステリーのGMガイドは、ゲームマスターがゲームの進行をスムーズに行うための重要な資料だ。GMレスの場合は、展開を伏せつつプレイヤーの代表者が進行を務められる進行ガイドが用意される。ゲームの準備や流れのほか、具体的な盤面の操作方法などテクニカルな解説も含まれることがあり、情報の階層化が重要になる。

POINT ✨

効果的なGMガイドは、多くの情報をカテゴリ別に整理し、見出しや小見出しで階層をつけ、いつでも確認したい箇所だけ見直せるようレイアウトされている。段落や余白を適切に設定し、情報の区切りを明白にすることで、GMが必要な情報を読み取りやすくなる。

check

ガイドの分量が膨らむ場合は、目次を設けることで、必要な情報にすぐに辿り着けるようにしよう。目次はガイドの冒頭に配置し、全体の構成を明確に示す。項目ごとにページを分けて、GMが読み上げる文と裏で把握しておく内容を区別できるとよい。

POINT ✨

GMはゲームの進行をスムーズに行うだけでなく、フェーズや展開によってルームを操作したりNPCを動かしたり、多くの処理を行いながら、個別相談に応じるなどPLをサポートする役割も担う。そのため、GMガイドには補足情報やヒント、注意点などが散りばめられている。

check

サイドバーを利用して、GMの裁量や、シナリオの背景情報、PLからよくある質問と回答例などを本文から分離してレイアウトした例。ふまえておかなければならない本筋は本文で簡潔に示しつつ、GMが迷ったときに必要な情報に効率的に当たれるようになる。

Ch.4-5-7 ✦

カード

ゲームシステムによっては不要だが、オンライン/オフライン共にカードを用いて情報が開示されていくシナリオが多い。伏せられたカードを調査することで、徐々に真相に近付いたり、交渉材料としたりすることができる。視覚的に盤面上の広い範囲をカードが占めるため、カードのデザインは雰囲気をつくり上げる重要な要素になる。

POINT ✦

証拠カードは、事件に関連する証拠品や手がかりを示す。死体の様子、部屋の状況、武器、指紋、足跡、血痕、目撃情報などが含まれ、PLはこれらの証拠カードを使って犯人や状況を推察する。

> **check**
> カードは移動させることもあるので、どこを調査したかがわかりやすいとよい。調査する場所によってカード裏面のベースカラーを変え、カード表面に見つけた場所を明記した例。

メイド待機室 I
室内に隠れて待ち伏せできる場所はないようだ

メイド待機室

ボイラー室 II

商人
昨日は仕入れで隣町まで行っていお客が来ても会えなかったよ。

旅人
森で拾った不気味な木の杖が商人に高く売れて宿代が浮いたんだ。

POINT ✦

証言カードは、証拠カードの中でも舞台に居合わせた人物の証言やアリバイ情報を提供するもの。事件当時の行動、人間関係や噂話、犯行の動機などが含まれることがあり、偽装されている可能性も含め、分析対象となる。

> **check**
> 直感的に証言とわかるように、人物を配置した例。証言した人物の素性も重要な情報になり、表情や書体を変えることなどで人物の性格を表現することもある。

ペーパーナイフ

アンティークのようだが
鋭い

主人の書斎

POINT

アイテムカードは、証拠カードの中でも物理的なモノを指すもの。凶器の候補になったり、貴重なアイテムは取引材料として活用できたり、ゲーム中に実際にアイテムとして利用できることもある。

check

表面にイラストを据えた例。他のカードと区別しやすくするだけでなく、特徴や用途を表すシンボルや色彩を活用しよう。例えば同じアイテムが出てきても、使用状況などが異なる場合がある。

POINT

イベントカードは、ゲーム内で特定のイベントが発生したことを示すカード。特定の状況で公開され、新たな調査場所や証拠が発見される、登場人物が行動するなどのイベントが含まれる。

教会の地下に隠された

階段を降りていくと

行方知れずの司祭が

静かに祈りを捧げていた

EVENT
隠し扉を解錠

check

エポックメイキングな内容でゲームの進行やプレイヤーの推理に影響を与え、状況が大きく変化・進化するため、緊迫感を与える個別のデザインが望ましい。特別な情報カード、「EXカード」も同様だ。

PC3. 鍛冶師
サスキアとして
任務遂行

目標達成

時空を超える冒険者たち
INSTANT CHRONICLES

PC4. 調理師
ミエレットとして
任務遂行

目標達成

時空を超える冒険者たち
INSTANT CHRONICLES

POINT

エンドカードは、ゲーム終了後にPLが演じたキャラクターをSNSなどで報告する目的の画像。ネタバレしやすく公に感想を発信しづらいマダミスにおいて、エンドカードは効果的なPRツールだ。

check

シナリオのタイトルと、個々のキャラクターのビジュアルや名前、コメントなどを魅力的にレイアウトし、プレイ後に思わず共有したくなるようなデザインを目指す。

Ch.4-5-8 ✦

✦ 頒布用コンテンツ 8 ✦

セッションルーム

TRPGと同様に、マーダーミステリーでもGMがシナリオのセッションルームを構築することがある。カードの調査が必要なオンライン用シナリオでは、多くの場合、公式のルームデータがコンテンツに含まれており、ワンタッチで展開される。複雑な要素を視覚的に整理するため、ユドナリウムなど立体的な盤面を構築できるツールも人気だ。

POINT ✦

セッションルームは「盤面」と呼ばれ、メインの要素はシナリオの舞台を表現したテーブルと、テーブルにマッピングされたカードである。限られたスペースで全体を捉えることのできる、見やすい配置を目指そう。

check

テーブルは共有（初期配置）スペースと、分割された各キャラクターのスペースに分けられる。引いたカードを各自が所有できる場合、キャラクターごとのカード置き場が必要になる。

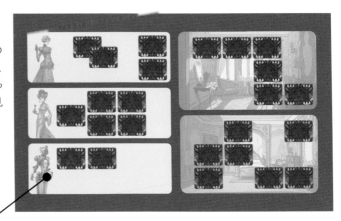

POINT ✦

カードは重ねた状態でプレイヤーに引かせることができるが、引かれたカードはバラバラになる。カードがどこにあるか見やすいよう、カードの裏表いずれもテーブルと差異のあるトーンに設定する。

check

キャラクターごとにカードを整理する充分なスペースを設けられない場合、初期の配置でカードが重なっていなければ、キャラクターマーカーを置くことで所有者と紐付けることができる。

POINT

盤面データはできるだけ軽くまとめるのが望ましいが、プレイ中はズーム機能や拡大表示機能を使って情報を確認することも多い。文字やイラストが鮮明で見やすい画像を作ろう。

check

引きで全体を表示させると細かい文字は読めなくなる。カードや情報を色分けしておくことで、プレイヤーが素早く情報を探し出すことができる。種類ごと、またキャラクターごとに、異なる色を割り当てるとよい。

POINT

ステイタスやチャットパレットと連動するキャラクターコマを作ることができる。平面の画像を立たせて3Dコマにする場合、視点によってはキャラクターが判別できなくなるので注意しよう。

check

マップに沿ってコマを動かす必要がないのであれば、テーブルにキャラクターイラストを固定配置するほうが見やすいことがある。よく動かす調査トークンなどを直感的にドラッグしやすい形状にしよう。

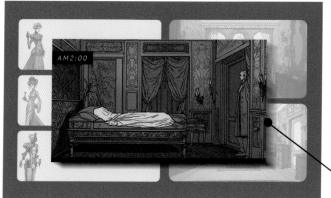

POINT

時代背景に合った装飾や小道具、建築や内装など、ゲームの雰囲気をデザインに反映することで、プレイヤーが世界観に没入しやすくなる。動画も表示できるが、全員が画面に注目している必要がある。

check

ゲームのフェーズによってルームのデザインをがらりと変えてみよう。隠し部屋など盤面が変化するギミックのほか、あらすじや読み合わせの資料を画像で表示させたり、待機画面を設けるなど工夫できる。

Ch.4-5-9

◆ 頒布用コンテンツ 9 ◆

パッケージ

オフライン用のマダミスは、ルールブックやハンドアウトが個別の冊子に分かれており、カードやトークンなどが同梱されることが多い。パッケージ（箱）の形態は本のようにめくって中身を確認することが難しいため、表面は表紙としてキービジュアルで興味を引きつつ、側面や裏面も活用して内容物をしっかり伝える必要がある。

POINT

パッケージは、側面や裏面も含めてトータルでデザインし、一目でゲームのテイストが想像できることを目指す。店頭での販売を視野に入れる場合は、特に側面が書籍の背と同様の役割を果たすため、タイトルに加え、シナリオの傾向を示すモチーフやアイコンを入れるとよい。

check

パッケージの質感や素材もクオリティを伝えるうえで重要になるほか、箱の形状にもいくつかのバリエーションがある。内容物を入れる身部分と身に被せる蓋部分に分ける場合と、差し込み蓋をつけた一体の箱にする場合とではテンプレートが異なるため、印刷会社を決めてからデータを準備しよう。

POINT

パッケージの裏面には、プレイ人数、推奨年齢、プレイ時間、GMの有無といった情報をまとめて提示するほか、購入者が自分に適したゲームかどうかを判断できるよう、登場人物やあらすじなどをレイアウトする。また内容物が揃っているか確認できるリストもあると便利だ。

check

購入のための前提情報に絞って、プレイヤーがゲームの手順ではなくゲームの世界観に興味を持ちやすくなる工夫をしよう。汚れ防止のためにパッケージを透明フィルムでシュリンク包装して販売する場合は、裏面を印刷せず、これらの情報をチラシを兼ねてペラの紙に刷り、添付することも可能だ。

マーダーミステリーの
デザインのアイデア

Chapter 4-6

前節では架空の作例をもとにデザインのポイントを解説したが、この節では、人々を魅了する実際の作品を紹介する。まずは稀有な制作者の作品とインタビューを、続いてデザイン的な見所のあるシナリオ作品群をガイドしていく。紙幅の都合で取り上げられたのは紹介したい作品のごく一部だが、豊潤な世界の一端に触れてもらえたら嬉しい。

▲パッケージ版 - 表紙

▲パッケージ版 - 内容物

▲パッケージ版 - シナリオ中面

TITLE ➡ 大正浪漫マーダーミステリー『鬼哭館の殺人事件』

シナリオ：小田ヨシキ（週末倶楽部）/ 表紙、コンポーネントデザイン：藤本ふらんく（週末倶楽部）/ 調査時間トークンデザイン：rui / キャラクター、裏表紙デザイン：テェミ

時は、大正。帝都の外れに、死人の藝術を揃えた奇妙な館が噂される。その名は「鬼哭館」。ここでは時折、客人を招き奇妙な展示が開かれる──。あえて華やかな大正浪漫のイメージではなく伝統的な意匠を用いて厳かな本のように仕立て、プレイ後に本棚に並べられるよう、パッケージ側面を書籍の背表紙のようにデザインしている。洋書を参考にしたノスタルジーな飾り枠をあしらいながら、えんじ色の地に和紙のようなテクスチャ使用することで、さりげなく和を感じられる仕上がりに。情報カードはトランプのように手に持つことが多いため、相手から見てカードタイトルがわかりやすいようデザインされ、タイトルは小説内の章見出しのようなあしらいで物語への没入感を高めている。

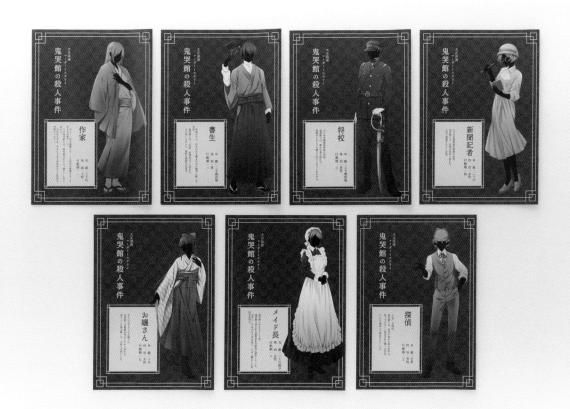

▲パッケージ版 – ハンドアウト

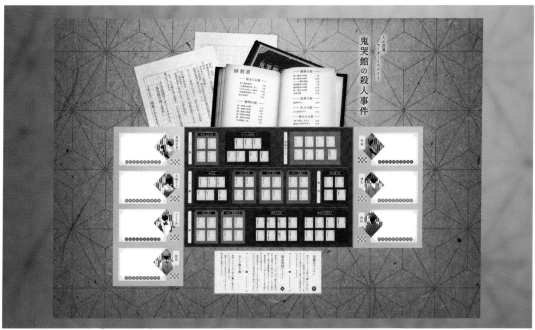

▲データ版 – ココフォリアルーム

週末倶楽部

⟿ INTERVIEW ⟿

『鬼哭館の殺人事件』をはじめとし、パッケージ / オンライン版ともにクオリティの高い人気シナリオを手掛ける、週末倶楽部さん。サークルを超えてパブリッシャーを立ち上げ、ゲーム製作を通じて蓄積されたノウハウを積極的にシェアし、個人やチームのナレッジを業界の共有知に押し上げようとする姿勢に感銘を受け、話を聞いた。

マーダーミステリーの出版レーベルを立ち上げた動機やきっかけ、経緯について教えてください。

一言でいえば、マーダーミステリーというゲームに惚れ込んだから、になります。3年ほど前にたまたま知人に誘われて初めてプレイし、独特の面白さを持っていることに衝撃を受けました。数本遊んだ後、自分でも作りたい！と思い立ち『鬼哭館の殺人事件』を作りました。この作品のおかげでさまざまなご縁に恵まれ、以降マダミス界隈にどっぷり浸かってしまいました。

そうして活動していく中で、作品を出していくのと同時に、この面白いゲーム文化が発展するためのサポートがしたいなと思いました。今までTRPGやボードゲームを作っていた経験から、ゲーム作りやデザインのノウハウがあったので、これを役立てられないかと考えました。専門の組織があったほうがやりやすいだろうと考え、立ち上げたのが、マーダーミステリーの出版レーベル「週末倶楽部」です。

以来、マダミスの発展をサポートしたいという理念のもと、マダミス製作のみならず、マダミス専門店と協力して『これから始めるマーダーミステリーの本』という雑誌を作ったり、マダミスアプリ「ウズ」のゲームをパッケージにコンバートする仕事をさせていただいたり、さまざまな活動を行っています。

『君がマダミス作家になるために』をはじめとした指南本も刊行されています。どのような想いでノウハウを執筆されているのでしょうか。

私はアナログゲーム作家を名乗らせていただいているのですが、元々は同人活動でTRPGを作っていた人間でした。今でこそ、たくさんの人が制作したさまざまな同人作品が流通していますが、私が始めた時はまだ数が少なく、周りに聞く人もおらず、制作が大変難航したのを覚えています。なにせ、漫画などのジャンルと比べてマイナー

でしたから、ググったりしてもなかなか情報が出てこなかったんですね。すごく不安なことも多かったですし、時間やお金の面でも要らぬ遠回りをたくさんしてしまいました。

マダミスは黎明期も過ぎ、私も作ってみたい！と参入される方が増えたタイミングで、当時の自分のように困っている人に、少しでも手助けできればと思い、自分たちが制作する中で得たノウハウをまとめてみた次第です。

マダミスのデザインについてお聞かせください。オリジナルの作品を世に送り出すためには、さまざまな領域のクリエイティブ要素が集結することになります。1つの作品としてトータルディレクションするために、必要な観点は何だと思われますか？

作品の企画段階で、ユーザーに伝えたいコンセプトを明確にしておくことだと思います。コンセプトを伝えるための手段として、ロゴであったりイラストであったりが存在すると思うので、まずその前提がないと統一感のないものになってしまうのではないでしょうか。伝えたいものが自分（あるいはチーム）の中で明瞭になって、初めてその表現が効果的であるか、費用に対してどのぐらいの効果が見込めるのか、といった検討が行えると思います。

そして、もう一つはそれらをうまく共有できるコミュニケーション能力が必要になります。もちろん、ロゴからイラスト、DTPまですべてに精通している必要はありません。ただ、それらの専門家とスムースに連携できるような努力は行いたいですね。たとえば、要素をしっかり言語化したり、イメージ資料を用意したりすることでより理想的なものが作れると思います。

これまでのデザインのやりとりや、外部クリエイターとの協働で、「これは失敗だった！」と反省した例など、シェアできる経験があれば教えてください。

反省点としては、やはり言葉とビジュアルには大きな差

がある、ということがあった、ということでしょうか。過去に、デザインの打ち合わせをしていた際に「ポップなカラーリングで」という言葉を用いたことがあります。ポップ、とはどんな色かを指摘されました。デザインに対して造詣が浅かったこともあり、ポップといえば「パステルカラー」のようなものを想像していましたが、ビビッドな色合いの場合のポップもあり……言葉をデザインに直す際、一意に取れないんだと改めて思った出来事でした。

この他にも、文字だけだと解釈が複数とれて難しいと言われるケースが多いので、以来必ず参考画像をしっかり添付するようにしています。

すべてにコストをかけるのが難しい場合、特にこれはこだわったほうがよい/コストをかけてでもor自身でスキルを身に付けてでも頑張ったほうがよいと思う部分はありますか？

最もコストをかけるべきは、表紙あるいは作品キービジュアルだと思います。どんなにゲームの中身が良くても手に取ってもらうことができなければ、評価のされようがありませんから……まずは、遊んでもらうための工夫が必要です。そこで、最も影響があるのがやはり表紙(キービジュアル)になるのではないかと思います。お金がかかっても、思い切って外注してしまうのが良いと思います。今なら、仲介サービスもたくさんあり、素敵なイラストレーター・デザイナーさんとコンタクトも取りやすいので敷居は低くなってきています。

自身でスキルを身に付けて頑張ったほうが良い分野は、エディトリアルデザイン(効果的な紙面を作るためのデザイン)ではないでしょうか。マダミスというゲームの特性上、プレイヤーに多くの文章を読ませることを強いる傾向にある中で、可読性の低さは作品体験を大きく損ないます。

また、原稿を書き上げてからもテストプレイで細かな修正が多発しますから、エディトリアルデザインを外注してしまうと修正のたびに連携が必要になり、時間とコストがかさみます。であれば、自分でやってしまうのが費用対効果が高いと思います。

併せて、さまざまな有償/フリー素材にあたる機会も増えると思います。作品を可視化するための素材を探し、実際にデザインに組み込むにあたって、コツやアドバイスがあればぜひ教えてください。

本当にそれが必要なのか？ を自問することだと思います。例えば「血のついたナイフ」という証拠カードを作るとします。このとき「ナイフ」のイラストと文章という組み合わせが一般的ですが、何のためにこのイラストがあるのでしょうか？「マダミスでよくこの形式を見るから」で採用している

場合は、今一度考えてみてほしいです。ナイフの画像は、おそらくフリー素材でたくさんありますが、他の証拠に使えるイメージが同じようなテイストで揃っているとも限りません。証拠ごとにコミック調や実写風などテイストが異なると、ユーザーのプレイ体験のノイズになってしまいます。

また、たまたま使用した画像が「軍事用の特別なナイフ」だった場合どうでしょうか？ 採用時には気付かなくても、詳しいプレイヤーが「こんな専門的なナイフを素人が入手できるはずがない、犯人は軍事関係者に違いない」といった推理をしてしまったらどうでしょうか？ 既存の素材を活用する場合、オーダーメイドではないがゆえの齟齬が必ず発生してしまいます。その齟齬をケアできているか、齟齬が生じる恐れをふまえてでも素材を活用するメリットが存在するのか？ よく考えて使用することが大事だと思います。

例えば、私が過去に制作した『沈丁花の沙汰』は江戸時代が舞台で「お白州」が登場するのですが、これは見たことはあっても文章ではピンと来ない人が多いと考え、お白州の有償素材を説明に使用しました。文章がメインだと想起させづらい部分をビジュアルでカバーするのはとても有効なアプローチなので、上手く活用していきたいですね。

マダミスという領域においてどのような未来を見据えていますか？ サークル/パブリッシャーとして目指している今後の展開や、挑戦してみたいことがあれば、教えてください。

今後は、体験価値が重視される市場になっていくのではないかと考えています。

マダミスが、小説や漫画といったコンテンツと違うのは「能動的な遊び」な点だと私は考えています。物語に直接関わって、展開が自分たちの手で動くという経験は他ではなかなか得られないものです。ただ、最初は「自分と違う人間になって殺人事件を議論して投票」だけでも新鮮だったものが、段々それだけだと刺激が少なく感じられていくのではないでしょうか。マダミスという土壌を使った新しい試みを、飽きられないためにも続けていかなくてはいけません。しかし、それはあくまでヘビーユーザー向けの考えであり、新規参入者には刺激が強すぎるとも思います。これから興味を持ってくれる人に向けて、楽しく遊べる環境を整えていくことも重要だと考えています。

ですから、週末倶楽部としては、新しい体験価値を生み出す挑戦、そして新規参入者を迎えるサポートを行っていきたいと考えています。具体的な方策として、新しいゲーム製作やマダミス専門情報発信サイトの作成など、すでにたくさんのプロジェクトを動かしているので、ご期待に添えるよう頑張っていきたいです。

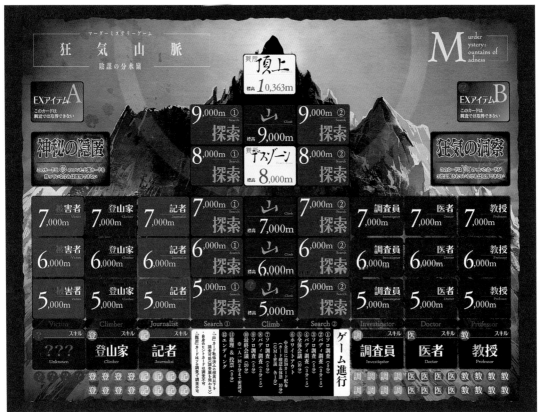

▲『陰謀の分水嶺』- ココフォリアルーム

SCENARIO

TITLE ▶ 狂気山脈『陰謀の分水嶺』

制作：ダバ＆まだら牛（共同制作）／ ボードデザイン：しまどりる／ 企画・制作：合同会社フォレスト・リミット

南極最奥地に発見された新たなる世界最高峰「狂気山脈」。そこで発見された異常な死体……そして、その死体の調査のために狂気山脈に乗り込んだ調査登山隊の中で起きた奇妙な殺人事件。ブリザードのせいで山に閉じ込められた登山隊は、疑念と狂気をはらんだまま調査を開始する──『狂気山脈』シリーズの第一弾。オンラインで配信されることを前提に作られ、プレイヤーが自分を投影しても違和感がないよう、ある程度キャラクターの性格やライフパスを自由に決められるようになっている。さらに情報を自分事として消化してスムーズに感情移入できるよう、役ごとの色分けで情報整理をしやすくしたり、フレーバーテキストの書体を変えてプレイヤーがリアクションを取りやすいようにするなどの視覚的工夫がなされている。

SCENARIO

TITLE ▶ 狂気山脈『星ふる天辺』

制作：ダバ＆まだら牛（共同制作）／ ボードデザイン：しまどりる／ 企画・制作：合同会社フォレスト・リミット

『狂気山脈』シリーズ第二弾。すでに第一弾を遊んだ、あるいは配信を見たなど、シナリオの中身を知っている人だけが遊ぶことのできる特殊な形式をとったマーダーミステリー。2周目のプレイとなる登山隊は、全員うっすらと奇妙な既視感にとらわれており、この山に来たことがある気がする、この先に何があるか知っている気がするなど、前回プレイまでの記憶を織り交ぜて会話しても構わない。

SCENARIO

TITLE ▶ 狂気山脈『薄明三角点』

制作：ダバ＆まだら牛（共同制作）／ ボードデザイン：しまどりる／ 企画・制作：合同会社フォレスト・リミット

『狂気山脈』シリーズ第三弾。第一弾と第二弾を遊んだことがある人が登れる最後の山。奇妙な既視感はそのままに、登山隊はこの山で何が起こるか知っている気がする。しかしその期待ともいえるものが、すでに前回良い意味で裏切られたことも知っている。最後の山には何が待っているのだろうか。あなたはもうあの山に登らずにはいられない。

まだら牛

自作のTRPGシナリオ『狂気山脈』を起点にマダミス『狂気山脈』シリーズを世に送り出した、まだら牛さん。TRPGシナリオを原案としたアニメ映画化プロジェクト『狂気山脈 ネイキッド・ピーク』では、これまで2億円近い資金調達（クラウドファンディング）を成し遂げている。遥かな頂きを一途に目指すクリエイターに、ゲームの設計思考を聞いた。

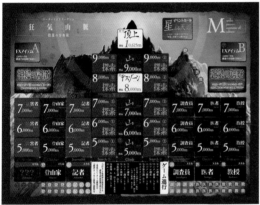

▲『星ふる天辺』- ココフォリアルーム
▶イベントカード

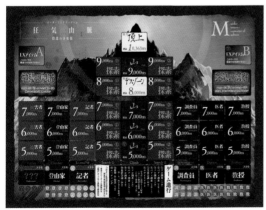

▲『薄明三角点』- ココフォリアルーム

◆ マーダーミステリーの制作を始めた動機やきっかけ、経緯について教えてください。

　前提として、マダミスが日本に流入して遊ばれ始めていた初期の段階で、早いうちに自分もそこに関わっておきたかったっていうのがありました。なぜかというと、僕がTRPG版の狂気山脈を書いたときにはもうTRPGのブームに乗り遅れていたので、マダミスはこれから流行りそうだなというタイミングで作り出したかったんです。

　マダミス『狂気山脈』は僕とダバさんと2人で共同制作していて、主にシナリオの研究と執筆はダバさんが担当してくれました。僕は企画発案者ではありますが、メインライターではない形でクレジットされています。

　実は僕はマーダーミステリーはひとつも遊んでおらず、テラゾーさんが作ったマダミス『LYCAN』の配信プレイを見ていて、面白そうだなと思ったのがきっかけです。

　当時YouTubeのコラボ文化が浸透してきた中で、視点配信という遊び方ができるゲーム配信が熱かった。お互いのチャンネルにお邪魔してコラボコンテンツを用意するのではなく、同じところで遊んでいるものをそれぞれの視点でそれぞれのチャンネルで配信する形です。TRPG的な遊びとしてマダミスを捉えたときに、TRPGの配信はひとつのセッションをひとつのチャンネルで流すことが多かったけど、マダミスだったらそれぞれの視点で見えている情報が違うので、視点配信に価値がある。よりコラボ文化との相性が良く、ひとつのフォーマットとして、TRPGに続き、チャレンジする意義があると感じました。

　その上で、全くの新作を作るよりは、狂気山脈という同じ舞台を使ったほうが、TRPG版ですでに狂気山脈を遊んでくださっている方々、狂気山脈を通じて僕の作品を知ってくださっている方々に手に取っていただきやすくなるだろうなと考えたんですね。

僕は演劇にしろ映画にしろジャンルは箱だと捉えていて、フォーマットの制限がクリエイティブを生むのであって、クリエイティブそのものを制限しかねない「TRPGだったら／マダミスだったらこうあらねばならない」といった思想の押し付け合いは不毛だと思うんですよね。TRPGみたいなマダミス、マダミスみたいなTRPGがあって全然いいと思いますし、作りたいものを作り、遊びたいものを遊べばいい。

はじめにダバさんとこういうゲームにしたいって構想をやりとりした中で、「頭の回転が早くて賢い人が勝つゲームにしたくない」って言ったんです。推理力が勝つゲームじゃなくて、それぞれの視点でどう考えて何を大事にして動いたかっていうのが反映される作りにしたかった。ミッションも配分制ですし、配分次第では全く推理しなくても高得点になったりするので、その人その人が何を大事にして、どういう化学反応が生まれて、結果どういう物語が生まれたかっていう経緯が満足度に繋がるゲームになるといいなっていうのが、狂気山脈のコアな部分の思想です。

それは僕がマダミスを推理ゲームとして面白いと思ったんじゃなくて、それぞれの視点で見えているものが違い、追っているストーリーが違った結果、ひとつの事件をテーマにいろんな物語が生まれるのがリアルでいいと感じた点だったからです。それをマダミスというフォーマットの中で工夫して表現した結果、マダミスの枠に収まらない何かになったんだとしたら嬉しいですね。

これは僕発案の配置なんですけど、僕のものの作り方として、先に箱を作ってしまうんです。要素の数を決めてしまう。たとえば今回でいうと配信でやることを前提に、まずプレイヤーを5人と決めた。配信の構成を考えたときに長時間になってしまうので、前半と後半に分けた。自由にカードを引いたり好き勝手に密談ができる方式にすると番組が構成しづらいので、ソロで調べるフェーズと密談で調べるフェーズに分けてそれぞれ調査のルールを設けた。その調査回数が何回あるとちょうどいいかを考えると、35枚程度でおそらく40枚だと多い。35枚を配置するときにどう配置するか。舞台は山と決まっているので横よりは縦、せっかくだから山の形に、そして1000m刻みの標高にしよう。それで、35枚があの配置になりました。

というように、箱を先に決めて、その中に収まるよう必要

な要素を配置していき、情報を削ったり統合したりして、盤面の中に過不足なく入れ込む工夫をしました。

ゼロイチで何かを創造できる方もいますが、多くの場合は制約の中で創意工夫が生まれます。舞台だったら舞台の中でできる工夫をするはずです。ハコの大きさや導線が決まっていてできることが限られる中で、どうお客さんに見せたらベストか考える。本もそうですよね。綴じられた世界で見開きをどう目線で追うか考えたときに、デザインの工夫が生まれる。ゲームづくりも同じようにしているっていう感覚です。

まず目指したのは、配役の情報が色分けされていて、だいたいこの色を見たら誰の情報かわかるという視認性の良さです。ゲームデザイン的に考えたときに、情報だけでゲームは作れないんですよね。ついルールと情報でゲームを制御できると考えちゃうんですけど、それよりも実はぱっと見の雰囲気やビジュアルが与える印象のほうが、場を支配する力が強かったりします。

例えば一致団結すべきときには一致団結したくなるような、相手を疑うべきときは相手を疑いたくなるようなプレーンではない書体を使うだとか、ここに注目してほしいっていうときに「ここは重要な情報です」と書いて情報量を増やすのではなく、書体で強調すること、あるいは記号を一個与えることで視線誘導したりだとか、見た目でPLの意識に呼びかける工夫はしています。

実はあのHOでも情報量が多すぎると思っているくらいで、見出しの付け方や要素の配置は気を配りましたが、さらに情報を絞る余地はあったんじゃないかなと今になって思います。遊んでくれる方はミステリーが好きで本を読むのが好きなひとばかりじゃないですし、文字量の多さに敷居の高さを感じたり、目が滑ってしまう気持ちが僕はわかるので、端的な表現を重視してると思います。

終わってみて思うことといえば、実は終わってると思っていないんですよね。作品は完結してますし、続編を作るつもりもないんですが、プロジェクトとしては続いていく。マダミスやTRPGって、言ってみればごっこ遊びなんです。オンラインで遊びやすくはなったけど、原理的にはすごくアナログな方法で遊ぶもので、時間が経って、遊ぶ人や遊ぶ

ために必要なツールが変わっても、作品はそうそう劣化しない。

むしろ息が長いコンテンツにできるんじゃないかなと思って、時代によらず楽しめる内容にしているつもりです。クトゥルフ神話自体がもう100年近く続いているものですし、その要素を借りた新しい物語である『狂気山脈』は、きっと10年後に遊んでも面白さが変わらない。じゃあいかにこのコンテンツを永く遊んでもらえるものにするか、っていうのが勝負どころだと思っています。

成功についても、最終的な販売目標数を内部で立てていますが、おそらく皆さんが想像するより途方もなく高い設定です。短期的な売上ではなく、10年20年かけて何本売ろうみたいな計画を立ててやっているので、逆に入り口となる1作目を無料にすることにも抵抗がありません。

作品が眠らないようにメンテナンスをして、この先、遊ぶ環境が変わったらそこに合わせて作り直したり、パッケージ版をリニューアルして出すタイミングがあるかもしれないですし、まだまだ目標の途中だなという気持ちでいます。3作目はオフライン版を求める声を多くいただくんですが、これもまだ技術的に現実的じゃないので、パッケージじゃなくオンライン公演型にするとか、ビジネスモデルもセットでこの先も考え続けていくんじゃないかと思います。

終わっていなかった! 失礼しました。映画づくりをされているので、しばらく『狂気山脈』から離れることは難しいかもしれませんが、現在特に関心のあるテーマや、今後の展開、挑戦してみたいことがあれば、教えてください。

僕が作るものは作品同士がどこかで微妙にリンクしていて、深く知ると繋がりがみえるような裏設定があることが多いです。例えば、TRPG版『狂気山脈』とマダミス版『狂気山脈』は全く別の話で、どちらから入っても遊べますしネタバレにもならないんですが、裏では繋がっている。今

TRPG版をベースにしたアニメ映画を作っていますけど、それとマダミスが無関係かというと関係は大いにありますし、いろんなことをきっかけにいろんな作品を思い出してもらえるよう意識して「繋げる」ものづくりをしています。

特に映画づくりは長いので、映画にかまけている間に存在を忘れられてしまうと作品が死んじゃうんですよね。自分の怠慢で作品を殺すのは嫌だなぁと思うので、常に作品や話題を提供して、忘れられないような試みをし続けるよう動いています。

僕はマダミス作家になるつもりもTRPG作家になるつもりもなくて、カードゲームも作ってますし、今後コンピュータゲームも作りたいと思ってますし、ジャンルに囚われずいろんなものを繋げていきたいです。連作にするつもりのなかったマダミス『狂気山脈』が3周できる作品になってしまったのも、繋げるのが好きだからですね。

裏で流れているテーマや設定に連関があったり、繋がりを感じられる既存の作品群で影響を受けたものはありますか?

たくさんありますが、それこそ有名なのは庵野秀明さん。憧れの人です。僕が高校生の頃に流行った『ガンパレード・マーチ』という作品も、裏設定でいくつかの作品世界とリンクしていて強く影響を受けました。オタクは裏設定が好きなので、そういう作品もどんどん増えましたよね。

「作家と作品を分けるべきか論争」がありますが、僕は自分のことを振り返ってみても、不可分なもの、分けて考えられないものだと思っているんですよね。その時々で考え方は変わるかもしれないし、表現は変わるかもしれないけれど、誰か一人の作家性や感性でものを作ること、根底に一人の人間がいて、放っておいても人生の繋がりみたいなものがコンテンツに表れていく……いわゆる日本的なものの作り方を、自分も好んで志向していると思います。

PC4 仁和寺 登美 (75)

PC1 蒼流 万里 (26)

全体導入

全体読み合わせ

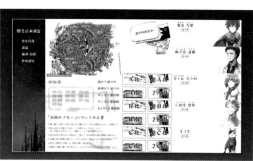

▲ココフォリアルーム

SCENARIO

TITLE ➡ 『ブルーホールミステリー〜夜明けの
まちと「奇跡のブルー」〜』

シナリオ：いとはき ／ デザイン：サトウテン ／ 推理構成・監修：ユート ／
プロデュース・企画：眞形隆之

「ブルーホール」という世界の東に位置する、夜明けのまち。外部の世界から訪れた4人と1匹の旅行者は、この世界特有の資源「ブルー」の中でも特別な「奇跡のブルー」の噂を耳にする。「奇跡のブルー」はどうやら運命を変える奇跡を起こすことがあるという――。イラストレーターのサトウテンによる『架空旅行記「BLUEHALL 夜明けのまちを歩く」』とのコラボレーションで生まれた作品。「ブルーホール」の世界観をベースに「夜明け」をテーマとし、美しいカラーイラストや愛らしいキャラクターたちが描かれた盤面で物語が進行する。

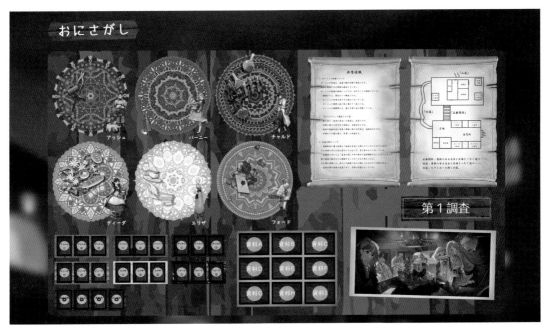

▲ ココフォリアルーム

おにさがし

▲ キービジュアル

カード裏面▶

おにさがし

▲ キャラクターハンドアウト表紙

✦ SCENARIO ✦

TITLE ➡ 『 おにさがし 』 シナリオ：いとはき / デザイン：夏子

ここはハレル村。規模は小さいながらも村人たちは互いを信頼しか
つては支え合っていた。しかし30年前、平和なはずのこの村で起
こったある事件をきっかけに、疑心暗鬼になった村人たちは議論を
通じて罪を犯した者を裁く「おにさがし」の制度を導入する。それか
ら月日は流れ、満月の光が村に輝くある夜、ハレル村の村長が謎の
死を遂げる。彼の死の真相を掴むため、息子のレイドは容疑者であ
る6人を集めた──。「満月の夜」をテーマに円のモチーフで全体
が構成され、キャラクターごとに異なる曼荼羅のような絵模様を用い
て、見分けやすくも統一感のあるデザインがなされている。

163

いとはき

丁寧な描写で感情を揺さぶる物語を紡ぎ出す、作家のいとはきさん。マーダーミステリー『エイダ』で一躍有名になった後も、期待を裏切らない作品をコンスタントにリリースし、多くの人を魅了してきた。セッションルームのデザイン担当、GMガイドのエディトリアル担当、映像演出担当など分業の製作チームとオンライン公演チームを率いる、新世代の商業作家だ。

マーダーミステリーの制作を始めた動機やきっかけ、経緯について教えてください。

　一番最初に作ったのは、商業的には3番目に発表した『おにさがし』という作品で、もともと身内向けに作って友人に回し始めた5人用のシナリオでした。まだマーダーミステリーを1、2作品しか遊んでなかった状態のときに作ってみたものです。それを皆に喜んでもらえたのがモチベーションになって、本格的に制作を始めました。

　マダミス専門の実店舗さんと繋がりがあって『おにさがし』をプレイしてもらったところ、これは商業化できるんじゃないかという話で進めていったんですけど、他のマダミス作品をプレイする数が増えるにつれて、自分の作品が稚拙だったり、推理導線が破綻していたりするのに気付いて、このまま出すのは違うなって思い始めたんですね。結局『おにさがし』に関しては、最初に作った世界観だけそのままに、キャラクターを1人増やして6人用のシナリオとして全く別のストーリーに書き直したものが、今商業化されているものになります。

身内向けに作品を作るところから始める方は多そうですね。作家として転機になったご自身の作品や、現在の制作の方向性が定まった出来事があれば教えてください。

　一番大きかったのは『エイダ』がヒットしたことですね。商業作家としてやっていこうと思えたきっかけは『エイダ』でした。身内だから楽しんでもらえたシナリオが、一般的に楽しんでもらえるかは不確実じゃないですか。自分ができることや伝えたいことが、自分を知らないお客さんから認められてもらえることなのか、世に出してみないとわからないところでもあるので。自分の得意なことと市場価値との適合性をみる必要があったんです。

　そこでまず、無料 / オンライン / GMレスっていう一番

遊んでもらいやすい形態をとって、自分ができる両極端、推理の側面が強い『マーダーミステリーゲーム』という作品と、物語の側面が強い『エイダ』という作品を用意しました。どちらかがヒットするようであれば作家としてもやっていけるだろうと考えて出したところ、思った以上にエイダのほうが流行ってくれました。

『エイダ』は、初心者にも広くおすすめできる王道のファンタジーでありながら、印象の埋もれない作品でした。長く愛される作品になったポイントはどこにあると思いますか？

　自分の中でもいろいろ分析をしていて、それでも確実なこれっていうものはないんですけど、ひとつには、当時は「マダミスとはこういうものだ」っていう型があったように思います。今でこそ多様な作品が生まれていますが、ある程度想定されている展開がある中で、ひとつ抜きん出たものを作りたいなと思って練ったのが『エイダ』でした。それが当時遊んでいる人たちには刺さって、他とは違うシナリオ / 広めたいシナリオとして認知されたんじゃないかなと感じています。

　内容以外の面では、配信者さんの影響が大きいかなと思います。マーダーミステリーを自分ではプレイしないけどエンターテインメントの一種として視聴している層にとって、『エイダ』というシナリオはとっかかりやすく、画面映えするシナリオだったんじゃないかなと推測しています。

　あくまで僕の想定ですが、視聴者の多くはマダミスを楽しみに来るというより、配信者さんたちが何かを演じて盛り上がっているところを見たいと思うので、ロールプレイがしやすいシナリオや、盛り上がりどころが明確なシナリオが、配信者さんからも選ばれやすいんだと思います。

マダミス『エイダ』に実装されたココフォリアルーム。一見シンプルな盤面だが、シーン別にデザインされ、ギミックや演出など、オンラインセッションを盛り上げるさまざまな趣向が凝らされている。

ネタバレに繋がるため、オープンな場では感想が飛び交うことの少ないマダミスですが、実際どのようにプレイされてどのような評価をされているか、作者が配信以外で観測できるポイントありますか？

　有志の方が集計してまとめてくれているシナリオの人気ランキングで挙げていただいてるのを見ると、作品のポジションを把握する助けになると思います。またfusetterという伏せ字で呟ける機能でTRPGやマダミスの感想を呟いている方も多いので、感想はそういうところで見ています。

　マダミスって同じ卓の中でも楽しんだ人とうまく楽しめなかった人がいたり、配役によって不公平感が生まれることが少なくないので、『エイダ』に関してはなるべく一定の体験を与えて全員の満足度が高まるように工夫しました。それが功を奏して感想を述べやすい、翻って作者としても観測しやすい状況にはなっていると思います。

『エイダ』は無料のウェブサイト版から始まって、後に有料のココフォリア / ユドナリウム版が頒布されるようになりました。世界観が貫かれつつも、それぞれ別々の、かつ他方が霞まない体験が提供されています。こちらのセッションルームはどのようなオーダーで実現したのでしょうか。

　『エイダ』のユドナリウム版はすけるとんさん、ココフォリア版はかさんという方にデザインしていただいたんですが、いずれも元々ファン作品だったんです。こちらからオーダーしたのではなく、ファンの方が作ってくださっていた盤面の中から、公式に採用させていただいた形になります。『エイダ』は無料のウェブ版でGMレスでも成り立つにもかかわらず、自分でGMとして回したい、より良い体験を与

えたいと考えている方が少なからずいることがわかったので、ユドナ版、ココフォリア版の頒布に至りました。こだわりが込められた盤面をお届けすれば、求められて体験が一般化するだけでなく、次回以降の作品のマネタイズにもなります。実は『エイダ』の特設サイトもファンの方が作ってくださったものを譲り受けた形です。

　盤面を外部の方にこちらからオーダーして作ってもらったのは、『おにさがし』、『マーダーミステリーゲーム』、『ブルーホールミステリー』の3作品です。

『ブルーホールミステリー』はクラウドファウンディングで実現した連作のマダミスプロジェクトですが、オリジナルの作品とは違う立ち位置になりますか？

　『ブルーホールミステリー』に関してのみ、僕の制作チーム Hand Knitting とは別の布陣で取り組みました。4人のうち1人はUZUでの実装を担当して、もう1人は全体的なプロデュース担当、さらに推理と物語を切り離した分業制になっています。物語とシナリオ構成を僕が、推理構成をユートさんが担当する形で始まったんですけど、実際作り始めてみると推理面と物語面の調整で摩擦が起こり、具体的な相談が必要になりました。

　『ブルーホールミステリー』は、イラストレーターのサトウテンさんが描いた架空旅行記として「ブルーホール」という世界観が先にあり、その舞台を借りてひとつの時間軸で作ったシナリオです。サトウテンさんには新規のイラストを何枚か描き下ろしていただきましたが、もともと「夜明けのまち」のイラストがいくつかあったのをお借りしていて、世界観とシナリオの内容に齟齬がないか質問を頻繁にお送りし、都度確認して作っていきました。原作の旅行記のファ

ンの方もたくさんいるので、下手な改変にあたらないようにという点を気を付けました。

中でも普段と違って難しかったのは、すでに名付けられている地名を使わないといけない点で、情報として記憶するプレイヤーの負荷にならないよう、印象に残る場所の名前を使う、繰り返し登場させるといった工夫をしました。

幸いしたのは、デザイン上こういう姿をしている、こういう場所であるということがすでに可視化・言語化されているので、それを発想の起点にして、旅行記を引用しながらさまざまな具体的な設定を生み出すことができた点です。

普段はご自身のHand Knittingというチームを組織されており、引き続きコラボレーターも募集されています。どのような布陣の制作チームや協働体制が理想的だと考えますか？

たとえば『日陰草の住む屋敷』では、チーム内で一人が盤面制作、僕が推理と物語の制作、もう一人が添削や校正とGMガイドの作成を担当して、スムースな分業ができました。

理想としてはもうひとり執筆担当としてシナリオライターがいるといいなと思っています。やっぱり今の一人執筆体制だと、シナリオ制作に一番時間がかかってボトルネックになりやすいので、それを解消したいんです。ライターに関しては書いてもらわないと才能がわからず、かつすでに書ける方はご自身で活動されていて誘えないので、人材募集が実はとても難しくて、書ける仲間を増やすのが目下の課題だったりします。

それが主な動機ではないんですが、半年ほどかけて参加者それぞれ一本シナリオを仕上げましょうっていう「S-Knit（サニット）」というオンラインプログラムを企画しています。作家志望の方々が集まって、個別作業だけれど一緒の時間を使って書くことで、通常行えない意見交流や悩んだとき詰まったときのサポートが得られる機会となります。これでもし優秀な作品が作れる人、手伝っていただける人と出会えたら、これは完全な任意ですがお声がけできたらいいなと考えています。勧誘と交流と製作支援を兼ねてやっている無料プログラムです。

たくさんの作品がリリースされている中で、作家がどういう面を強化したら作品が面白くなると思いますか？

市場分析すると、推理を重視する人と物語を重視する人と両方を重視する人とでお客さんの層が変わるので、自分の作品がどこに届くのかなっていうのを意識しながら書くことができればよりハマりやすくなると思います。

全員が感動的な作品や全員が本格推理の作品を作る必要は当然なくて、自分のスキルが刺さるお客さんがいるのか、自分の得意なこととそれを喜んでくれる人の接点をイメージして作ることが大事です。今は「500作品遊びました」「600作品遊びました」みたいな人がザラにいるので、その倍以上のマダミス作品があるはずです。その中で埋もれないように持ち味を生かした作品を出せれば、一定の評価を受けられると思います。

僕がストーリーに重きを置くのは、ストーリーって被りづらいんですよね。ギミックやトリックに頼りすぎないように、物語体験として差別化して個別の評価が受けられるように僕は意識しています。

どのような未来を見据えていますか？　制作者として目指していることや、挑戦してみたいことがあれば、教えてください。

マダミスに関しては、『タニスア』を皮切りに、コンスタントにオンライン公演をリリースして、収益化の仕組みを分散させたいです。オンラインでしかできない体験をより追求できたらいいですね。

ただ、僕はシナリオを届けられればいいので、マダミスに固執している訳ではないんです。エモクロアTRPGのシナリオとして『コイントス』や『エイダ』の世界と繋がる『リスピア』を発売したり、他の作品も続編の構想が進んでいたりしますが、新たな挑戦として、ストーリープレイングの領域でオリジナルの物語体験を作ってみたいなと考えています。

僕の想いとしては、誰かの人生に影響を与えるものを作っていけたらいいなって。自分が何かに感動したときって心が揺れて、折に触れて思い出したり、行動方針が変わったりするんですよね。自分の作る物語でそれが叶うなら、形は何でもいいんです。

▼エモクロアTRPG『リスピア』－タイトルビジュアル

シナリオのデザイン実例

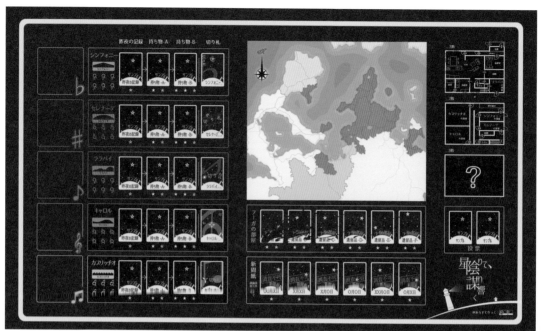

▲ ココフォリアルーム（サンプル）

▲ エンドカード

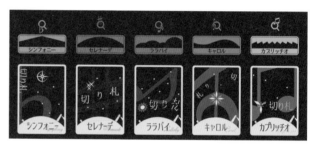

▲ 調査ポイント、マーカー、カード（サンプル）

TITLE ➠ 『星陰りて、謀り響く』 シナリオ：あろすてりっく / デザイン：あろすてりっく

世界の隙間でささやかれるウワサ話、陰謀論を信じる「夏音」という秘密結社。そのリーダーであるフーガが殺害された。容疑者は5人。灯台爆破計画のため集まっていた信頼できる夏音のメンバーだった――。調査に使用するマーカー類はユニバーサルデザインに基づき、色の違いだけでなく形の違いで識別できるよう美しくデザインされている。クリエイティブ・コモンズ・ライセンスの元に公開されているため、フォントやツールの著作権表記が徹底されている。カードにはそれぞれ星座がデザインされており、エンディング後に制作秘話が楽しめる。

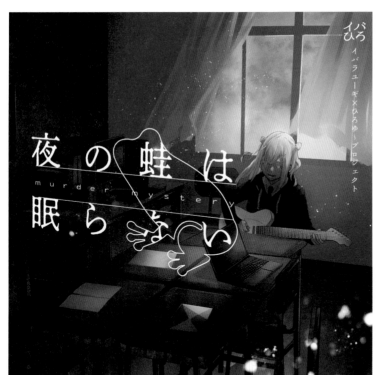

❖ SCENARIO ❖

TITLE ➡ 『夜の蛙は
眠らない』

シナリオ：イバラユーギ（NAGAKUTSU）／イ
ラスト：衿崎、狐白燈、てんみやきよ／デザ
イン：めめこ、おれんじ／企画：ひろゆ～

創ることに魅せられた少年たちが青
春を駆け抜けるマーダーミステリー。こ
んな学生時代を過ごした人も、そうで
ない人もノスタルジックを感じるような
シナリオ。登場する4人の少年たちや
NPCたちのイラストのかわいらしさは
必見。このシナリオを一緒に駆け抜け
たプレイヤーは、終了後それぞれのキャ
ラクターに愛着を持ち、青春時代の思
い出がひとつ増えたようなそんな気持
ちになるだろう。

▶メインビジュアル

❖ SCENARIO ❖

TITLE ➡ 『ゆっくりと
苦しみをもって』

シナリオ：イバラユーギ（NAGAKUTSU）／イ
ラスト：衿崎／デザイン：めめこ、おれんじ
／企画：ひろゆ～

オンラインマーダーミステリーには珍し
く、メモを取ることが禁止されているシ
ナリオ。メモ禁止の理由は、マーダーミ
ステリーにおける推理や駆け引きの楽
しみは持ちながら、キャッチコピーであ
る「広がる景色、伝えるマーダーミステ
リー」の通り、自分にだけ見える景色を
表現してほしいという想いからだろう。
それぞれのキャラクターハンドアウトに
込められた想いはもちろん、眼前に広
がるイラストの美しさにも注目してほし
い。

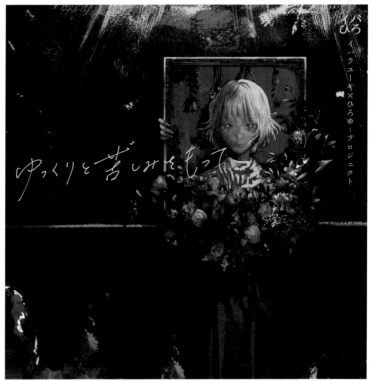

▲メインビジュアル

▲キービジュアル

✦ SCENARIO ✦

TITLE ➡ 『RPGの掟』

シナリオ：ごまいぬ / イラスト、デザイン：ごまいぬ

長い旅の末、勇者たちはみごと魔王を打ち倒した。こうして世界に平和が訪れた……と思った矢先、勇者の死体が発見される。「レトロゲーム」がデザインのテーマとなっており、ココフォリアの盤面は8bit時代のRPGをモチーフにドット絵風、メインビジュアルはRPGの取扱説明書のキャラクターイラストをモチーフに制作されている。往年のRPGを彷彿とさせるようなデザインがまさにタイトルを体現しているが、『RPGの掟』とはいったいなんだろうか。ストーリーと共にぜひRPGの世界を遊んでみてほしい。

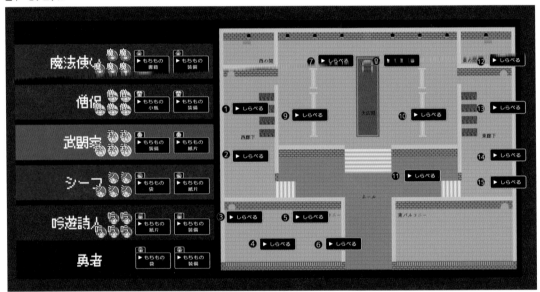

▲ココフォリアルーム

▲トレーラー動画

▲パッケージ版 - 表紙

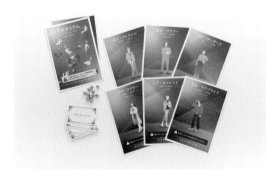

▲『アスタリウム』ハンドアウト、カード、トークン等

▲『アスタリウム』裏表紙

✦ SCENARIO ✦

TITLE ➡ 『アスタリウム』

シナリオ：Paragene（TOXY GAMES）／ イラスト：Otama

2154年、有害な宇宙放射線から人体を守る金属「アスタリウム」が発見され、これをきっかけに宇宙開拓は大きく加速し、富裕層の一部は宇宙への移住を開始した。ある日、宇宙ホテル「エリジウム」の屋内プールで関係者4人と宿泊客2名は2つの死体を発見する——。パッケージにはプレイ人数が想像できる宇宙服に身を包んだ6人が描かれ、宇宙の美しさ、浮遊感と不安を表現している。「SCI-FI MURDER MYSTERY」シリーズの2作目であり、シリーズを通して同じタッチとスタイルでデザインされている。

✦ SCENARIO ✦

TITLE ➡ 『カサンドラ・エクスペリ』

シナリオ：Paragene（TOXY GAMES）／ イラスト：Otama

「SCI-FI MURDER MYSTERY」シリーズの3作目。自然災害を予測するAI「カサンドラ」が予言した、3時間以内に起きる殺人事件。これから自分が犯人になるかもしれないという緊張感を抱えながら臨む、新感覚のマーダーミステリー。「予言」というテーマから、中世の宗教画の構図などを参考に、プレイヤーの想像を限定しすぎないよう、さまざまな絵画やSF映画の雰囲気など、時代を混ぜ合わせた複数の要素を用いてデザインされた。

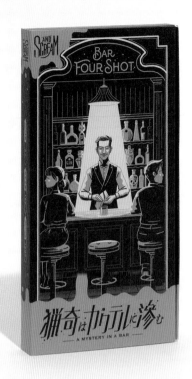

▲ パッケージ版 - 表紙

▲ ハンドアウト、シナリオ、カード、コースター

▲ ハンドアウト

SCENARIO

TITLE ➡ 『猟奇はカクテルに滲む』

シナリオ：JUNYA YAMAMOTO / イラスト：小尾洋平（オビワン）/ デザイン：小尾洋平（オビワン）/ PRODUCED BY THE NAZO STORE

謎解きがついたマーダーミステリー、AND SCREAMシリーズ第1弾。薄暗いバーに訪れた客の視点で物語は進行し、バーに飲みに来た4人の仲間が初めてのマーダーミステリーゲームを試しにやってみる——という本作のシチュエーションをなぞって、初めてマダミスをやる人も自然にプレイできるようデザインされている。ヴィンテージ感のあるデザインにまとめつつ、暗めの配色の中にビビットなピンクを効かせ、バーのおしゃれな雰囲気を楽しめるようになっている。

▲パッケージ版 - 表紙

▲ハンドアウト、シナリオ

▲カードボード、カード

✦ SCENARIO ✦

TITLE ➠ 『軌跡はバイオレットに染まる』

シナリオ：JUNYA YAMAMOTO / イラスト：小尾洋平（オビワン）/ デザイン：小尾洋平（オビワン）/ ディレクター：あん、K / PRODUCED BY THE NAZO STORE

謎解きがついたマーダーミステリー、AND SCREAMシリーズ第2弾。山間の街で起きる3つの事件。過去から未来へ繋がる軌跡と密室から消えた首飾りの謎が交わる物語。4人用マーダーミステリーでありながら、2人ずつに分かれそれぞれ謎を解いた後、全員で謎を解いていく特殊な構成。パッケージは、色数を絞ってレトロな雰囲気をまといつつ、モチーフの首飾りを箔押しの罫で装飾し、高級感を演出している。個々のハンドアウトがパッキングされていたり、カードを置く盤面が付属していたり、パッケージを開けた時から遊び方に迷うことのない動線が確保されている。

▲パッケージ版 - 表紙

▲パッケージ、ルールブック

▲ハンドアウト、カード、資料

TITLE ➡ オートマチックミステリー『エミリーは羊よりも賢い』

シナリオ：田中佳祐 / ゲームシステム：新澤大樹 / デザイン：中村圭佑

コミュニケーションで、ストーリーを進める「オートマチックミステリーゲーム」。10年前にプレイヤーたちが通訳を担当した、新聞記者で現在は作家のアルフレッドが、妻のエヴリン、娘のエミリーを連れて久しぶりに来日する。手紙で交流を続けていたプレイヤーたちは、彼らと食事の約束をしたが、その矢先、妻エヴリンから急ぎの電報が届く。「フタリ ユクエフメイ タスケテ」──。地図、新聞の切り抜き、キーワードカードが付属し、相手にキーワードを言わせるとゲームが進み、地図や新聞の切り抜きを読み解くことで、少しずつ物語のピースを集めていく。パッケージはアルフレッドが帰国した頃から届いていた手紙を想起させるコンパクトな設計。ミステリーでありながら、謎解きパズルであるような感覚で楽しめるように、パッケージは記号的なモチーフが使われ、青の箔押し加工が施されている。ミステリー作品のストーリーだけ味わいたい人も、じっくり推理をしたい人も楽しめる、2人用コミュニケーション推理ゲーム。

▲ パッケージ版 - 表紙

▲ パッケージ、ルールブック

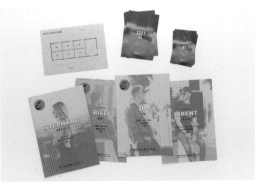

▲ ハンドアウト、カード、マップ

TITLE ➤ メタフィクションマーダーミステリー
『Motel Nobody』

シナリオ：田中佳祐 / デザイン：金浜玲奈

誰も訪れることができず、誰にも知られていない。誰も宿泊客のいないモーテルに各々の思いを抱えて集まった5人。アメリカの古い映画がモチーフとなっており、モーテルで参加者たちが奇妙なゲームに巻き込まれていく様が、いたずら書きのような取り消し線や、犯行声明のようなフォントを変えた不気味な文字で演出されている。紙を使ったアナログゲームという特性を活かした体験が用意されている。

▲ ルールブック中面

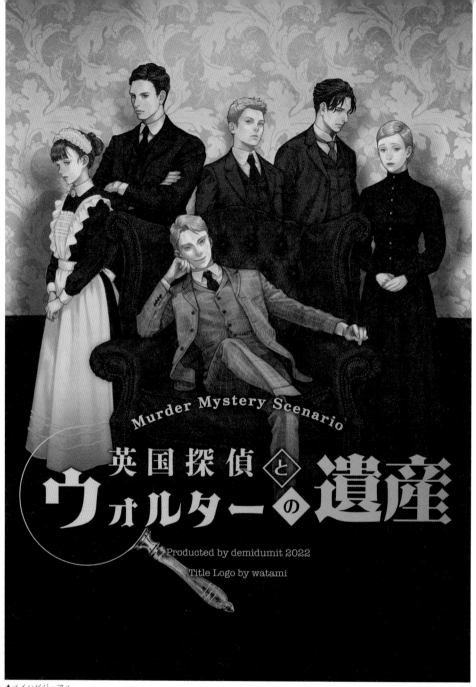

▲メインビジュアル

TITLE ▶ 『英国探偵とウォルターの遺産』 シナリオ：demi（demidunit）/ イラスト：demi（demidunit）/ タイトルロゴ：わたみ

英国貴族ウォルターの死の謎と、彼の残した莫大な遺産をめぐる、遺産相続ミステリー。メインビジュアルは探偵モノのミステリー映画のポスターにインスパイアされ、「豪華な椅子に座る探偵」と「その後ろに控える容疑者たち」の構図で描かれた。タイトルは「ウォルターの遺産」を略称としてSNS上で拡散しやすいよう、ロゴでも部分的に目立たせるようにしている。キャラクターの衣装は舞台である19世紀末イギリスのデザインに寄せられているが、プレイヤーが親近感を抱けるよう、髪型には現代的な要素も入れている。背景の壁紙はウィリアム・モリスのパターンをアレンジしている。古めかしさを演出するために服や背景にはくすんだ色を用いて、全体は黄色がかった色彩に調整している。6時間という長丁場のマダミスであるため、ルールをしっかり理解するための練習用ココフォリア盤面等も用意されている。

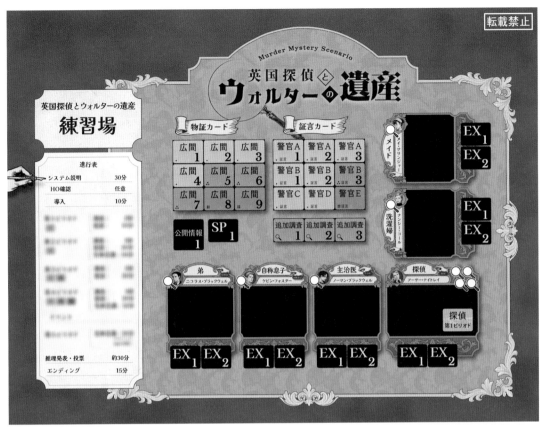

▲練習用ココフォリアルーム

物証カード 車掌の荷物 3

白手袋

上等な白の手袋。
車掌が今着用しているものと全く同じだが、
左手の親指の腹のところにだけ
薄い炭の汚れがついている。
袖口に鉄道会社の社名が刺繍されている。

※内容は架空のものです。

追加調査：4

▲カードデザイン（サンプル）

探偵
第1ピリオド

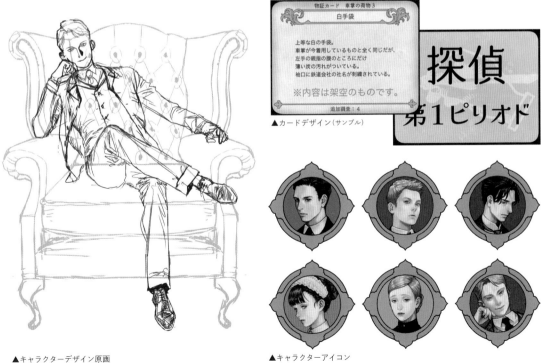

▲キャラクターデザイン原画

▲キャラクターアイコン

▲メインビジュアル

あの日のあなたと祝杯を

シナリオ：上星
イラスト/デザイン：山口介

◆→ SCENARIO ←◆

TITLE ➡『あの日のあなたと祝杯を』

シナリオ、プロデュース：上星 / イラスト、デザイン：山口介 / スペシャルサンクス：みらい、「#マダミス慟哭」で応援してくださった皆様

記憶喪失の幼女を保護した、街一番の富豪。新聞広告を打つと、幼女の親を名乗る者が5人も現れた。立候補者のうちの一人である天才博士の研究所に、全員を集めたところ、親捜しを始める前に博士の遺体が発見される──。メインビジュアルは、博士死亡の真相究明と並行して幼女の取り合いが発生することを示唆し、シリアスな世界観を崩さないよう、セピア系の配色でまとめられた。また、この幼女は俯瞰視点で描かれ、題字のサイズや焦点をずらすことで、心の揺れと奥行きが表現されている。写真をイラスト調の綿画にしたカード、選択できるキャラクターをアンティークなフレームで並べた待機場所など、全体を通してヨーロッパを舞台にしたミステリー小説らしい雰囲気を醸し、装飾と視認性を両立させるこだわりが伝わる。

▲キャラクターカード

▲カード裏面

▲キャラクター待機所

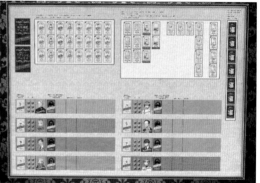

▲ユドナリウムルーム

TITLE ➡ 『この慟哭は届かない』

シナリオ、プロデュース：上星 ／ イラスト、デザイン：
山口介 ／ スペシャルサンクス：yoshi-p、みらい、カ
ルペン晴子

人里離れた山奥にあるロボット研究所。そこで
は博士と5体のロボットたちが暮らしていた。し
かし、ある夜、博士が死体となって見つかる。
容疑者は残されたロボット5体。この中に博士
を殺した「殺人器」がいる――。キャラクター
はロボットゆえに金属的でありながら、色味や
付属品、フォルムなどが個性豊かで可愛らし
いデザインだ。メインビジュアルはシリアス感と
荒廃した雰囲気、世界観を提示することで物
語への没入感を高め、導入の役割を果たして
いる。ロゴは「慟哭」の二文字を押し出し、「慟
哭」という言葉に馴染みがない人にも、文字に
入った切り込みで引き裂かれるような苦しみ、
激しさが伝わる表現となっている。「この慟哭」
は誰の慟哭なのだろうか。プレイしてぜひ確か
めてみてほしい。

▲メインビジュアル

役職
雑用ロボ

君は博士に作られ
たロボットの1体だ。
雑用接きたらけの雑器
（きゃらはな）な体か時
嘆、その名を相応しく、
研究所内の雑器を担
当している。他のロボッ
トたちの手伝いを受ける
も。君は心に留まる
。博士はもちろん、他
のロボットたちから相
談を受けることも多く
他のロボットたちと
なく訪ねる所、困った
ときに相談する相手
は発掘ロボの「クリー
ン」だ。特に親しい

役職
掃除ロボ

君は博士に作られた
たロボットの1体だ。
博士にクリーンと
いう名前を与えられ
た。その名に相応しく
研究所内の清掃を担
当している。特に留ま
るロボットの掃除を認
める。倉庫には掃除
用具がしまわれてい
るため、倉庫の鍵は
掃除ロボの「ガーデン」と
共に管理を任されてい
る。その他、倉庫を
ほつす主に管理ロボ
が担当している。特に
親しいのは雑用ロボの
「チープ」だ。掃除ロボ
のクリーンと雑用ロボの
チープは親しくしてい
る。

役職
発見ロボ

君は博士に作られた
ロボットの1体だ。
また、一番の名前で
もある。博士に「ファ
インダー」という名前を
与えられた。その名に
相応しく、研究所内の
探しを担当している。
管理を任されている
パソコンには膨大な
データが収められてい
るが、さすがに全部は把握
できていない。

役職
庭師ロボ

君は博士に作られた
ロボットの1体だ。
3メートル近い大き
な体が特徴、博士に
「ガーデン」という
名前を与えられた。限
師として、研究所敷
地内の草木を補修・
管理している。倉庫
には脚梯などが入っ
ているため、倉庫の
鍵を渡されている。
仲間思いの性格、
特に親しいのは掃除
ロボの「クリーン」。
博士との関係を良好

役職
管理ロボ

君は博士に作ら
れたロボットの1体
だ。三番目に体が大
きい。博士にライ
センスという名前を
与えられた。その名
に相応しく、研究
所内にある全ての
扉のロックを解除
できるキーを持っ
ている。研究所のみなら
ず、ロボットの管理も
任されている。それ故、
現にこのロボット
たちはリーダーを失
っているところがあ
る。

▲キャラクターカード

STORY

（本文省略）

▲ストーリーカード

▲ユドナリウムルーム

▲『荒廃のマリス』パッケージ版 - 表紙

✦ SCENARIO ✦

TITLE ➠ 『荒廃のマリス』

シナリオ：イバラユーギ（NAGAKUTSU）/ イラスト：衿崎 / デザイン：おれんじ

同シリーズ『星空のマリス』と対比的な世界観をメインビジュアルで表現。地上の荒んだ世界と、地下の美しい世界。『荒廃のマリス』は、紫色の靄がかかっていて見えない空の下、地上に取り残された人類の物語。メインテーマは〈無知は罪だ〉──「好奇心を、探求心を、向上心を、絶やすことなく燃やし続けろ。」知識を探求し続けるキャラクターたちは議論し、葛藤し、全員でその結論を出す。プレイヤーも考えることを楽しむシナリオになっており、キャラクターシートなども『星空のマリス』とは対照的に整頓されたデザインになっている。

✦ SCENARIO ✦

TITLE ➠ 『星空のマリス』

▼『星空のマリス』トレーラー

シナリオ：イバラユーギ（NAGAKUTSU）/ イラスト：衿崎 / デザイン：おれんじ

同シリーズ『荒廃のマリス』と対比的な世界観をメインビジュアルで表現。『星空のマリス』は、地下に逃げ延びた人類の物語。対比が際立つように、象徴でもある大きな塔とそれらを彩る星空が印象的だ。メインテーマは〈知識は罪だ〉──「人は知る事で憎み、知る事で争い、知る事で殺し、知る事で滅んだ。その学びを決して忘れる事なく、否、決して思い出す事なく生きていこう。」知識は罪だと教えられてきたキャラクターたちはのんびりとしたファンタジーな世界観で生きている。キャラクターシートなどもシナリオの特徴である絵本のような世界観を表現したデザインとなっている。

▲『荒廃のマリス』パッケージ版 - ハンドアウト

よく遊びに来る少女　パティ
パン屋の息子　グラ
道具屋の看板娘　アルテ
太陽屋　ヘリオス
太陽屋の弟子　サン
星空屋の弟子　ミスタ
ミスタの妹　スタリー

▲『星空のマリス』キャラクターデザイン

▶『幻想のマリス』トレーラー

✦ SCENARIO ✦

TITLE ▶ 『幻想のマリス』

シナリオ：イバラユーギ（NAGAKUTSU）／イラスト：衿崎／デザイン：おれんじ

同シリーズ『星空のマリス』『荒廃のマリス』のリリース後に制作されたマリスシリーズの前日譚となるシナリオ。白い壁と天井、長い廊下。透明な硝子、白衣を着た大人たち、冷たい視線。無機質な部屋、4つのベッド。マリス先生。子どもたちの世界は、それがすべてだった──。店舗公演していた2作品への導線としてオンラインで無料公開され、GMレスで遊べるため初心者でも手に取りやすい。メインビジュアルは病院をイメージし、閉塞感を表しつつも他のマリスシリーズと同様の美しいビジュアルを踏襲している。

マーダーミステリーのデザイン

定価：本体2,500円＋税
ビー・エヌ・エヌ

❦ おわりに

　TRPGもマーダーミステリーもプレイヤーの想像力とコミュニケーションが鍵となる。コロナ禍で集中的にオンラインセッションを経験し、シナリオを彩るビジュアル要素がどのように人々の振る舞いや体験に影響を与えるのか、デザインの視点から考察できるタイミングが来たと実感したのが本書の始まりだ。

　この期間に我々が出会った才能あるクリエイターたち、遊んだ仲間たちとの濃密な時間を、実は多くの方が同様に獲得したのではないだろうか。作り手も遊び手も分け隔てなく共に遊び、物語を紡ぎながら、その背後にある思想やアイデアの芽に触れ、さまざまな知見を得た。

　私たちがどのような状況においても、新しい物語や知らない世界に没入できるのは、まさにデザインの力が生み出す魔法だといえる。これらの創造力が人々の心を豊かにし、新たなコミュニケーションの場を生み出すことを願っている。

　本書の制作過程では、改めて多くの作品のデザイナーやクリエイターの方々にご協力いただいた。彼らの熱意と情熱から多くを学ばせてもらっただけでなく、自ら企画にコミットしてくださる方もあり、大変心強かった。この場を借りてすべての協力者の方にお礼を申し上げたい。当然、紙幅の都合ですべて紹介できなかったが、我々が感銘を受けた作品はこの他にも数え切れないほどあることを断っておく。

　最後に、本書を手に取ってくださった方に感謝したい。本書を通じて、少しでも新しい発見や楽しみを提供できたなら幸いだ。

BNN編集部

TRPGのデザイン

2023年5月15日　初版発行
2024年6月15日　初版第4刷発行

企画・制作　　　BNN編集部
ブックデザイン　倉持美紀
レイアウト　　　平野雅彦
撮影　　　　　　水野聖二
編集　　　　　　石井早耶香、山本佳代子
編集協力　　　　須鼻美緒
執筆協力　　　　Montro（p124-135）

発行人　　　　　上原哲郎
発行所　　　　　株式会社ビー・エヌ・エヌ
　　　　　　　　〒150-0022　東京都渋谷区恵比寿南一丁目20番6号
　　　　　　　　Fax: 03-5725-1511　E-mail: info@bnn.co.jp
　　　　　　　　www.bnn.co.jp

印刷・製本　　　シナノ印刷株式会社